The Rise and Fall of Art Needlework

its socio-economic and cultural aspects

In the nineteenth century a new needlework style 'Art Embroidery' gave rise to major commercial ventures of the time. The significance of these ventures is explored in this book, particularly the contribution made by women employed in the industry; auditing their working practices, then relating this to our understanding of gender history. These ventures stimulated the commercial side of embroidery in the late nineteenth century, by mobilising commercial activity through numerous agencies, department stores, depots and charitable institutions. A craft became a major industry, and in examining these important developments, the organisational structure of these enterprises, their marketing techniques in relationship to their predominantly female workforce, will be evaluated. The theme of business enterprise is a conduit which runs throughout, yet the work is not intended as an economic history, but rather business history as social history. The economic significance of this business to female employment in the nineteenth century has been previously overlooked, due mainly to the employment of outworkers, a hidden element of employment. Linda Cluckie is an Associate Lecturer at Sheffield Hallam University in Business Enterprise History and Class Gender and Nation.

The Rise and Fall of Art Needlework

its socio-economic and cultural aspects

Linda Cluckie

Arena Books

First published in 2008 by Arena Books

Arena Books
6 Southgate Green
Bury St. Edmunds
IP33 2BL

www.arenabooks.co.uk

Distributed in America by Ingram International, One Ingram Blvd., PO Box
3006, La Vergne, TN 37086-1985, USA.

Cluckie, Linda
 The Rise and Fall of Art Needlework its socio-economic and cultural
 aspects
1. Embroidery industry – Great Britain - History
2. Embroidery industry – Great Britain – Employees - History
I. Title
338.4'774644'0941

ISBN 978-0-9556055-7-4

BIC categories:- AFWK, AKB, AKF, AFW, ACVN, AFH

Printed & bound by Lightning Source UK

Cover design
by Jon Baxter

Typeset in
Times New Roman

Dedication

To Michael for providing beautiful inspiring places in which to write and for his dedication and patience, though this book would not have been possible without the encouragement and guidance from Dr. Myrthdinn Lewis

Preface

In the nineteenth century a new form of needlework 'Art Embroidery' fuelled entrepreneurial ventures. The significance of these ventures will be explored in this book, and the contribution made by women employed in this industry, investigating their prevalent working practices in relating this to our understanding of gender history. The embroidery ventures stimulated the commercial side of embroidery in the late nineteenth century, mobilising commercial activity through numerous agencies, department stores, depots and charitable institutions.

Embroidery took on the form of a major commercial enterprise, and in examining these important developments, the study will evaluate the organisational structure of these enterprises, their marketing techniques and their relationship to their predominantly female workforce. The theme of business enterprise is the conduit which runs throughout, yet it is not intended as an economic history, rather business history as social history.

The growth and development of 'Art Embroidery' in Britain circa 1870-1890 will be explored giving special consideration to the support received from the art establishment in designing for and educating embroiderers. The art fraternity promoted embroidery as a commodity providing income for women. Finally the decline of the embroidery business in the British Isles will be examined, as work was sent overseas where labour was cheaper.

The publication aims to make a valuable contribution to our understanding of the embroidery business, the dynamics shaping its development and the role of women employed in the industry. In particular the thesis will reveal the economic significance of the embroidery business to female employment in the nineteenth century, which has been hidden from view, mainly due to employing outworkers, a hidden workforce. Though a social history, the thesis will demonstrate this hidden workforce made a contribution to the British economy.

Linda Cluckie
October 2008

Contents

viii

CHAPTER 1
The Commercialisation of Art Embroidery

The traditional view of embroidery as a socio-cultural phenomenon linked to the role of women and the home now requires some revision, and this book will especially challenge the ideas of Rozsika Parker in *The Subversive Stitch*.[1] For Parker, embroidery was a vehicle to subjugate women, and this stereotype is based on the premise that embroidery was mainly a device to keep women in the home. Embroidery, it will be argued, went beyond the confines of the female at home, and was an instrumental device for supplementing the incomes of a vast number of women in nineteenth century Britain.

It was estimated in 1872, that three million, out of six million women in Britain had to support themselves, and their dependents.[2] Embroidery was a key means by which a considerable number of women in the nineteenth century earnt a living and others could supplement their income. Hence, far from feeling subjugated, the embroiderers took positive steps to improve their financial circumstances. Historians have failed to give sufficient consideration to the fact that embroidery provided important pecuniary employment, furthermore, that it could be characterised as a business. This study will explore the business ventures of women in this field, investigating the form of work organisation and how this relates to our understanding of gender history.

The economic imperatives associated with embroidery, as a means of supplementing income stimulated the commercial side of this area of endeavour in the late nineteenth century, mobilising commercial activity through numerous agencies, depots and department stores. Additionally the commercial practices provided a conduit for philanthropic institutions. In examining such developments, this thesis will evaluate the organisational structure of these enterprises, the marketing techniques utilised and their relationship to their predominantly female workforce.

This study will make a valuable contribution to our understanding of the embroidery business in Great Britain, the dynamics which shaped its development and the role of women employed in the industry. In particular, the thesis will reveal the significance of the embroidery business to female employment in the nineteenth century, which has been obscured from view due to employment of outworkers, a hidden workforce. The focus throughout is based upon socio-cultural factors in the nineteenth century, for it is they that shaped changes in art and design history. Both socio-cultural history and art and design history require

[1] Rozsika Parker, *The Subversive Stitch, embroidery and the making of the feminine,* (London, 1996)
[2] 'Art Work for Women' in *Art Journal* (London, 1872) p.103

examination in the analysis of women employed in the embroidery industry. The popularisation of embroidery in the nineteenth century was specifically due to British architects designing for churches, prior to being seized and utilised by silk manufactures and retail outlets as a commodity by those wishing to rescue the silk industry from French competition. Consequently, as commercial factors are important in developing analysis and introducing business history, Parker's theory of embroidery subjugating women is challenged. Though the focus remains on socio-cultural issues pertinent to the late nineteenth century, business marketing methods require examination, for it is they that shaped the formation and operation of institutions. As Miller states, business history as social history, often neglects themes such as paternalism,[3] a theme which is equally pertinent to this thesis. Patriarchy, matriarchy and altruism are key issues, which shaped commercial, educational and philanthropic institutions, enabling the new form of art embroidery to become a commodity.

A study of art embroidery consequently requires an in depth examination of art and design histories, for these are the factors which shaped style changes. In the nineteenth century, styles of art and design changed not so much through the teaching of design but through socio-cultural political and religious changes. Genres of art have always changed for these reasons, but the nineteenth century was unique in that due to the industrial revolution the patronage of the arts extended to the middle classes. Most exceptionally, the expansion of the British Empire led to deterministic art and design changes reliant upon Imperialism, not only through the two way exchange of ideas and Said's creation of 'the other', but perhaps interestingly upon the white man's burden of manifest destiny, as illustrated in Liberty's embroidery catalogues portrayed in chapter six. The art establishment was the first to promote art embroidery, taking influences from the East, medieval gothic and Renaissance period to be discussed in chapter two. However, as with all art the main influence for stylistic changes is a derivative of social and political changes.

Embroidery and the Art Establishment

The general historical context for the thesis and the origins of art embroidery will be discussed in chapter two *The Genesis of Art Embroidery* prior to examining the commercial implications. The attitudes and fears of the time play complementary roles associated with government and religious politics to control society. There was, by the

[3] M. Miller, *The Bon Marché, bourgeois culture and the department store, 1869-1920* (London, 1981) p.7

1820's -1830's a severe division between the wealthy and the poor. At a wider cultural level, society feared the industrial revolution, church going had dropped drastically over the first half of the nineteenth century and fears heightened in the aftermath of the Catholic Emancipation Act. The French revolution was still close in people's minds, with underlying fears of similar uprisings in Britain. Further, the escalation of working class agitation was seen by some thinkers as arising from a lack of spiritual guidance resulting in Carlyle's theories that the working class required guidance.[4] Major changes were required to appease the poor and to improve the quality of life.

There was a move by politicians and Tractarians to get the nation back into church, instigated by a massive church building and restoration programme, complete with a return to pomp and circumstance. Religious ceremony became a spectacle of glorification to entice parishioners, for which women nationwide were encouraged to embroider ecclesiastical furnishings. The rebuilding of the House of Commons, in 1837-1867, fuelled the architectural debate of what became known as 'The Battle of Styles' and the reason why that occurred is well documented.[5] Design ideas of Pugin and Owen Jones who wrote at great length on the gothic style, are examined as their views played a decisive factor in architectural and embroidery styles and ultimately in the commercialisation of embroidery. The medieval gothic was the choice for the House of Commons and ultimately church building. Medievalism was adopted by the nation as a form of escapism, a return to a romantic age full of chivalrous notions.

How the development of gothic medievalism led to a new style of art needlework in Britain c.1870–1890 will be explored with special consideration given to the patronage received from the art establishment. Patronage from the art fraternity is a theme carried throughout the study, particularly the art of networking. John Ruskin and William Morris, who furthered Pugin's ideas, called to the nation's artists not to replicate, but to adapt, to examine the Renaissance arts and the arts of the East. Whilst their ideas are discussed in chapter two, a full analysis will occur in the final chapter, '*The Rise and Fall of Art Needlework*'. Central to these issues are the careers of some of Britain's greatest architects and designers, who designed embroideries as an integral part of the interior.

Architects appointed to participate in the church building programme designed interiors as an extension to the exterior; the medieval theme carried throughout in stain glass windows and

[4] Isobelle Anscombe and Charlotte Gere, *Arts and Crafts in Britain and America*, (London,1978) p.9
[5] Roger Dixon and Stefan Muthesius, *Victorian Architecture*, (London,1995) pp.142-181 and Michael Snodin, 'Style' in Michael Snodin and John Styles (eds.)*Design and the Decorative Arts, Britain 1500-1900* (London, 2001) pp.356-357

embroidered ecclesiastical wares, encouraging women of the parish to stitch their designs. Nineteenth-century artists were also influenced by medieval art, a return to concepts of chivalry and the age of Camelot inspired romanticism, which was well portrayed in paintings, poetry and literature of the period, and embroidery lent itself well to these style changes. From a design viewpoint it is important to understand the socio-cultural factors which provided artistic influence therefore chapter two, will examine the writings of William Morris, Walter Crane and Charles Eastlake, all of whom had a significant impact on the nation's taste and all of whom promoted embroidery for the home. Britain's architects combined medievalism with Renaissance art and were influenced by designs from the orient - Persia, India, Japan and the Ottoman Empire - which introduced stylised naturalism as opposed to Victorian realism.[6] The theme of orientalism plays an important part in the thesis since the oriental influence, which inspired British artists and designers, was combined with influences from the Pre-Raphaelite artists and their use of flatness in design, intrinsically referring to abstract form rather than three dimensional, realism. Flatness was to become the symbol of modernity.

The influence of oriental design is central to the work of John Mackenzie, who argues that the relationship between the East and the West was a one-way process. Indian craftsmen for example through their contact with the West conformed to English taste and fashion 'in a parodied form to feed the appetite for exoticism'.[7] From this perspective, Mackenzie concluded that India produced the types of goods which were demanded by the Victorians, and such a relationship may equally be applied to China and Japan in the nineteenth century. Such a simple one-way process, however, is open to question. As will be shown in chapter two, which examines the *Genesis of Art Embroidery*, artists and designers in Victorian Britain learnt much from the East and the relationship was more of a two way process. Artists and designers rebelled against the Victorian styles and were more influenced by the older cultures and styles of the East, preferably all that was best from their ancient architecture. Furthermore, oriental art was commercialised through department stores such as Liberty, as shown in chapter six, which raises issues concerning manifest destiny and Said's creation of 'the other'. Chapter seven, *The Rise and Fall of Art Needlework,* will revisit and summarise the issues, arguing that artists that truly adhered to the two way process moved British art into the postmodernist period. William Morris, however, though he claimed a belief in the two way process, eventually became a mere copyist of oriental design.

[6] Snodin, 'Style' pp.343-67
[7] John M. Mackenzie, *Orientalism, History, Theory and the Arts,* (Manchester, 1995) p.111

The two way process it could be argued began long before the nineteenth century since embroidery worldwide has always been a commodity and every country and race, both rich and poor, has enjoyed traditions of needlework. In the fifth century, South America, India, Greece and Rome enjoyed embroidery in considerable quantities.[8] In Britain, the earliest records of embroidery practices are found in the early middle ages[9] and medieval ecclesiastical embroidery became so luxurious and proficient, it was renowned throughout Europe. The history of English embroidery is therefore worthy of a brief mention here in order to understand its popularity during the nineteenth century. In the medieval period, it rivalled manuscript illumination and stain glass windows to become known as Opus Anglicanum, (English Work). Women worked along side men stitching with copious gold and silver threads on copes, which glittered and flowed when worn in processions.[10] Opus Anglicanum covered a specific period, which was terminated by the Black Death in 1348.[11] The popularity of embroidery for ecclesiastical work and royal apparel continued with the formation of the Broderers Company in 1430[12] formed to scrutinise all professional work.[13] The Renaissance, which had been gathering momentum since its origin in Italy, brought an end to the later medieval period, now regarded as the dark ages, and there was a cultural revival with 'fresh emphasis on personal human philosophy in the fields of learning, science, the arts, a noble ladies education, a privileged pastime, since materials were scarce and expensive.' Usually a man, employed for such services, drew patterns.[14] For example, Bess of Hardwick (1518-1608) employed such a man to draw patterns and all her staff including the stable lads were taught to embroider. Bess of Hardwick defies Parker's theories on subjugation, Bess was hardly a woman to be subjugated by embroidery and after four wealthy marriages, commissioned Hardwick Hall, Derbyshire, purpose built to house embroidery.[15] Bess worked diligently with Mary Queen of Scots, who was her ward, during imprisonment, their embroideries sometimes carrying secret messages,[16] became vehicles of power rather than the work of idle hands. Curtains were embroidered for four poster beds, and door hangings were made to keep out draughts, whilst table carpets and wall

[8] Synge, *Antique Needlework*, (London, 1982) p.xii
[9] Ibid. p.1
[10] Rozsika Parker and Griselda Pollock, *Old Mistresses, women, art and ideology*, (London, 1981) pp. 16-17
[11] Synge, *Antique Needlework* p.15
[12] Ibid. p.25
[13] Ibid. p.32
[14] Lanto Synge, *Antique Needlework* p.29
[15] Santina Levy, *An Elizabethan Inheritance, The Hardwick Hall Textiles*, (London, 1998) pp.17-18
[16] Margaret Swain, *The Needlework of Mary Queen of Scots*, (Bedford, 1986). pp.75-78

hangings gave an illusion of warmth to the home.[17] Large items such as these were only available to the very wealthy; but those less well off could emulate aristocracy by stitching stomachers, sweet bags, slipper bags, gloves and stockings.

By the mid eighteenth century costume was gloriously decorated and embroidery at the zenith of fashion for waistcoats and dresses.[18] Whilst garments were more likely to be embroidered by a professional, young ladies were able to show their prowess by stitching samplers, and silk pictures. During the nineteenth century embroidery had reached its zenith both as a hobby and profession, and this had commercial implications.[19] It became fashionable, for example, to cover legs of furniture, mantelpieces and armchairs. Embroidered items ranged from firescreens, piano covers, antimacassars and pictures. Embroiderer, Elizabeth Glaister, 1880, criticised the new passion for crewel work, where woollen thread was worked upon linen, alleging that many houses looked more like laundries, with furniture draped with embroidered linen.[20]

Clearly, such needlework had developed into a hobby and a leisure pursuit; but authors such as Parker and Synge encourage the notion of separate spheres linking embroidery with femininity and domesticity, failing to acknowledge the commercial aspects. Feminist historians whilst making a valuable contribution in bringing women back into centre stage fail to recognise that many women earned a living through these craft industries. Parker makes a sharp and clear distinction between embroidery as art and embroidery as craft, concluding that embroidery is an art form, a pictorial representation rather than a craft, because it does not 'comply with utilitarian imperative that defines craft'. Nevertheless, to classify embroidery as purely art, in itself provides difficulties, Parker argues, as it fails to distinguish it from painting, and attempts to move embroidery 'several rungs up the [genre] ladder' affirming hierarchical categories. To address these issues, Parker uses the term 'art' to define embroidery in relation to iconography, style and a social function.[21] The weakness in this argument, however, is that genres of paintings have always been defined into hierarchical categories. For instance, religious, historical, portrait, landscape, still life, flower, or animal paintings have always held hierarchical positions which change with the dominant ideology. Similarly, the medium in which they are worked, whether egg tempura, oil, watercolour, acrylic, pastel, pencil, photography or

[17] Levy, *Elizabethan Inheritance* p.6
[18] Synge, *Antique Needlework,* p.118
[19] Ibid. p.127
[20] Ibid. p.147
[21] Ibid.p.5-6

embroidery, all hold hierarchical positions on the genre ladder. Parker's argument reinforces embroidery as a domestic medium for females, yet embroidery was, as it will be shown in chapter two alongside stain glass on the top rung of the genre ladder in the medieval period, a position William Morris aspired to reinstate in the nineteenth century.

Art and Craft hierarchy, Parker argues has always been intrinsically uneven. The real difference she argues is where they are made and who makes them. Embroidery in the domestic sphere was made by women for 'love' whilst painting was predominantly by men for money.[22] Parker's treatise showed how embroidery, had been utilised to inculcate femininity and keep woman in the home, an informed academic publication which carried much weight but in doing so reinforced the dominant ideology that embroidery was and is a feminine hobby. *The Subversive Stitch* is too full of anecdotes of maligned female artists, suffragettes stitching banners and women silently stitching. These anecdotes only serve to persuade the reader that embroidery was maligned because of social attitude and Parker's intentions appear to try to rectify the matter. As she argues,

> *The contradictory and complex history of embroidery is important because it reveals that definitions of sexual difference and the definitions of art and artist so weighted against women are not fixed. They have shifted over the centuries, and they can be transformed in the future.*[23]

Since dominant ideologies change with each generation, it becomes hypothetical to argue whether embroidery is an art or craft, for how it is perceived by one generation may be very different to how it is perceived by the next. Enumeration is required rather than anecdotes to show embroidery's socio-cultural status in the nineteenth century. It will be argued that embroidery provided employment for numerous women, thereby providing independency, financial gain and empowerment. In order to do that embroidery had to become a democratised art, commercially viable, a commodity available to the middle class consumer. There is therefore the need to examine the evolution of embroidery into a commodity, for there has been insufficient attention to the concept of art as a commodity. Veblen's observations of nineteenth century society and consumption provide an excellent insight into the late nineteenth century class system. His theory of 'conspicuous consumption' stated that it was a requirement of the leisured class to show their pecuniary worth through their homes, dress, gifts, entertainment and leisure activities. As wealth develops, conspicuous consumption develops

[22] Parker, *Subversive Stitch* p.5
[23] Ibid. p.215

a hierarchical structure within the class system. The 'utility of consumption' as an evidence of wealth, was therefore a 'derivative growth'.[24] Veblen argued that for the middle classes, a cluttered room was essential.[25] As described earlier, living rooms of that era were full of embroidery, signifying the leisured time of the female members, thereby confirming the patriarch's requirement for the household to reflect his wealth.

Cupboards were largely unknown to all but the very wealthy and therefore clutter in the middle class home was common. However, some clutter was self imposed as it was fashionable to place ones worldly possessions on show.[26] The coming of the mass market, according to Fraser, meant that possessions on display increased demand, as the chipped cup would have to be replaced. It encouraged duplication, for the best tea service would be put on display and a second set utilised for every day use. The parlour was a place filled with the finest possessions on view, for discerning visitors, but never used by the family.[27] Rooms were laden with furniture; tables, chairs, sideboards, chiffoniers, escritoires, pianos and what-nots, all covered with tasselled velvet or embroidered cloths, bedecked with Staffordshire figurines, Doulton china bowls, enamelled tea caddies and stuffed birds.[28] Veblen argued that this clutter was a requirement of conspicuous consumption, that 'the apparatus of living' had grown, 'so elaborate and cumbrous' that the owners could not manage without help from servants who were therefore a necessary adjunct, to be 'endured and paid for, in order to delegate to them a share' in the 'onerous consumption of household goods'.[29] As the nineteenth century progressed, the upper middle class became relatively wealthier and there was a need to conspicuously consume, in order to keep ahead of one's peer group. Discarded items were frequently given to servants, particularly feminine attire, as the female members of the household had to stay one step ahead of fashion. *Punch*, aptly caricaturised the situation, when women of society were barely distinguishable from servants. A self perpetuating circle of consumerism was created as one had to be better dressed than neighbouring servants, and fashion in dress began to change exponentially. Household servants became accustomed to their apparent increased affluence and joined the circle of conspicuous consumption and would try to obtain things identical to their master's chattels when they

[24] Thorstein Veblen, *The Theory of the Leisure Class*, (New York, 1994) (reprinted, first edition, 1899) p.43
[25] Ibid. 41
[26] Hamish W. Fraser, *The Coming of the Mass Market*, (London, 1981) pp.50-51
[27] Ibid. p.51
[28] Ibid. p.193
[29] Veblen, *The Theory of the Leisure Class*, p.41

returned home to marry.[30] Items such as embroidered furnishings could easily be worked in the maid's spare time to be added to the dowry chest.

This expanding conspicuous consumption was also closing the social divide, between the upper and lower middle classes making it increasingly difficult to define the wealth of a person by a cursory glance. Lori Anne Loeb argues that the middle class in the nineteenth century could not be defined purely by income, which might range from £150 to £1000 p.a. and that other factors were involved such as freedom from manual labour outside and inside the home and the employment of servants. More importantly, the acquisition of goods conferred status. Luxury goods, Loeb claims, were 'not so much a reflection of hardened class lines as the ultimate, even if illusory, pleasures of an increasingly democratised society'. Loeb points to Cambell's ideas on 'self illusory hedonism' whereby 'the consumer desires a novel rather than familiar product' which enabled the consumer 'to project an idealised pleasure'.[31] Callen describes how industrialists and agricultural landlords upon becoming wealthy, and entering into the middle classes, had to follow certain conventions. Since leisure was a sign of both social and commercial achievement, their wives and daughters were discouraged from taking an active role in domestic production, which was gradually handed over to domestic staff and tradesmen.[32] As Veblen pointed out, there was a 'mandatory code of decency', in the middle class household where its members, were required to be:

> *ostensibly all spent in a performance of conspicuous leisure, in the way of calls, drives, clubs, sewing circles, sports, charity organisations, and other like social functions. Those persons whose time and energy are employed in these matters privately avow that all these observances, as well as incidental attention to dress and other conspicuous consumption, are very irksome but altogether unavoidable.[33]*

The middle class housewife was required to consume goods conspicuously for the reputability of the household and its head and those goods were to gradually increase in importance.[34] The lower middle class housewife however faced a dilemma, whilst there was a need to conspicuously consume to maintain standing within society, household finances would restrict the possibility. Embroidery was a means by which

[30] Fraser, *The Coming of the Mass Market*, pp.50-51

[31] Lori Anne Loeb, *Consuming Angels, advertising and Victorian women*, (Oxford, 1994) pp.4-5

[32] Anthea Callen, *Angel in the Studio*, (London, 1979) p.26

[33] Veblen, *The Theory of the Leisure Class*, p.41

[34] Ibid. pp.69-70

she might appear to be pursuing a leisurely pursuit, whilst covertly making an addition to household income, an issue discussed in chapter three, *History and Subsistence.*

Pecuniary Employment for Women

Young woman from upper working class families were presented with different fiscal challenges by 1850. Women out-numbered men, so many faced little chance of marriage, therefore employment was imperative. In 1851, the female population in England and Wales stood at 9.146 million compared with the male populace of 8.781 million, thirty years later the difference had almost doubled with women outnumbering men by 695,000.[35] Not only were marriage prospects limited, but many women had dependents to support. Once embroidery was firmly established as a commodity it provided appropriate employment for those in need of subsistence.

Women's work was written out of history, by census reports and by popular general consensus 'a woman's place was in the home.' If a woman took in 'homework' or worked in her spare time it was not, according to Callen considered to play any overt part in the functioning of the industrial economy.[36] However, Callen and Ewles viewed plain sewing of household and personal linen as a method of contributing to the domestic economy, or as with embroidery, it might be devoted to charitable purposes by sewing for the parish baby basket or embroidering for the bazaar.[37] Callen however argues that by the nineteenth century 'work' came to define activity directly related to the commercial market:

> *the buying and selling of goods or labour for the production of surplus value; thus women's work in the home: the reproduction of the labour force and the maintenance of the family, traditionally so central to the economy, became obscured and devalued within the new commercial concept of the market.[38]*

Yet, Callen argued that working women recognised the value of their contribution to the household economy, for as professional embroiderer, Mary Lamb, sister of Charles Lamb urged in *Needlework,* magazine, in 1815:

[35] Angela V. John (ed) *Unequal Opportunities, women's employment 1800-1918* (London,1986) p.36
[36] Callen, *Angel in the Studio*, p.26
[37] Rosemary Ewles 'Embroidery: one thousand years of history' in Lanto Synge (ed) *The Royal School of Art Needlework Book of Needlework and Embroidery* (London, 1986) p. 64
[38] Callen, *Angel in the Studio,* p.26

Women ... should embroider for money or not at all. Then they would see their work a 'real business' and allow themselves 'real leisure'. By embroidery for love women were taking work away from professional embroiders which was the only employment open to women.[39]

Chapter three, *History and Subsistence*, will examine the history of women employed in the embroidery trade, concentrating on their conditions of work, which were defined by sweated labour and unregulated employment. William Morris, the needlework schools and the Arts and Crafts movement set out to challenge sweated labour and to provide a good working environment. The growth in consumerism coincided with the popularity of embroidery, to the extent that working techniques changed and formulation of new working practices were required. Chapman claims that in hosiery manufacture employment in the ancillary trades for seaming and embroidery grew rapidly, expanding from 30,000 in 1733 to 50,000 in 1778 and to 75,000 in 1812. In the net embroidery industry employment rose from 20,000 in 1812 to 110,000 in 1831,[40] whilst the silk glove industry at its peak in 1835 employed 150,000 embroiderers in the East Midlands.

. Labour, Chapman informs was so scarce in the early nineteenth century there was a shortage of embroiderers in England, therefore work had to be sent to Ireland and France.[41] By the 1850's homework or cottage industry had insufficient capacity to supply demand, the embroidery industry needed restructuring. By the middle of the century, many homeworkers were employed directly by a distribution contractor, cutting out the middleman, and many wholesalers began setting up their own workshops.[42] Examining the evidence from Kingsley and Mayhew it becomes perspicuous that the government held some culpability for creating sweated labour, particularly in the business of embroidering military insignia. Such was the demand for embroidery that thousands of women were exploited. Embroiderers in cottage industries in Ayrshire allegedly became blind and tens of thousands were employed in the sweated labour in Nottingham's lace industry.

It should be born in mind that the embroidery industry did not simply involve household furnishings and garment decoration, but played a major role in the lace industry. Handmade lace is performed by interweaving threads tied to bobbins placed upon a pillow, though lace

[39] Ibid. p.43
[40] Stanley Chapman, *Hosiery and Knitwear, Four Centuries of Small Scale Industry in Britain, c.1589-2000*, (Oxford, 2002) p.64
[41] Ibid. p.156
[42] Fraser, *The Coming of the Mass Market*, p.131

may also be embroidered by needle and thread, the difference apparent only to the specialists discerning eye. Lace produced by mechanisation may have improved production quantities but as it will also be shown increased handwork, as many processes could not be completed by machine. Smocking reached its peak in the later half of the nineteenth century with artistic dressing a feature discussed in the chapter on Liberty, lasting until 1890.[43] In the second half of the century Richelin Guipure or Renaissance embroidery was much in demand, strongly resembling lace work, (plate 1.2).[44] It would appear that Britain did not have a monopoly in the market for embroidery and competition was fierce. According to Barbara Morris, from 1855 there were increasing quantities of machine made Madeira work for collars and cuffs imported from Switzerland, with which Britain could not compete.[45]

The market for embroidery was international and the Glasgow embroidery firm of Samuel and Thomas Brown for example, exported to France, Germany, Russia and the USA. The firm exhibited at the Great Exhibition of 1851 'specimens of muslin worked by the female peasantry of Scotland and the North West of Ireland'. By 1857, the firm employed 2,000 men and women in their warehouse and between 20,000 to 30,000 embroiderers working for them in the west of Scotland and Northern Ireland.[46] Lichten agrees that work was sent to Ireland after the famine of 1846-1847, primarily as a philanthropic venture, then it became commercial providing employment for half a million, embellishing embroidering collars, and touches to costume.[47] Embroidery, a labour intensive exercise was also extremely costly, the accounts of William Ball and Son, silk glove manufacturers show that in the 1850's the cost of embroidering the gloves was more than the cost of making the fabric, dyeing, dressing and packaging put together.[48] Such high costs and the modus operandi of the fashion trade encouraged sweated labour, which remains notoriously poorly paid. William Morris and the embroidery schools set out to train embroiderers in their profession and chapter three will show how some upper working class women in Britain were trained and how they progressed from apprentice to improver to assistant.

Hundreds of fancy repositories and depots were set up throughout Britain, where hand made items could be placed for sale. Through examination of trade and commercial directories, it is evident that many specialised in art needlework and some acted as agents taking embroidery for sale on a commission basis. The startling number of commercial

[43] Barbara Morris *Victorian Embroidery* (London, 1962) pp.41-45
[44] Ibid.p.45
[45] Ibid. p.40
[46] Ibid. p.37
[47] Frances Lichten, *Decorative Art of Victoria's Era*, (London, 1950) p.118
[48] Chapman, *Hosiery and Knitwear* p.157

depots and repositories enumerated in trade directories indicates the popularity of embroidery. Charity bazaars were held with frequent regularity, the wealthier members of society would donate embroidery for sale to raise money for charity unwittingly, yet ultimately encouraging the commodification of embroidery.

The Commidification of Embroidery

The nineteenth-century commodification of embroidery was encouraged by the businesses of Morris, Wardle and Liberty, which will be examined in chapters four, five and six. Morris's initial embroidery projects were for his marital home, The Red House, and on a commercial basis for ecclesiastical work along with stain glass. Chapter four, *Morris & Co. and the Family Firm* will consider the work of William Morris, his contribution in changing the nation's taste and the commercialisation of embroidery. He was famous in his own time as a designer and the protagonist of the Arts and Crafts movement. His firm, Morris & Co. set about changing the world of design, famous initially for stain glass and embroidery before moving into textiles and furniture design. Morris was influenced by orientalism and chose influences from Persia and the Ottoman Empire for his embroideries. This chapter will illustrate the way in which he adapted those designs to his own interpretative style leading to an innovative method of branding, a term not coined in his day, but a concept which was quickly realised, when other firms tried to copy the 'Morrisian' look.[49] Morris set up a school of embroidery managed first by his wife and her sister and later by his daughter May. This chapter will assess primary sources to establish the size and success of the embroidery side of the business. Extant sales and production figures will be evaluated to establish the importance of the embroidery department. Morris' marketing techniques, particularly in sales will be examined in terms of how the business evolved and what made it successful and distinct in the market. The firm produced only high quality goods and reputation was a key factor in the development of the firm. Morris' method of networking it will be argued provided a platform for launching the firm and played a significant role in promoting his designs. Finally, the chapter will evaluate how Morris reconciled socialism with capitalism and how he reconciled lecturing on the democratisation of art, whilst producing high quality goods, which only the very wealthy could afford. For Morris, his enterprise was more than a business venture, it became a vehicle for promoting the democratisation of art.

[49] Lesley Hoskins, 'Wallpaper' in L. Parry *William Morris* (London, 1996) p. 204

Morris owed the originality of his soft new art colours to Thomas Wardle, an expert in dying techniques which is too infrequently acknowledged. Thomas Wardle was a leading dyer and printer of silk based in Leek. His firm was surrounded by a cluster of silk manufacturers in a very uncertain market and the need to promote silk was paramount to the success of the dye works. Wardle was assisted by his wife Elizabeth in setting up an embroidery society and school in order to promote art embroidery, which Wardle designed. Chapter five, *The Leek Embroidery Society* will explore why a small market town, in Staffordshire should become one of the leading suppliers of art embroidery, supplying several large department stores. The characteristics of Leek need to be identified, as the emergence of the small family firm in the mid nineteenth century and the clustering of related industries play a significant role. Through family connections, Wardle became linked to Morris and dyed the firm's embroidery threads. In order to promote his silks, Wardle formed the Leek Embroidery Society, which developed an embroidery school, their dual purpose was to commercialise embroidery. The method of marketing products of the society, together with Wardle's silks will be examined as he, like Morris, relied heavily upon networking, a theme which runs throughout chapters four, five and six. His connections with leading department stores, particularly Liberty, further pushed his products to the forefront of attention. It will be argued that Wardle was an innovator, however, for although he followed the general trend for eastern designs he was not a copyist and similar to Morris produced branded goods.

The Leek Embroidery Society and school will be investigated to determine the organisational structure of each and the extent of Elizabeth Wardle's involvement. Elizabeth's motives require analysis, to question whether she was purely assisting her husband in his endeavours or whether deeper needs were fulfilled. With her children grown up and a husband away on business frequently, did Elizabeth have a need to be needed and did she operate the school with a matriarchal or maternal approach? With her social standing as a leading member of Leek society, were Elizabeth's actions dictated by duty to participate in local affairs or did such involvement relieve the ennui of upper middle class life? The answer of course may lie in a rather complex integration of several factors. Many embroidery schools and societies, which existed in the late nineteenth century, faced a paradox. On the one hand, institutes such as the Royal School of Art Needlework were non-profit making organisations with a philanthropic zeal to help young women. On the other hand, they were operated on a commercial basis and this raises issues as to how they reconciled commerce with their charitable status. Further issues are raised regarding the characterisation of these

philanthropic institutions as they were selective about whom they helped, generally young women, of 'gentlebirth yet impoverished means'[50] who found themselves in need of financial support. Titled Ladies selected staff and pupils very carefully, generally setting up the organisations and they only helped those who were willing to help themselves. This chapter will investigate the organisation of such ventures, the methods of training and apprenticeships and enquire as to the likely outcome of the embroiderers once their apprenticeship was concluded. Many questions will be raised as to the motives of these titled ladies: were they the parasitic ladies of leisure, the flâneuse of society, or were they the maternal saver of souls? Were they helping to maintain the class system, the hegemony of the male, or were they teaching women to have independence and the ability to sustain themselves financially?

Once the schools, with the help of Morris and Wardle had established embroidery as a commodity, the new department stores the 'Cathedrals of Commerce' were keen to participate in selling their embroideries. Embroidery however is not easily mass produced, therefore chapter six, *Liberty and the other 'Cathedrals'* will examine alternatives deployed by the department stores to provide sufficient embroideries in store. Many of the themes from the two previous chapters are continued since the growth of the department store coincided with the growth of paternalism as the store owner encouraged the extended family notion. Members of staff were treated as 'family', though there was a hierarchy through which modern managerial methods emerged. Networking was important in the rise through society for the store owner to achieve status beyond that of shop keeper, to make a place for himself within the higher echelons of society. Networking was important as a marketing tool to attract the wealthy customer but it was equally important to network between manufacturer, designers and the store.

Liberty employed many famous designers including Wardle to design for the store but the textiles designed and printed bore the name of Liberty in the selvedge. By this method of branding, Liberty gained a reputation for a very distinct style. Many catalogues illustrate the goods sold by the store; Liberty promoted the oriental image, the bazaar and the new 'aesthetic' taste. Oscar Wilde was one of the major protagonists of the Liberty style and the synergy between Wilde and Liberty promoted each other. Liberty sold both Morris & Co. and Leek embroidery kits, but in order to promote the oriental image shipped hundreds of historical embroidered pieces from all over the continent. After the Russo–Turkish war (of 1877-78) Liberty acted as agents to receive embroidery made by women and children in Constantinople, which they widely advertised as

[50] National Art Library (hereafter NAL) Pressmark 43.A.2 (J) *Vice Presidents Report to the Council, 1875*

undertaking in the name of humanity. The ideology of imperialism requires examination, as it represents a significant factor. The fervour of Britain being the greatest empire ever, far greater than even the Roman Empire, augmented demand from the new consumer society.

There was a craving for Eastern art in all its forms and embroidery became a fetishised commodity, for possession of such was to appropriate 'the other'. To appropriate Eastern art, anglicise it and make it affordable, led to the nationalisation of culture, and a democratisation of art. It will be argued that the entire marketing concept of the company indicated the superiority of Britain over the East, engaging in a discourse of the civilising power of the Imperialists. Liberty was one of the first department stores to sell by mail order, thereby reaching a wider audience than the London set. Debenham and Freebody also sold embroideries and kits but in order to achieve greater sales they began selling British antique embroideries, the catalogues reading more like modern day auction house catalogues. Debenham & Freebody therefore did not aspire to the branded look, but to the more conventional department store image as outlined in Crossick and Jaumain's *Cathedrals of Consumption*.[51]

The image of department stores is best portrayed by Émile Zola in *The Ladies Paradise* (1899). Zola epitomised the effects of store advertising, the way in which stores appealed to the middle class female shopper, persuading her that she was saving money. In one example, Madame Marty forgetting her husband's presence revealed her purchases of lace to other women: one piece bought because it was a bargain, at cost price, the next because she had been assured it was the very last, the next, a veil she admitted was a little expensive, but could be given to her daughter. Madame Marty then revealed twenty six yards of lace, which had only cost one Franc a yard, its future use was unknown, but she liked the pattern. On catching sight of the terrified face of her husband, a teacher, she made the excuse that at least she had forgone the five hundred Franc piece of lace.[52] The layout of the store was important and Zola's store was full of tempting items of lace and embroidered silks, hung from the balustrades, 'like professional banners suspended from the gallery of the church'.[53] The store was laid out in such a way as to tempt the middle class female shopper and in Zola's observations, the store had to be a 'vast feminine enterprise, woman must be queen in the store, she must feel it a temple elevated to her glory, for her pleasure and for her triumph.' He saw it as the place where middle class women might go as if 'supplicants to a dream, to relieve their ennui, to pass time, to escape

[51] G. Crossick and S. Jaumain, (eds.) *Cathedrals of Consumption* (Aldershot, 1999)
[52] Émile Zola, *The Ladies Paradise*, (California, 1992) (reprinted, first edition, 1883)p p.74-75
[53] Ibid. p.225

domestic confines.' Interpreting Zola, Ross declares that women were becoming a commodity themselves:

> *Zola evokes both the condition of the woman consumer and the image she is called upon to purchase: herself as commodity, as superior commodity in the masculine traffic in women. As the image of the mannequin is refracted out onto the streets, consumers and female passers by become indistinguishable from the mannequins; all are soulless but beautiful replicants "women for sale".* [54]

Woman, according to Zola, was the goddess and worshipper at the alter of fashion, and the department store elevated her at the same time as manipulating and captivating her.[55] Retailers, through marketing and pricing policies, carefully planned captivation and manipulation. In *The Ladies Paradise,* the store's manager, Mouret explained to banker Baron Hartmann, Director of Crédit Immoblier[56] that,

> *We don't want a very large working capital; our sole effort is to get rid as quickly as possible of our stock to replace it by another, which will give our capital as many times its interest. In this way we can content ourselves with a very small profit; as our general expenses amount to the enormous figure of sixteen percent, and as we seldom make more than twenty percent on our goods it is only a net profit of four percent at the most; but this will finish by bringing in millions when we can operate on considerable quantities of goods incessantly renewed.* [57]

Everything depended on capital incessantly renewed, the system of piling up goods, cheapness, marketing, and 'awakening new desires within women'. Creating temptation to which she would fatally, succumb 'yielding at first to reasonable purchases of useful articles for the household, then tempted by their coquetry, then devoured.'[58] After 1860, department stores were aimed at middle class customers, goods 'sold strictly for cash, prices were fixed and marked, profit margins were low and the aim was a large volume of business. Aggressive selling and advertising was another feature, and bargain sales played their part in

[54] Kristin Ross, Introduction in Émile Zola, *The Ladies Paradise,* (California, 1992) pp.xvi-xvii
[55] Ibid. p.xv
[56] Zola, *The Ladies Paradise,* p.54
[57] Ibid. p.67
[58] Ibid. p.69

this.'[59] The introduction and development of marketing techniques according to Church occurred at different times and speeds according to the economy, industry or product. Different categories of goods required different marketing methods often depending on the characteristics of the purchaser rather than the product, and social factors led to firms becoming the mediator between the product and consumer.[60] Church argues that negotiations between firms were important to the outcome of production and design. He points to the importance of market conditions and information associated with the nature of the goods and agrees with Butsch that 'consumers participate in shaping new products and practises.'[61] Chapter six will examine the rise of Liberty as a market leader in forming the type of product to be developed and its relationship to the consumer.

Social attitudes of the middle class, particularly the snobbery which existed amongst them was utilised by many commercial enterprises, first introduced by the firms of Wedgwood and Boulton who each independently sought royal and aristocratic patronage, to give lead to the rest of society,

> *in the confident knowledge that social emulation would*
> *ensure emulative spending in the rest of society ... he knew*
> *that a product made more fashionable at the apex of the*
> *social pyramid would rapidly spread through the closely*
> *packed layers of English society to the wider social base*
> *where the mass market he sought was to be found.[62]*

Wedgwood developed and adjusted his pricing strategy, in order to satisfy upper and middle class customers. Certain goods demanded high prices necessary to make his goods esteemed as ornaments in 'palaces' whilst other ranges were kept at lower prices to tempt the mass market. Boulton's price policy was different, to make great quantities with small profits, but he was equally intent on the patronage of the famous and fashionable who would draw attention to his goods, by making them more desirable and, once coveted by the socially emulative market, he made them more accessible in price to the mass market.[63] Towards the end of the nineteenth century smaller shops faced fierce competition from

[59] Fraser, *The Coming of the Mass Market*, p.131
[60] Roy Church, 'New Perspectives on the History of Products, firms, marketing, and Consumers in Britain and the United States, since the Mid-Nineteenth Century', in *Economic History Review*, LII, 3(1999) pp.413-414
[61] Ibid. p.431
[62] Neil McKendrick, John Brewer and J.H. Plumb, *The Birth of a Consumer Society*, (London, 1982) p.71
[63] Ibid. pp.73-74

department stores and were unable to compete with the low prices guaranteed by ticketing. In addition, department stores had the benefit of large shop windows which allowed people to compare prices; culminating in every shop large and small lowering their prices. With smaller profit margins, selling large quantities became imperative.[64] Embroidery was one item that was sold in large quantities, and it was not only department stores which benefited from the increased demand for embroidery, for even small retail outlets showed profitable gains. Mrs. Emma Wilkinson of 44 Goodge Street, Tottenham Court Road, London wrote in her book *Embroidery: its History, Beauty and Utility* (London, 1856) that she had issued from her 'establishment upwards of 60,000 sq. yards of traced and perforated muslin for embroidery.'[65] Similarly, *The Artist* reported the success of the opening of M.Sepon Bezirdjain's studio and his efforts to popularise the Arabian and Persian style of decoration in England. Tracings of over 100 patterns were in the course of reproduction 'which will do much to lift the art of embroidery out of that horrible fancy needlework and teapot cosy groove into which, in the hands of the philistines it is apt to fall.'[66] The teapot cosy continued to be embroidered, but those with taste stitched in the new art embroidery style, favoured by Ruskin and Morris. They and their ardent followers including designers many of whom had been employed by Liberty established the Arts and Craft movement with societies throughout Great Britain.

The Arts and Crafts movement closely adhered to the teachings of Carlyle's working principles and the economic teachings of Ruskin and Morris's ideals on democratising art, all of which will be examined in closer detail in chapter seven, *The Rise and Fall of Art Needlework*. Many groups and societies were set up which specialised in embroidery; those set up in the Lake District will be examined as they had a close connection to Ruskin. Their influence spread to America, where Candace Wheeler sold embroidery through Tiffany & Co. Wheeler had been influenced by British work seen in America at the Philadelphia exhibition in 1862 but, adopting a very different style to that being stitched in Great Britain, she organised a co-operative, giving women it will be argued a far higher degree of independence. Why therefore with the popularity of embroidery providing pecuniary employment for women in the United States and Britain should it suddenly demise after the First World War?

The conclusion will analyse the factors, which brought about the demise of embroidery, as a means of employment for British women. Embroidered garments maintained popularity, and work was given to

[64] Zola, *The Ladies Paradise*, p.68
[65] Barbara Morris *Victorian Embroidery* p.38
[66] 'Art Trade, Decorative Needlework' in *The Artist, journal of home culture* (London, 1886) p.330

either the couture houses in France or China where labour was cheap. It will be argued that there were a number of complex intertwined factors and from a microcosmic level it would be a simplification to state that it was a change in fashion; on a macrocosmic level many factors need consideration, in particular economic and design constraints directly attributable to the Arts and Crafts ideals.

CHAPTER 2
The Genesis of Art Embroidery

Four interconnected themes were influential upon the design aspects of Art embroidery including medievalism, Pugin's gothic style, his notions of form and function and the influences from Eastern and renaissance art. Each aspect will be examined in full, but it was religion that acted as a catalyst in making embroidery a commercially viable commodity. The reasons for this occurring will be explored along with the ideals of Ruskin and Morris, for they applied Pugin's theories, whilst at the same time believing in the democratisation of art. Ruskin and Morris held firm beliefs in methods of production, to bring art into life and life into art.

The genesis of art embroidery has direct correlation with medievalism therefore, an understanding of the medieval period is imperative to the study. Medievalism was studied in depth by architects, designers and philosophers and medieval notions of chivalry and romance infiltrated into society. Inspired by literature, architects and designers eyes were turned towards medieval art which they adapted for the modern day. Augustus Welsby Pugin (1812-1852) adopted the medieval gothic for his churches during a massive church building programme. Following ever decreasing congregations the government after 1840 devised a programme to build churches throughout Britain, in order to tempt people back into church. The building programme requires discussion as it gave rise to the production of embroidery in parishes with new or renovated churches, leading to the formation of embroidery groups.

Pugin's choice of medieval style will be explored for it was his ideas, which influenced designer, writer and socialist William Morris (1834-1896), and Owen Jones architect and designer (1809-1874) who revolutionised design promoting Pugin's attitudes on form and function of design. Though Owen Jones was influenced by orthodox medieval styles he studied Eastern and European art and architecture, strongly favouring forms from eastern countries, particularly India. British imperial presence in the nineteenth century is important to the study of art and design. In particular Indian influences played a major part in shaping and stimulating art, and this chapter will examine the form and function of Indian designs and their relationship to the medieval gothic.

Victorians looked back to the past to a period they felt more romantic, as escapism from fears bought about issues such as the appalling conditions and poverty which existed in many communities for the most part of the nineteenth century. Fears in society were generated by the repercussions from the industrial revolution, which Powers' argues

alienated the classes in society, with politics impacting on daily life and instability created by periodic economic depressions. Wages, Powers states, fell continuously from 1879 until 1886 and the word 'unemployment' entered the *Oxford English Dictionary* in 1882.[67] Artists and designers have always responded politically, their work inextricably reflecting social and political views, their delving into historicism reflecting the Renaissance period whereby at least some of mankind became cultivated on a higher level. Examining the working methods and romanticism of the medieval period, and studying the arts of different cultures moved the world from modernity to postmodernity.

Medievalism Revived

The Victorians had a strong interest in the medieval, and it is difficult to determine when the interest in medieval times became popularised in Victorian society. Indeed, the origin of interest can be traced back to the eighteenth century. For example, in Charles Eastlake's opinion it was the politician Horace Walpole (1717-1797) who sowed the seeds for change in taste, when he built his gothic residence Strawberry Hill.[68] Literature most certainly popularised the medieval with novels such as *The Waverley* (1814) and Ivanhoe (1819) by Sir Walter Scott (1771-1832) and Tennyson (1809-1892) in his *Poems* continued the romance of the medieval, which included *Lady of Shalott*, 1832, *Morte d'Arthur, and Locksley Hall* all revised and republished in 1842.

These writings had a significant impact upon Victorian society promoted by the romance of Victoria's sovereignty in 1837. The queen's accession to the throne was celebrated at Eglinton in 1839, with the re-enactment of a medieval tournament. The medieval jousting contest was rained off, but the romance of the event must have stayed with her, for three years later in 1842, she celebrated her marriage to Prince Albert by holding the Bal Costume, where everyone dressed in medieval costume, and acted out modes of chivalry. In 1844 Robert Thorburn painted Albert in armour, a costume he had not worn for any specific event, but as Girouard argues was representational, the armour indicative of chivalrous qualities in civilian life.[69] Medieval chivalry, as practised in the medieval period was to become the order of the day, promoted by the queen and Tennyson, her Poet Laureate from 1850 onwards. Throughout the century, Tennyson continued to write and rewrite poems based on medieval mythology, and in 1859, he reached his zenith with *Idylls of the*

[67] Alan Powers, '1884 and the Arts and Crafts Movement' in *Apollo,* April 2005 pp.61-65
[68] Charles Eastlake, *Hints on Household Taste* (London, 1868) p32
[69] Mark Girouard, *Return to Camelot* (New Haven and London, 1981) p.115

King, which sold 10,000 copies in the first month.[70] According to Girouard it was Walter Scott who gave thousands of readers a version of the Middle Ages that captured their imaginations so vividly.[71] Christmas festivities in the nineteenth century owe much to his poem *Marmion* which described a medieval Christmas,[72] whilst his *Waverley Novels* brought castle and halls to life leading Eastlake to proclaim that Kenilworth became 'once more the scene of human love, and strife, and tragedy.'[73]

Literature influenced artists, especially the Pre-Raphaelite painters who portrayed many of the scenes from literary sources. Artists and royalty were promoting wittingly or unwittingly medieval chivalry as an antidote to the horrors and social isolation they perceived as caused by the industrial revolution. Medieval chivalry was revived by artists, and promoted by the queen, but it was Pugin who brought it to the attention of society and as Cain and Hopkins observed, 'Chivalrous medievalism left its imprint on every facet of Victorian culture...Pre-Raphaelites to medieval castles and gothic churches.'[74]

Pugin and the Gothic Style

Pugin is important in understanding the fundamental changes in the concept of design in the nineteenth century as he had very decisive views on the nature of architecture and designed the contents of interiors of his buildings to co-ordinate with the exterior, an holistic doctrine that was to be followed by architects throughout the nineteenth century. Pugin contributed to a vision of building, which projected the idea that interior design mattered as much as the exterior and that the gothic style should be carried throughout. This ideology had a considerable impact upon designers throughout the century, especially the designs of William Morris, who would carry the gothic style throughout interiors from stain glass windows, floor tiles, wall paintings, furniture, embroidered drapes and wallhangings, and in the case of ecclesiastical work embroidered alter frontals. Pugin's tenets of architectural design were that every feature of a building should have a practical function and that ornament might legitimately enrich any feature, as long as it did not disguise it.

The great test of architectural beauty Pugin wrote, was that the building should be honest, that, 'fitness of design to the purpose to which

[70] http://www.charon.sfsu.edu/Tennyson/TENNCHRON>HTML

[71] Girouard, *Return to Camelot* p. 34

[72] Ibid. p.36

[73] Charles Eastlake, *A History of Gothic Revival, (Leicester,1970), (reprinted, first edition, 1872)* pp.112-113

[74] PJ Cain and AG Hopkins, *British Imperialism-Innovation and Expansion, 1688*-1914 (London,1993) pp.31-32

is intended, and that the style should so correspond with its use that the spectator may at once perceive the purpose for which it was erected.'[75] This principle was carried through to the interior. In *The Present State of Ecclesiastical Architecture,* published in 1843, Pugin described how the interior of the church should be designed. The influence on design, he insisted, should follow medieval traditions in both stain glass, embroidered alter frontals and vestments and that it must not slavishly copy medieval designs.[76] Owen Jones, John Ruskin, William Morris and many others, especially the Arts and Crafts movement espoused Pugin's teachings. Owen Jones was inspired to study oriental design and colours and his book entitled *The Ornament of Grammar,* 1856, provided a popular source for design material. John Ruskin wrote *The Seven Lamps of Architecture* and *The Stones of Venice* based upon the study of architecture of Venice and Morris followed Pugin's ideology of holistic design. Morris's interest in embroidery followed the advise from Owen Jones who re-iterated Pugin's notion that,

> *the Decorative Arts arise from, and should properly be attendant upon, architecture ... As architecture, so all works of the decorative arts, should possess fitness, proportion, harmony, the result of which is all repose.*[77]

Though medieval gothic, romance, and chivalry were popular trends which influenced Pugin's architectural designs, he interpreted a specific style of gothic, creating a unique trend, choosing not just gothic design but a very specific period, that of the fourteenth century.

The creativity of Pugin was demonstrated in 1836 when the House of Commons burnt down and a competition was organised to find a design for the new building. Architecture in Britain was varied, ranging from classical, baroque, Tudor, medieval, Norman, and Saxon. Architecturally the building needed to surpass any other; it needed to be grand, it needed to reflect the glory of the world's largest empire, a symbolic gesture to Britain's imperial destiny. Which style to adopt caused much debate and became known as the 'Battle of Styles'.[78] The problem was, which style would truly represent the powerhouse of the empire? From the numerous entries submitted, Sir Charles Barry's design was selected. Barry employed Pugin to draw up the outside elevation and it was Pugin who designed the interior. He took an holistic

[75] AWN Pugin, *Contrasts* (New York, 1969) (reprinted first edition, 1836) p.1
[76] AWN Pugin, *The Present State of Ecclesiastical Architecture* (London, 1969) (reprinted, first 1843) pp.23-40
[77] Owen Jones, *The Grammar of Ornament* (Hertfordshire, 1986) (reprinted first edition, 1856) p.5
[78] Eastlake. *A History of Gothic Revival* p.333

view and carried gothic medievalism to the interior of the building, from floor tiles, wood carvings, seating and paintings. Although it was Barry who won the commission, the importance of Pugin's design concept needs to be appreciated. As Clive Wainwright states, 'Pugin is now wholly associated in our minds with the Gothic Revival Style'.[79] Further, as Hitchcock argues, Pugin was at the time better known to people than Barry, due to the many books he had written on church architecture, his book *Contrasts* written in 1836 for example earnt him many commissions.[80]

In *Contrasts* (1836) Pugin explained why the medieval should be adopted in England, espousing the virtues of the fifteenth century Perpendicular style, with its spires reaching to the heavens.[81] By 1840 though he had clearly decided that the earlier fourteenth century English Decorated was the perfect phase of medieval architecture. By this time the building of the House of Commons was well under way and Pugin's hands were tied to the gothic Perpendicular as dictated by Barry's initial design.[82] Pugin chose the medieval style denouncing eighteenth century neo-classicism as he thought all Roman art to be 'barbarous, because the Romans had tried to destroy Christianity ... but once Christianity had spread over the whole of western Europe ... art arose purified and glorious'.[83] He denounced the Tudor style as debased, because Henry VIII's destructive reformation 'gave rise to the Protestant or destructive principle.'[84] The reformation he claimed had dealt a

> *fatal blow to ecclesiastical architecture in England. ... the*
> *most glorious edifices of the middle ages have either been*
> *entirely demolished or so shorn of their original beauties,*
> *that what remains only serves to awaken our regret at what*
> *is forever lost to us.[85]*

Pugin's tenets of architectural design were that every feature of a building should have a practical function that ornament might legitimately enrich any feature, as long as it did not disguise it, that a building should be honest. Pugin proclaimed gothic was English, unlike classical or Renaissance. Classical, he argued was pagan, representing worldliness, whilst the gothic church represented the spiritual. Early

[79] Clive Wainwright,' Principles true and False: Pugin and the Foundation of the Museum of Modern Manufactures', in *Burlington Magazine* Vol. COX no.105, June 1994 pp357-364
[80] HR Hitchcock, 'Introduction' in AWN Pugin *Contrasts* (New York, 1969)(reprinted, first edition,1836) p. 12
[81] AWN Pugin, *Contrasts*.
[82] HR Hitchcock, 'Introduction' in AWN Pugin *Contrasts*, p. 12
[83] Pugin, *Contrasts* p.1-7
[84] Ibid. p.21
[85] Ibid. p.23

English churches, Pugin considered primitive, small, rustic churches, the Perpendicular Gothic was debased and degenerate, and he preferred the Decorative Gothic of thirteenth and fourteenth century churches with naive, aisle and porch, preferably a tower and spire.[86]

Pugin changed British attitudes regarding architecture, the problem of the battle of styles was resolved, and it became an unwritten rule that in the main classical would be used for civic buildings, baroque for theatres and the gothic style for churches. Pugin fought hard to improve design teaching and was instrumental in the formation of the government schools of design established at Somerset House in an attempt to provide design education, in 1837. Yet the problem was not resolved, leading to the Superintendent painter William Dyce resigning in 1843 criticising the lack of training applicable to the manufacturing industry. The debate came to a head in 1845 with the publication of letters in *The Athenaeum, The Spectator* and *The Builder*, cumulating with a debate in the House of Commons in June that year. Pugin, according to Clive Wainwright, threw himself into the debate by writing an open letter to J.R. Herbert, a fellow Catholic friend and member of staff at the School of Design. The letter complained about the lack of training, that pupils were imitators of style and should be taught to combine 'all the spirit of medieval architects, and the beauties of the old Christian artists, with practical improvements of our times.'[87] Pugin and Owen's teaching impacted upon the great art critic Ruskin and designer Morris, who in turn had an irrevocable effect upon the design world. Ruskin denied having read Pugin's books and publicly criticised his work, hence he was denounced by the painter Frank Howard who gave a paper in 1852 to the Liverpool Architectural Society entitled *Stones of Venice and Principles of Art* in which he accused Ruskin of plagiarising Pugin. Howard accused Ruskin not only of plagiarism, but of disguising the fact by his abuse of Pugin. Five years later *Building News*, reviewing Howard's paper which had just been published, agreed with Howard, but thought the debate was too late as Pugin was by then dead; yet as Hill states the debate continues.[88] A similar debate can be applied to Morris, for designs exist which have clearly taken inspiration from Pugin, giving rise to the valid argument that Pugin may well have entered the annals of history as the greatest designer of all time, had he not become insane. But his greatest downfall was his conversion to Catholicism. As Eastlake wrote in 1868,

[86] Charles Harvey and Jon Press, *Design and Enterprise in Victorian Britain* (Manchester, 1991) p.17 and Pugin *Contrasts* pp.1-7

[87] Wainwright, ' Principles True and False', pp.357 -364

[88] Rosemary Hill, 'Pugin and Ruskin' in *The British Art Journal,* Vol. II no.3 Spring/summer 2001 pp.39-45

Pugin was the first who deftly expanded the true principles
of what he not ineptly named Christian art ... There was,
however, one drawback to his efforts. He blended his
theological convictions with his theories on art, and the
result was that the two became identified in the public
mind.[89]

The Catholic Emancipation Act of 1829 spread fear amongst many
British politicians. The establishment therefore frowned upon Pugin's
conversion to Catholicism. Yet theological convictions and art were
intrinsically linked in the public mind, for groups of women existed in
almost all parishes to stitch embroideries for the new or refurbished
churches. Mordaunt Crook in his introduction to Eastlake's *History of
Gothic Revival* stated that 'The Anglican and Catholic revivals added a
new and different liturgical enthusiasm, and in the hands of A.W.Pugin,
Carpenter and Butterfield, liturgy and archaeology were transmuted into
architecture.' In this way, Crook argues, the Gothic revival which began
as ecclesiastical dogma, was after the 1830s no longer a cult, it had
become a crusade.[90]

On Form and Function of Design

Pugin remonstrated against nineteenth century eclecticism, of over-
ornamentation, of decorating every inch of surface, purely for the sake of
ornamentation. In 1841, in *The True Principles of Pointed or Christian
Architecture* he wrote 'that all ornament should consist of enrichment of
essential construction' stressing that ornament should never be 'actually
constructed instead of forming the decoration of construction'.
Influenced by Eastern art forms, Pugin pointed out that eastern nations
always 'decorated their construction and never constructed decoration.'[91]
Owen Jones supported this viewpoint, and wrote that, 'Construction
should never be decorated. Decoration should never be purposely
constructed.'[92] The geometric structure of Pugin's designs were based on
an architectural format developed largely by Owen Jones with his silk
designs for Spitalfields taken from his illustrations in *Plans, Elevations,
Sections, and details of the Alhambra* 1842 and *The Grammar of*

[89] Eastlake, *Hints on Household Taste* p.32
[90] J.Mordaunt Crook 'Introduction' in Charles Eastlake *A History of The Gothic Revival* (Leicester,
1970) p.57
[91] Wainwright,' Principles True and False', pp.357 -364
[92] Jones, *The Grammar of Ornament* p.5

Ornament in 1856.[93] The latter agreed with Pugin's theory, that 'All ornament should be based upon a geometrical construction.'[94]

More importantly, it was flatness of design which symbolised modernity in relation to nineteenth century art. The Victorian popular three dimensional realistic representations of full blown roses and Landseer's animals were scorned by the art fraternity. Instead the flatness of art prior to Raphael became paramount in nineteenth century modern art. Fourteenth century Italian renaissance art sowed the seeds of modernism and Italian renaissance art with its flatness, symbolism and representation was promoted by artists such as Walter Crane. He defined 'Flatness of Treatment' as the current notion of decoration and stated that it was an adequate characterisation of decoration.[95] On Japanese embroideries, Christopher Dresser remarked, 'There is nothing *outré* in their patterns for by flatness of treatment and evenness of distribution they bid defiance to all the canons of European art.'[96] Pugin called for the principle that decorative ornamentation 'must consist of pattern without shadow, with forms relieved by the introduction of harmonious colours'.[97] William Morris instructed that one should never introduce shading, but, 'combine clearness of form and firmness of structure with the mystery, which comes of abundance, and richness of detail.'[98] May Morris warned that painting with a needle was a 'danger' for it 'tempted some to produce highly shaded imitations of pictures',[99] whilst Arts and Crafts embroiderer, Mary Turner, explained in a clearer fashion, that too many embroiderers sought life-like rendering of the object to be embroidered.[100] Artists turned to nature for their inspiration, as Pugin observed:

> *the real source of art is nature...the best artists of every nation and period have taken it as their standard ... I am now preparing a work on floral ornament, in which by disposing natural leaves and flowers in geometrical forms, the most exquisite forms are produced.[101]*

[93] Linda Parry, *William Morris Textiles* (London, 1983) p.8

[94] Jones, *The Grammar of Ornament*, p.5

[95] Walter Crane, *The Claims of Decorative Art* (London, 1892) pp. 4-5

[96] Christopher Dresser, *Japan its Architecture, Art and Art Manufactures* (London 1882) p. 441

[97] Partha Mitter, *Much Maligned Monsters, history of European reactions to Indian art* (Oxford, 1977)p.223

[98] William Morris, 'Textiles' in William Morris (ed) *Arts and Crafts Essays by Members of the Arts and Crafts Exhibition Society* (London, 1903) (1893) p.36

[99] May Morris, 'Of Embroidery' in William Morris (ed) *Arts and Crafts Essays by Members of the Arts and Crafts Exhibition Society* (London, 1903) (1893) p.214

[100] Mary E. Turner, 'Of Modern Embroidery' in William Morris (ed) *Arts and Crafts Essays by Members of the Arts and Crafts Exhibition Society* (London, 1903) (1893) p.356

[101] Wainwright 'Principles True and False', pp.357 -364

Owen Jones wrote that 'In all surface decoration all lines should flow out of a parent stem. Every ornament however distant should be traced to its branch and root. *Oriental Practise.*'[102] Referring to Indian art, he, noted that there was an absence of superfluous ornament, nothing added without purpose, nor which could be removed without disadvantage.[103]

> *Harmony of form consists in balancing and contrast of the straight, the inclined and the curved ... all junctions of curved lines with straight lines should be tangential to each other. Natural law. Oriental practise in accordance with it ... flowers or other natural objects should not be used as ornaments, but as representations of them. Universally obeyed in the best periods of Art, equally violated when Art declines. ... colour should assist development of form, light and shade.[104]*

Nature found harmony as Selwyn Image so eloquently expressed:

> *By design I understand the inventive arrangement of lines and masses, for their own sake, in such a relation to one another, that they form a fine harmonious whole: a whole, that is, towards which each part contributes, and is in such a combination with every other part that the result is a unity of effect, so completely satisfying us that we have no sense of demanding in it no more or less.[105]*

In addition, he urged that one should learn one's business in the schools, but should look to nature for inspiration.[106] It was not only medieval art and nature which artists took inspiration from, as can be seen in the above quotes from Owen Jones, where he intersperses his notes with the words *Oriental Practise.* Indian and Persian art combined the notions of nature, flowers with geometric forms, inventive arrangement of lines, and a harmonious whole. Morris in particular became interested in the soft muted colours of Indian textiles and plate 2.1 shows the similarity of his designs to Indian and Persian art. By the nineteenth century, Partha Mitter argues that the preoccupation with Indian design coincided with

[102] Jones, *The Grammar of Ornament* p.6
[103] Ibid. p78
[104] Ibid. p6.
[105] Selwyn Image, 'On Designing for the Art of Embroidery' in William Morris (ed) *Arts and Crafts Essays by Members of the Arts and Crafts Exhibition Society* (London, 1903) (1893) p.414
[106] Ibid. p.419

the rise of a new aesthetic movement, which demanded the reformation of industrial design.[107]

On Indian Art

India was a huge exporter of textiles, and during 1600-1800 it revolutionised European taste with its chintz, which captured the textile market. During the eighteenth century imports from India caused much hardship amongst weavers in Britain, provoking riots and satirical poems about noble women who preferred exotic finery to English homespun products.[108] In the nineteenth century preoccupation with Indian design returned at The Great Exhibition of 1851, where Owen Jones observed that 'The Exhibition of the Works of Industry of all Nations' was barely opened to the public ere attention was directed to the gorgeous contributions of India.' The work, he stated, had unity of design, skill, and judgement in its application, elegance and refinement.[109] So highly praised were the textiles from India, Henry Cole purchased the entire collection for South Kensington Museum, now the V&A. By the 1880's, South Kensington Museum held the world's 'most significant' collection of Indian textiles. The collection was studied by architects and designers, as it epitomised flatness, bold yet simple colouring and above all symbolic rather than representational images.[110] Indian art was studied and appropriated by artists and designers, such as Morris and Wardle, who believed they could take all that was best of Indian art, without becoming mere copyists. In the catalogue for the Colonial and Indian Exhibition, in London, 1886 Sir Thomas Wardle, silk dyer and designer wrote about the Indian exhibit claiming,

> *it was not the display of an effete nation sunk in oriental lethargy, with no thought save luxury and repose, neither is it the tribute of a conquered nation laying its best gifts at the feet of the conqueror, but it is the work of a power acting the part of a regenerator, guiding the myriad hands in paths of reproduction industry, making the most of natural gifts, and supplementing them by appliances of modern science.*

[107] Mitter, *Much Maligned Monsters*, p.221

[108] Ibid. p.221

[109] Jones, *The Grammar of Ornament*, p77

[110] Tim Barranger, 'Imperial Visions' in John M. Mackenzie (ed.), *The Victorian Vision, Inventing New Britain*, (London, 2001) pp. 324-325

Britain, he argued made it all possible by constructing their iron roads, waterways and ocean transport, which would have been unobtainable to natives.[111] Successful empire building, Kiernan argues 'gave the European man a fresh title to be loved, honoured and obeyed by his wife as he was – he believed, or deserved to be – by his colonial dependants.'[112] In order to make Indian art England's own, it was necessary not to copy it, but to take the best, adapt it, thereby making it British. This process was appropriating the other's art and maintaining patriarchal power. That is not however how artists in the nineteenth century saw matters, as they viewed it more as a two way process. Owen Jones praised the use of colour in India's textiles, which, in common with most Eastern nations he considered were perfect. Aware that artisans would blindly copy Indian patterns Jones warned that, 'The principles belong to us, not so the results … if this collection should lead only to the reproduction of an Indian style in this country; it would be a most flagrant evil.'[113] On The Great Exhibition Jones noted that it was not only India 'but all the other Mohammedon countries, Tunis, Egypt and Turkey' which 'attracted attention from artists, manufacturers and the public which has not been without its fruits'.[114]

Art Journal reported on the 1870 Exhibition of Indian Textile Fabrics at the Indian Museum, in Downing Street, that a temporary collection had been gathered from all parts of India which would be of great value to English manufacturers. The collection indicated what oriental taste and skill could produce which would tax the manufacturer's 'utmost resources to equal the result.' The Indian government, Art Journal reported, was owed a heavy debt and,

> *we trust that it may be paid in the mode most grateful to the feelings of those who have laboured to wed the art and skill of England to the art and skill of the art of India – that is to say by a resulting improvement in the manufactures of England.[115]*

The two way process was unfortunately to have a degenerative effect upon Eastern art. India in trying to produce goods for the British market were distorting English and Chinese flower decoration as the plants were alien to them, so as Mackenzie remarked, 'What had been sent out to help

[111] National Art Library (hereafter NAL) pressmark A.47 Box 1. Thomas Wardle, . Colonial and Indian Exhibition, 1886. Empire of India. Special Catalogue of exhibits by the Government of India and private exhibitors. Royal Commission and Government of India si court. (London 1886) p.35
[112] Kiernan *Imperialism and its Contradictions* p.160
[113] Mitter, *Much Maligned Monsters,*p.221229
[114] Jones, *The Grammar of Ornament* p.77
[115] *Art Journal* 1870 p.23

Indian craftsmen to conform to British taste were returning in a parodied form to feed the appetite for exoticism.'[116] Mackenzie also argues that chinoiserie was an imaginary construct of the orient made to satisfy the West's vision of China and therefore as much a product of the West as the East.[117] When Morris & Co. began carpet manufacture in 1880, May Morris issued a circular stating that a new branch of the business had been created 'in an attempt to make England independent of the East for carpets' which claimed to be works of art. The art of carpet making in the East was dead and she declared that these countries would 'in time come, receive all influence from, rather than give any to the West.'[118] When May Morris refers to the art of carpet making in India being dead she referred to the fact that Indians had turned to making carpets of gaudy bright colours, which they believed Victorian England required. Marx's prediction in *The Future Results of British Rule in India* (1853) warned of such degeneration:

> *England has to fulfil a double mission in India: one destructive, the other generating – the annihilation of old Asiatic society, and the laying of the material foundations of Western society in Asia ...The Indians themselves will not reap the fruits of the new elements of society scattered among them by the British bourgeoisie, till in Great Britain itself the now ruling classes shall have been supplanted by the industrial proletariat, or till Hindoos themselves shall have grown strong enough to throw off the English altogether ... When the great social revolution shall have mastered the results of the bourgeois epoch, the market of the world and the modern powers of production, and subjected them to the common control of the most advanced peoples, then only will human progress cease to resemble that hideous pagan idol, who would not drink the nectar but from skulls of the slain.[119]*

The ancient arts of the East were still revered as having pioneering artistic merit, based upon its ancient culture and civilisations which stood in stark contrast to the art of Africa, which was considered barbaric and denigrated as such by artists. In 1882, Lucy Crane quoted Carlyle to the effect that 'the first spiritual want of a barbaric man, is decoration ... he

[116] Mackenzie, *Orientalism, History, Theory and the Arts* pp.110-111
[117] Ibid. p.109
[118] JW Mackail, *The Life of William Morris* (London, 1922) Vol. II p.5
[119] Karl Marx, The Future Results of British Rule in India(1853) cited in VG Kiernan *Imperialism and its Contradictions* (London, 1995) frontispiece

scratches patterns on his weapons, paddles, tools and utensils ... and on his own body, next he begins weaving, at first geometric, then imitations of animal and vegetable life.'[120] The implication was that geometric patterns were considered more basic, less skilled than representational images, and that the natives were considered primeval. In the catalogue for the Colonial and Indian Exhibition, 1886, Sir Thomas Wardle, wrote upon the exhibits presented by African colonies. He explained how slow Africa was in civilising, but that they were important ports of call for British vessels, their chief exports derived from palm oil and rubber. He described the climate as unhealthy, particularly in the Gold Coast, Lagos, Sierra Leone and Gambia. The African colonies exhibited native cloths, embroideries in silk and cotton, coloured and embroidered leather, pottery, baskets, brass ornaments and gold and silver mats. Wardle wrote that the whole display was that of a 'savage people struggling into civilisation.' Wardle felt the exhibits were 'all of a barbaric type, although the various cloths [were] very beautiful' and that the natives had made considerable progress under European guidance.[121]

By the late nineteenth century, however, that notion had changed, greed and expanding imperialism, led to the fight for Africa. Crane wrote,

> *Greedy eyes are now turning to Central Africa. ... Already the rampant explorer, posing as the benefactor of humanity, has gone far and wide, and the representatives of the blessings of civilisation, with the bible in one hand and the revolver in the other, call on the aborigines to stand and deliver.*[122]

This short quote from Crane raises an interesting concept, that of the bible being used to civilise. Similarly in Britain, religion it will be argued was used to calm the masses. The massive church building programme that took place in the nineteenth century was central to the genesis of art embroidery and therefore requires examination.

Religion, Art and Patriarchal Control

In Disraeli's *Sybil*, he conjures the notion of two nations, on the one hand the ever-growing wealthy industrialists, and on the other the mass of the population who were poor and subjected to increasing poverty, social deprivation and dehumanisation.[123] These notions are

[120] Lucy Crane, *Art and the Formation of Taste* (London 1882) p.12

[121] NAL. Pressmark A.47 Box 1. Thomas Wardle. *Colonial and Indian Exhibition, 1886*, p.35

[122] Walter Crane, *The Claims of Decorative Art*, p. 138

[123] See Benjamin Disraeli's novel, *Sybil: or the two nations* (Oxford 1926) (1845)

inextricably linked with design, for in order to maintain some semblance of social order amongst the diaspora of British society, the ruling classes embarked upon a massive church building programme. The 1851 Religious Census showed that 5.25 million people in Britain, excluding those ill, infirm or at work, deliberately did not attend church, roughly one third of the population. The main reason given that there was a general distaste for the social separation and degradation felt by the poor upon entering the church.[124] The middle classes frightened by these figures, feared that those not attending church would turn to alcohol or opium. Petitions were taken to parliament and according to Dickens, in 1854, there was an organisation who were to be 'heard of in the House of Commons every session, indignantly petitioning parliament for acts of parliament that should make these people religious by main force'.[125] Parliament had been granting money to churches in the region of £100,000 per annum between 1809-1820 with an additional £1million in 1818 and £500,000 in 1824, to build churches in parishes where the population was more than 4,000.[126] Thus, it will be argued that the church was used quite purposefully as a means of controlling the masses. Though the government and public funded the building of these churches, it was the wealthy industrialists who became the churches' benefactors and who would commission the architects to design stain glass windows and embroidered alter frontals for their church. Overtly, the landed gentry still dominated British politics, but after the 1840's power was gradually transferred to the middle class as architects and designers were appointed by this group to design the new churches. Power shifts in the nineteenth century play a key role, particularly the way in which leading architects and industrialists with the help of their wives became concerned with socio-political issues. Socialist concerns were for education, philanthropic ventures and self help rather than charity, enabling ones fellow mankind, no matter how poor to maintain some respectability. Artists and designers commissioned to design churches and ecclesiastical wares were ultimately given a power status rarely in the history of man bestowed upon an artist. The artists and designers who received accolades for their ecclesiastical work were to receive commissions for private work from the wealthy and therefore encouraged to participate in secular work.

Poverty gave rise to fears of a revolution, the proletariat rising as they had in the French revolution. The industrial revolution gave rise to

[124] Joan Bellamy, John Golby, Gerald Parsons, Gerrylynn Roberts and Dennis Walder, 'Population, Culture and the Labouring Classes in *An Arts Foundation Course*, Culture: Production, Consumption and Status, (London,1990) p.69
[125] Charles Dickens *Hard Times*, (London, 1969) p.66
[126] David Craig (ed.) *Hard Times*, (London, 1969) p.361

fears and doubts never experienced before, man's place was uncertain, the future less certain. Religious attendance had fallen sharply and without a God, without the belief in heaven and hell, fears grew. Pugin, Janet Miniham argues,

> *was arguing for a sophisticated integration of ethics and aesthetics, and was working out a theory of art criticism that inextricably linked both concerns together as instruments of social renovation.*[127]

Thus, 'social renovation' was urgently required and the ideal forum was the church. Harvey and Press argue that 1,727 churches were built between 1840 and 1876 with a further, 7,144 being rebuilt or restored at a total cost of £25 million, during which time 397 parishes were created.[128] There was most certainly a frenzy in church building, and from the 1840's a new theory about the planning and arrangements for churches evolved. According to Addleshaw and Etchels, nineteenth century Tractarian ideals still largely govern church designs today, and that hardly an Anglican church exists in the world which does not display their ideals. Tractarianism stemmed from a reawakening of interest in the decoration, pomp and regalia of religious ceremony. The Tractarians produced *Tracts for the Times* in 1833, which stimulated discussions on the church and the state. This led to the formation of The Cambridge Cambden Society with over 700 ecclesiologists and members of parliament,[129] to promote the study of Ecclesiastical architecture and the restoration of churches in need of repair. Collectively they were romantic medievalists who dreamt of repeating the architectural triumphs of the medieval period, and a return to medieval ceremony. The architecture it was decided should be that of the thirteenth century gothic.[130] Tractarians were opposed to evangelical beliefs and emphasised doctrines of apostolic succession and sacramental grace.[131] Eastlake questioned why more churches were to be built when the existing ones could not be filled. He recorded how empty the churches were when he was a young boy, the air of grim respectability, the wizened faced pew opener eager for stray shillings, the hassocks on which no one knelt. He observed the length, the unimpeachable propriety, the overwhelming dullness of the sermon, and then the gorgeous ceremonial rites celebrated in Italy utterly independent

[127] Janet Minihan, *The Nationalisation of Culture* (London, 1977) p.276

[128] Harvey and Press *William Morris, Design and Enterprise, p.57*

[129] GWO Addleshaw and F. Etchels, *Architectural Setting of Anglican Worship* (London, no date) p.57

[130] Ibid. p.204

[131] Harvey and Press, *Design and Enterprise*, p. 14

in their association with medieval usage.[132] It was of course Eastlake's 'gorgeous ceremonial rites' in Italy, to which the Tractarians aspired. Mackail, Morris' friend and biographer wrote that when Morris set up in business the aesthetico-Catholic revival was going on in London. 'To plain men and women to whom the apostolic succession was tiresome and meaningless they could at least enjoy the beauty of Anglo-Catholic ritual.'[133] With its pomp and circumstance, the elaborate churches were successfully designed to fill the humble man with awe and wonderment.

Architects of the new church buildings followed Pugin's ideology to carry gothic features throughout the interior of the building, as in the medieval period. Stain glass and embroidery added warmth, light, colour and splendour to the church. Architects began asking their wives, daughters and women of the parish to stitch embroideries to their designs and from this practise developed embroidery societies. Many of those societies continued after the church embroidery was complete, becoming involved with secular work, which will be examined in the succesive chapters. The purpose of these societies was to find suitable employment for young women and to ensure stability and morality within the parish. All had romantic notions of the medieval paternalism, the church's patriarchal hold over the town, and the proper place for benevolence was within one's own parish.[134] It was as Roberts points out, the paternalist's duty to exert a firm moral superintendence over the poor.[135] Setting up embroidery groups for stitching for the new churches was a way in which the architect's or benefactor's wives could participate in the guidance of girls of impoverished means. They could educate, deploy, watch over and exert moral pressure upon the young girls within their parish. The architect George Edmund Street (1824-1881) in whose offices Morris worked, was an advocate of gothic revivalist styles and believed in Tractarianism.[136] In *Ecclesiologist* vol. xix (1858), for example, Street points out the importance of wall painting and stained glass windows. He pursued the ideas of the Pre-Raphaelite Brotherhood and insisted that architecture drew upon related crafts such as stained glass, metal work and embroidery all of which he incorporated in his buildings.[137] Street designed churches not as an empty building but to house furniture and furnishings. Alter frontals were initially worked by Jones and Willis, a leading ecclesiastical outfitters and by 1854 a small influential group the Ladies Ecclesiastical Society which was founded by Street's sister and

[132] Eastlake, *A History of The Gothic Revival* pp116-117
[133] Mackail, *The Life of William Morris,* p.150
[134] David Roberts, *Paternalism in Early Victorian Britain (London, 1979) p.*35- 48
[135] Ibid. p.5
[136] Ibid. *p.*48
[137] Harvey and Press, *Design and Enterprise,* p29

Mrs Agnes Blencowe.[138] The group quickly became known and influenced the establishment of societies in a number of parishes throughout the country. Architect's wives formed societies deploying the services of benefactor's wives and eventually the services of young impoverished women who worked embroideries such as church kneelers, alter frontals, super frontals and chasubles.

Pugin's *Book of the Church,* Kennel Digby's, *The Broad Stone of Honour* and Thomas More's *Catholici,* were well known in the nineteenth century.[139] Their writings influenced Carlyle, Fitzgerald and Kingsley who set out to train an elite to set a code of practise for the ruling classes, to instil the right moral qualities, to stop the worship of money and the placing of expediency before principle.[140] As Cain and Hopkins claim,

> *The perfect gentleman adhered to a code of honour which placed duty before self advancement. His rules of conduct were Christian as well as feudal in inspiration and his rank entitled him to a place in the vanguard of Christ's army, though with the knights and officers rather than among the infantry.*[141]

These notions gave rise to Christian socialism which was an organised movement with its own head quarters, committees and periodicals. The organisation lasted only a few years but its influence lasted for the rest of the century and is of relevance to the thesis as its ideologies gave rise to philanthropic ventures which reinforced paternalistic control. Christian Socialists believed that the educated could be improved or bettered by helping those less fortunate. Ruskin, although not involved with its foundation, believed in Carlyle's Christian Socialist ideas, which in turn influenced his economic and social theories. Ruskin too was concerned with the condition of the working man, yet he was no democrat, believing in a hierarchy of Marshalls, landlords, companions, tenants and retainers.[142] Socialism, Girouard argues was combined with Christianity for fear socialism would destroy Christianity.[143] Engels however related the sudden rise in socialism with the ending of English monopoly in the world market.[144] In this respect, the argument of David Roberts seems valid, when he suggests there were different agendas, arguing that Carlyle saw Captains of Industry as England's salvation, whilst Disraeli saw in

[138] Linda Parry *William Morris Textiles* (London, 1983) p.10
[139] Roberts, *Paternalism p.*48
[140] Girouard, *Return to Camelot,* pp.260-261
[141] Cain and Hopkins, *British Imperialism,* p.23:
[142] Girouard, *Return to Camelot,* p.250
[143] Ibid p. 134
[144] Powers, ' 1884 and the Arts and Crafts' pp.61-65

them the means of reviving old feudal ways.[145] The latter argument may suggest that the government wished to maintain control of the general public, through the church. However, accepting the former argument that the Captains of Industry were England's salvation, then surely their motives in employing women to support themselves and their dependents by commercial means was the way for their salvation? An understanding is required of the Victorian's mind for as Roberts states 'almost all Victorian paternalists held four basic assumptions about society: it should be authoritarian, hierarchic, organic and pluralistic.'[146] Eastlake in his widely read book, *A History of the Gothic Revival* wrote,

> *Mr Ruskin has ably brought before us the poetry of medieval art; Pugin and other writers have shown its practical advantages. It remains for the rising generation of architects to profit by these hints, and to show their prevailing taste has not been called forth by the whims of a clique or the blind passion of an antiquary, but that it is based on the moral and intellectual convictions, no less than on the social habits of the age.[147]*

The rising generation of designers and architects were to heed these words, they combined art with paternalistic authority and socialist ideals, and they interpreted medieval socialism to fit nineteenth-century requirements, hence it is important to understand how artists and designers interpreted these notions within their work.

On Work

The working methods of gothic revivalists were articulated through a group of intellectual artists and designers, which came together as a social group. Of key importance here was the Pre-Raphaelite Brotherhood formed in 1848 when they were according to Walter Crane the newest sensation in the art world.[148] The Pre-Raphaelites looked back towards the Italian renaissance period of the thirteenth and fourteenth century, the same period that Pugin considered to have been the zenith of gothic architecture. The Pre-Raphaelites looked at art prior to Raphael and although their Gothic period was relatively short lived, they, according to Timothy Hilton radically changed English art. For example, Hilton in his account of the Pre-Raphaelites argues that they needed 'this

[145] Roberts, *Paternalism,* p.178
[146] Ibid. p.2
[147] Eastlake, *Hints on Household Taste* p.35
[148] Walter Crane, *An Artists Reminiscences* (London, 1907) p.38

sudden dip into historicism, in order to slough off connections with the recent past, and emerge to reinvigorate English painting.'[149] Similarly, in the 1850's, Digby Wyatt traced the historical succession of medieval Italian sculptors whom he considered had the greatest technical excellence for carving and modelling.[150] A key figure in the promotion of The Pre-Raphaelites work was Ruskin, who felt that there was more to painting than the mere production of pictures. As Hilton argues, Ruskin considered paintings as an instrument of immense moral power,[151] a strong element within Renaissance paintings, and which fitted Eastlake's vision of the social habits of the era.

Eastlake's *Gothic Revival* was finished in 1870 and published in 1872, the zenith of the revivalist movement. For those wanting to understand the gothic style in more detail, Eastlake, interestingly divided the Gothic revival into four periods, the Rococo, The Picturesque, The Ecclesiological and the Eclectic, which he graphically described in *A History of Gothic Revival.*[152] Yet Eastlake is probably better remembered for *Hints in Household Taste,* for which he became immediately famous, the book providing drawings for household furniture, garden furniture and other objects. In this work, Eastlake attempted to show readers how to furnish their houses with a sense of the picturesque, which would not interfere with modern notions of comfort and convenience. He stated that there prevailed a great deficiency in public taste,

> *but by degrees, people are awakening to the fact that there is a right and wrong notion of taste ... The revival of ecclesiastical decoration, for instance, has called ladies attention to the subject of embroidery; and they are relinquishing the ridiculous custom of endeavouring to reproduce in cross-stitch worsted, the pictures of Landseer and Frank Stone. There is a growing impatience of paperhanging which would beguile the unwary into shadowy suspicion that the drawing room walls are fitted up with trellis work for training Brobdingnag convolvuli.*[153]

Eastlake was an architect, and Keeper and Secretary of the National Gallery.[154] His designs owe much to Owen Jones *Ornaments of*

[149] Timothy Hilton, *The Pre-Raphaelites* (London, 1983)(1970)p.58

[150] M. Digby Wyatt, 'On Renaissance' in Owen Jones, *The Grammar of Ornament* (Hertfordshire, 1986) (reprinted, first edition,1856) pp.109-127

[151] Hilton, *The Pre-Raphaelites,* p.58

[152] Eastlake *History of Gothic Revival*

[153] Charles Eastlake, *Hints on Household Taste,* p. 12

[154] Crook, 'Introduction' in Charles Eastlake, *History of Gothic Revival,* p.20

Grammar, 1856, though Eastlake's designs for furniture proved extremely fashionable, so much so that by the 1890's they were according to Crook 'quite commonplace'.[155] Not that everyone enjoyed the gothic for as reported in *The Artist*, Oscar Wilde criticised the gothic for being warlike, with its furniture capable of being used as weapons.[156] Though Eastlake had a great impact upon public opinion, it was Ruskin and Morris who had a deeper impact in the artistic world. Their political thinking encouraged the formation of the Arts and Crafts movement, which will be discussed in chapter seven. Ruskin's *The Nature of Gothic* in *The Stones of Venice* (1879) described the attributes of the gothic style, the skills of medieval craftsmen, and the pleasure they took in their work.[157] Ruskin and Morris wrote prolifically, toured the country lecturing, encouraging people to take pride and pleasure in their work, and encouraged many embroidery groups both in Britain and America. Whilst Ruskin philosophised, it was Morris who showed the practicalities of the application of Ruskin's theories. Paul Greenhalgh rather romantically exaggerates, alleging that it was Morris who invented a past, labelled 'the Goths' in order to invent a present and a future.[158] For as it has already been shown, Morris was nearly half a century behind the gothic movement though he was the first to take furnishings and embroidery based on medieval designs into the home.

Morris was the first to try and deploy the working methods advocated by Ruskin, based upon medieval guildsmen. Mackail, William Morris's biographer and friend records that in 1860 church decoration was a major industry. Though many major ecclesiastical embroidery firms existed, the architects encouraged their wives and daughters to stitch their designs. Morris grasped the implications of this commercial enterprise and it became the main employment of Morris, Marshal, Faulkner & Co.[159] By 1862, Mackail states that the restoration of Anglican churches and church services were taking place all round the country, restoring their ancient beauty and symbolic ritualism. Mackail records that commissions for MMF came in from all over the country, and eventually the movement began to spread from ecclesiastical into secular life and became known as aestheticism.[160] Walter Crane who had worked closely with Morris reflected in 1911:

[155] Ibid. p.20

[156] *The Artist* 1 January, 1881 p.23

[157] John Ruskin, 'Nature of Gothic' in J.G.Links (ed.) *The Stones of Venice,* (London, 1960) pp.157-190

[158] Paul Greenhalgh, 'The Trouble with Utopia' *Crafts* no.140 May/June (1996) pp. 24-25

[159] Mackail, *The Life of William Morris,* p.150

[160] Ibid. p.167

Morrisian patterns and furniture soon became the vogue.
Cheap imitations on all sides set in, and commercial and
fantastic persons, perceiving the set of the current, floated
themselves upon it, tricked themselves upon it, tricked
themselves like jackdaws with peacock feathers, and called
it the aesthetic movement.[161]

Ruskin and Morris had the greatest impact upon contemporary thinking
regarding working conditions, both expounding Carlyle's theories of the
chivalry of work, and both becoming actively involved with putting these
theories into practise. *In Past and Present* Carlyle wrote,

The latest gospel in the world is, know thy work and do it ...
A man perfects himself by working ... No working world,
anymore than a fighting world, can be led on without a
whole chivalry of work, and laws and fixed rules which
follows out of that - far nobler than any chivalry of fighting
wars. Such chivalry of work could convert the idle
aristocrats into a real governing class, and hard working but
previously selfish mill owners into noble Captains of
Industry.[162]

These ideas were taken onboard, particularly by the arts and crafts
movement in idyllic notions, as an antidote to the industrial revolution.
Many artists turned to socialism, and in Crane's opinion the only hope for
art and humanity lay in socialism.[163]

The artists wanted to see a return to the guilds of medieval
working, artists striving together for perfection. Thomas Carlyle at the
AGM of The Society for the Protection of Ancient Buildings, (SPAB) in
1884 gave a speech making a comparison of the freedom enjoyed by
medieval workers compared with the drudges of the capitalist system.[164]
'Where the love of art is sincere' wrote Crane,

all a man would ask would be security of livelihood, with a
fair standard of comfort and refinement, and materials to
work with. For the rest it would be simply a pleasurable

[161] Walter Crane, *William Morris to Whistler, papers on art and craft* (London , 1911) p.20

[162] Girouard, *Return to Camelot,* p. 131

[163] Walter Crane, *The Claims of Decorative Art* p.139

[164] Gillian Darley, ' Salvation Army' in *Crafts* no. 140 May/June (1996) pp. 26-29

thing to exercise his creative powers for the benefit of the community and the praise he may win.[165].

Paramount in their ideology was to rid the country of cheap shoddy work, for every man and woman to always produce the highest standard of craftsmanship. Morris stated their intentions clearly in 1893 when he wrote:

> *It is this conscious cultivation of art and the attempt to interest the public in it which the Arts and Crafts Exhibition Society has set itself to help, by calling special attention to that really most important side of art, the decoration of utilities by furnishing them with genuine artistic finish in place of trade finish.*[166]

In the same publication Crane wrote,

> *When both art and industry are forced to make their appeal to the world and impersonal average rather than the real and personal you and me beauty becomes divorced, ill considered bedizenment of meaningless and unrelated ornament. The very producer designer and craftsman has been lost sight of, his personality submerged in that of a business firm – reached the reducto ad absurdam of an impersonal artist or craftsman trying to produce things of beauty for an impersonal and unknown public.*[167]

Walter Crane was impressed at the age of twelve by Ruskin's *Modern Painters,* by Tennyson's *Lady of Charlotte* and by The Pre-Raphaelite paintings and Japanese prints, Italy and the Renaissance period.[168] Crane, who became an illustrator of books, also designed embroideries for The Royal School of Art Needlework, he was a friend and colleague of William Morris and according to Crane, Morris's art was an,

> *outward and visible sign of a great movement of protest and reaction against the commercial and conventional conceptions and standards of life and art which had*

[165] Walter Crane, *The Claims of Decorative Art* p.75
[166] William Morris (ed), *Arts and Crafts Essays by Members of the Arts and Crafts Exhibition Society* (London, 1903) (reprinted, first edition,1893) p.xiii
[167] Walter Crane, 'Of the Revival of Design and Handicraft: with notes on the work of the Arts and Crafts Exhibition Society' in William Morris (ed) *Arts and Crafts Essays by Members of the Arts and Crafts Exhibition Society* (London, 1903) (reprinted, first edition,1893) p.10
[168] Walter Crane, *An Artists Reminiscences* pp.1-4

obtained so strong a hold in the industrial nineteenth century.[169]

The standard of life against which Ruskin and Morris rebelled is portrayed in the next chapter. The commercial stronghold on embroidery it will be argued lowered prices, lowered wages and many embroiderers lived in poverty. Ruskin, Morris and the Arts and Crafts Movement advocated the words of Carlyle, becoming his Captain's of Industry, they followed Ruskin's economic theories, attempting to put chivalry and art into work. Ruskin thought works of art could never be isolated from the social conditions which produced them and in which they could survive.[170] Hence the time was ripe for reform.

[169] Walter Crane, *William Morris to Whistler*, p. 21
[170] John Bryson, 'Introduction' in John Ruskin *Unto this Last, the political economy of art* (London, 1968) (reprinted, first edition, 1860) p.vii

CHAPTER 3
History and Subsistence

This chapter will examine the production methods of embroidery in the nineteenth century, the organisation of the work process, including the training and education of workers. To set the context, the chapter commences with a brief history of embroidery and working conditions during the medieval period and then exploring the appalling conditions endured by embroiderers in the early part of the nineteenth century. From Henry Mayhew's reports of 1849-1850, it becomes apparent why socialist designers of the Arts and Crafts Movement set out to improve conditions. Employment opportunities increased for embroiderers in tasks that machines were unable to accomplish, especially in the lace and stocking industry. Mechanisation increased the need for hand labour in certain industries but worsened conditions by lowering wages, for as Marx stated workers thrown out of one industry might find work in another, but the competition for that work lowered the wage demand. Increase in demand for hand labour had the effect of increasing sweated labour with an ever decreasing lowering of wages.[171]

Mayhew's investigation defined four categories of embroiderers, those employed in sweated labour, those who entered into training schemes, those that entered into viable business, and the fourth and final category, which have mainly been hidden from view, the middle class housewife operating covertly from their living rooms. The exploitation of workers in the embroidery trade, led to philanthropic measures to try and improve life for the embroiderer, and the motives of those involved with establishing such ventures will be explored. Trade directories record the many retail outlets and repositories that promoted embroiderers by marketing selling their wares. Once established as viable commercial business, exhibitions were held to promote embroidery, which would allow the amateur and professional to exhibit. The small retail outlets and exhibitions provide an insight into commercial practices, which set the scene for William Morris.

A Brief History - Medievalism to Nineteenth Century working practices.

Readers interested in the importance and history of embroidery throughout the centuries are advised to read Lanto Synge's

[171] Karl Marx, 'The Theory of Compensation as regards the Workpeople Displaced by Machinery' in *Capital,* (Oxford, 1999), (abridged edition) pp. 269 -273

comprehensive history, *Antique Needlework*.[172] For the purposes of this book in nineteenth century history, the study has to be concerned with the medieval period and the operation of the guilds for craftsmen of this period, which the designers of the nineteenth century set out to emulate. The appalling treatment and the dire conditions of nineteenth century embroiderers led to a movement by designers to return to the conditions, working practices and high standards placed within the medieval period, a time when embroiderers were highly prized and well rewarded as were other elite crafts people. For example, David Roberts cites Brian Tierney who argues that the poor in thirteenth century England were better cared for than at any other time until the twentieth century.[173] Professionals were always well rewarded and Synge quotes a twelfth-century Greek poet as stating that if he had been an embroiderer, 'his cupboard would have been full of bread, wine and sardines.'[174]

Embroidery, Synge states, had since the Anglo-Norman period been held in high regard, higher than painting and illumination, which was influenced by embroidery. He considered that one of England's greatest cultural contributions to the world was that of embroidered ecclesiastical works produced between 1250-1350, known as *opus anglicanum* (English work), embroidery which was exported all over Europe. By the thirteenth century *opus anglicanum*, was a lucrative industry with many individuals and workshops producing work for domestic and international orders as well as wealthy city merchants. In 1430, The Broiderers Guild was formed which applied extremely high standards, and insisted upon a seven year apprenticeship; any work they considered unfit was destroyed.[175] Guild members, Parry explains, were heavily fined if they did not follow regulations, working was confined to daylight, there was to be no Sunday working and standards in silks and gold thread were strictly regulated. It was an era of high professional practise, admired throughout the world. The Broiderer's Guilds records were lost in the great fire of London, so Parry relies upon French records, which indicate that by the fifteenth century men dominated the industry and women were paid far less than their male counterparts.[176]

During the seventeenth and eighteenth centuries Britain had a predominantly agrarian economy with cottage industries operated by the putting out system. The cottage industries received work from merchants, who collected the finished work at a pre-arranged time. Lemire's investigations into the clothing trade however, point not to

[172] Synge *Antique Needlework*

[173] Roberts, *Paternalism*, p.11

[174] Synge *Antique Needlework*, Synge further informs that Henry III paid the sum of £11 for a chasuble and alter-piece, thinking so highly of the embroiderer that he visited her, in her retirement. *p. xiii*

[175] Ibid. *pp.7-25*

[176] Linda Parry Women's Work in *Crafts* No. 128 (May/June 1994 pp.42-47

picturesque rural cottage industries but also to an urban putting out system - a shift from guild controlled workshops to one of domestic labour, which could use low paid female labour, working in urban anonymity.[177] In the seventeenth century, girls were given comprehensive training in needlework, to keep them off the parish poor rolls, and therefore the sewing trades were the second most prominent employment after domestic service.[178] By the eighteenth century centralised production for luxury goods provided security for the manufacturer, especially in trades such as quilted silk petticoats, where scrutiny of standards could be effective.[179] The coming of the industrial revolution and rising consumerism in the nineteenth century increased the putting out system, which in turn increased sweated labour. With increased demand for embroidered items, and increased prices, one might have expected an increase in embroiderer's wages, however, it will be shown that the opposite was the case and the sweating system reduced wages to poverty levels.

From *The Occupation Abstract of the Government Report on the Population of Great Britain* Mayhew calculated in his words 'a rough notion' of the number of embroiderers in the metropolis in 1850 as 692 of which 499 were aged under twenty and 33 were in business for themselves. He estimated that in total 35,000 females were employed as dressmakers, corset makers, seamstresses, bonnet makers, and milliners.[180] His assumptions must be considered with caution as some milliners and dressmakers performed their own embroidery, whilst others would put work out to professional embroiderers. Barbara Morris estimated that by 1849, 2,000 people in London alone obtained a living by embroidery, and in Scotland and Northern Ireland tens of thousands of females were employed in their homes as outworkers.[181] It will be argued that Barbara Morris's account is closer to the truth.

Suitable Employment for Women

Nineteenth-century census reports were highly inaccurate and recorded only the head of household's occupation. Where the woman might be the head of household, her work was probably seasonal, especially in the embroidery industry and therefore would not be recorded as an occupation. The government census reports therefore encouraged

[177] Beverley Lemire, *Dress, Culture and Commerce, the English Clothing Trade before the Factory,* (London and New York, 1997) pp.43-44

[178] Ibid. p.50

[179] Ibid. p.69

[180] Henry Mayhew in E.P. Thompson and Eileen Yeo (eds.) *The Unknown Mayhew : selections from the 'Morning Chronicle', 1849-1850* (London,1971) pp.163-164

[181] Barbara Morris *Victorian Embroidery* (London, 1962) p.73

the myth that women in the nineteenth century did not work. In reality there was in the nineteenth century great concern to create work for women, for as has already been revealed women outnumbered men, thereby decreasing the potential security of marriage. In 1858, Author Dinah Mulock Craik (1826-1887) called for women to help themselves, 'In this curious phase of social history.' Continuing to argue that, when marriage was ceasing to become 'the common lot ...we must educate our maidens into what is far better than any blind clamour for ill defined rights, into what ought always to be the foundation of rights, duties ... the duty of self-dependence'.[182] Such was the concern for the number of women requiring work in 1860 that J. Stewart in 'Art Decoration, a suitable employment for women' reported that the Committee of The National Association of Social Science had made several recommendations.

The committee suggested suitable employment for females should have prominent place, as several factors were decreasing employment opportunities for women. Sewing machines, the committee reported were destroying stitching as a trade and the straw plaiting industry was threatened caused by the diminishing size of bonnets. Due to population discrepancies three to four million women were 'doomed to the felicity of single blessedness'. Employment opportunities needed to be created but the Committee recommended that work for women should not be physically deteriorating. The work should be based on commercial principles in order that women received respectable remuneration, the employer received a fair profit and the public supplied with what it wanted, with the condition that it did not interfere with men's employment.[183] By 1872, the situation had worsened and *Art Journal* reported that women out-numbered men by one million, and three out of six million women it stated supported themselves and relatives dependent upon them.[184]

Pennington and Westover are wrong when they argue that the industrial revolution transformed society from household production to large scale factory production. Conditions, they contend 'stemming from the industrial revolution made the sexual division of labour into a controversial issue'. Women they claim were deprived of their productive skills in textile manufacturing.[185] Certainly some jobs may have been lost to women particularly in factory production, but more home centred jobs were created in finishing processes which machines

[182] Dinah Mulock Craik, 'On Sisterhoods, A Woman's Thoughts about Women' in Elaine Showalter (ed.) *Maude and On Sisterhoods* (London, 1993) p.77

[183] J.Stewart, 'Art Decoration - a suitable employment for women' in *Art Journal,* 1860 pp. 70-71

[184] 'Art Work for women' in *Art Journal* (London, 1872) p.103

[185] Shelley Pennington and Belinda Westover, *A Hidden Workforce, homeworkers in England, 1850-1985* (Basingstoke, 1989) p.1

were unable to carry out. Many processes could not be undertaken by machinery and therefore continued to be processed by outworkers. As Bythell states this was an integral part of large scale manufacturing.[186] Pinchbeck claims the invention of machinery deprived thousands of women of employment, whilst at the same time opening up entirely new fields of employment. Thousands, she claims were employed on lace work, within their homes, and of these workers, which included children, 150,000 were employed in embroidery.[187]

As cheaper machine-made lace began to replace pillow lace, three processes could not be performed by machine. 'Clipping', cutting off ends and knots formed during manufacture, 'scalloping', cutting out the shape of the lace at the edges and 'drawing', pulling out the thread which held together the lengths of lace in a breadth or piece.[188] Lace work had to be completed by embroidery, as even improved mechanisation could not do some of the processes, particularly joins and finishing off, which had to be completed by an embroiderer. One method, the process of lace running, involved embroidery resembling lace, to join seams and another called tambouring where a tambour hook was held below the fabric being worked, as opposed to a needle on top of the fabric, a method used on Brussels and Nottingham net.

Tambouring which was an older domestic industry than lace running had been introduced in the eighteenth century and since its inception been worked in small domestic workshops. Embroiderers in the lace industry were poorly paid, often treated cruelly by the master or mistress and frequently found emaciated.[189] Chapman argued that net made on the stocking frames was finished and much of it hand embroidered at home, executed by over ten thousand women and children working from home in the villages of Nottinghamshire, Derbyshire, Leicestershire, Yorkshire, Staffordshire and beyond. As early as 1810, the Nottingham lace industry alone employed 10,000 – 15,000 women and children to embroider patterns on the net.[190] This new homeworking process, with fierce competition for work, changed the putting out system to one of sweated labour, with its longer hours and ever decreasing wages.

[186] Duncan Bythell, *The Sweated Trades, Outwork in Nineteenth- Century Britain* (London, 1978) p.12
[187] Ivy Pinchbeck, *Women Workers and the Industrial Revolution, 1750-1850* (London, 1981) (1930) pp.209-210
[188] Pennington and Westover, *A Hidden Workforce*, p.57
[189] Pinchbeck, *Women Workers* p.215
[190] Stanley Chapman, *The Early Factory Masters* (Newton Abbot, 1967) pp. 19-28

Sweated Labour and the Need for Radical Change

The putting out system originated with cottage industry, whereby a merchant or his agent would take materials to a household to be made up and collected within an allotted time, quotas and quantities agreed at the outset. This was a system which was often abused giving rise to the quite different exploitive system of sweated labour. Abuse came in many forms; often the worker would have to pay for equipment such as her own needles, thread and candle to work by. Piece rates encouraged working all possible hours with little sleep, and fines were imposed if work was late. There was a clear continuum between putting out and sweated labour. According to Schmiechen, Henry Mayhew wrote with 'Dickensian core' letters to *The Morning Chronicle* describing the lives of London's sweated workers. Mayhew made the link between sweated work and poverty but also sweated work and prostitution. In 1849–1850, Mayhew claimed that 37,000 young and married women in the needle trades earned an average of 8s per week.[191]

Charles Kingsley in his novel *Alton Locke* provides similar accounts of tailors who earned 3s per week between them and paid 'everso much for fire,' 2d for thread, 5d for candles and then fined for late work, which had been given late on purpose in order that prices paid were lowered further.[192] Competition for work led to some offering to work for less, thereby lowering wages for all. In the lace industry, warehouses gave work to mistresses or agents who employed girls in their own home or gave work out to neighbouring villages. This method meant that work could pass through two or three mistresses before it reached the embroiderer, each taking their cut, leaving little for the embroiderer.[193] Sweating, according to Schmiechen,

decentralised production and fragmented the working class ... sweated workshop and homework labour force grew alongside the factory labour force and a symbiosis developed between factory and non factory production. It became increasingly common at the close of the nineteenth century, for employers to shift production back and forth between the factory or artisan shop and the home or small outwork shop...Sweating meant long and tedious hours of labour, abominably low wages...movement of work to unregulated

[191] James Schmiechen, *Sweated Industries and Sweated Labour, the London clothing trades 1860-1914* (London, 1984) p.61
[192] Charles Kingsley, *Alton Locke, Tailor and Poet, an Autobiography,* (London, facsimile of 1862) p.34
[193] Pinchbeck, *Women Workers* p.213

premises, often the workers home, beyond the eye of respectable manufacturer or government inspector...[who] could disregard all restrictions on hours, pace and conditions of work. [194]

Berg cites Adam Smith's theory that where there is labour, that labour will come cheaper than its market value. People would move to areas of work and the competition for that work would often lower wages. Berg argues that wages were forced below subsistence level, it 'transformed demographic conditions making population increase a major source of labour'.[195] As Berg states, 'As long as labour was cheap and plentiful there was little incentive to undertake capital investment and to increase productivity. Low wages, in effect, meant that primitive techniques were the most profitable.'[196] Social conditions often dictated a preference to work at home, the child rearing duties of women being a major factor, and women were prepared to take lower wages to do so, which had the effect of lowering wages for all. Such was the need for work that labour supply outstripped the demand, Pinchbeck arguing that 'workers were unable either to demand an adequate remuneration or to resist oppression in the form of unjust prices for materials, arbitrary reduction of rates and payment for goods.'[197] Another factor causing poverty was that work for women was seasonal even in the embroidery industry.

Mayhew for example reported on a seamstress who also embroidered; she stated that work was unreliable with seasonal gaps, and in cloak manufacture the winter slack lasted from December to March with the summer slack period running from August to October. In between other work had to be found, such as making ladies nightcaps for which she was paid between 6½d to 1s per dozen and competition was fierce meaning work could be lost if someone offered to work for less.[198] Similar conditions existed for embroiderers employed in silk bobbin net industries. A report given by manufacturer, Felkin, to the Factories Commission, in 1831 observed women who worked upon the shawls for six weeks, working six days a week, fourteen hours a day, earning 1s per day. An increase in British net exports, he observed, only served to halve the worker's wage, as competition for work grew, exacerbated by increased competition from Belgian and Saxon embroiderers.[199] Duncan

[194] James Schmiechen, *Sweated Industries* pp.2-3
[195] M. Berg, *The Age of Manufacturers* (London, 1985) p.132
[196] Ibid. p.132
[197] Pinchbeck, *Women Workers* p.213
[198] Henry Mayhew in Anne Humphreys (ed.), *Voices of the Poor, selections from The Morning Chronicle 'Labour and the Poor' (1849-1850)* (London, 1971) pp. 67-68
[199] Pinchbeck, *Women Workers* p.211

Bythell cites Engel's observations of cotton handloom weavers in Lancashire, though a different trade, their income was similar to that of embroiderers 'they live almost entirely upon potatoes, supplemented perhaps with a little porridge. They seldom drink milk, they hardly ever eat meat'. Bythell also reminds us that in the late nineteenth century Charles Booth recounted that the sweated trades meant irregular hours and overcrowding, exhausting the vital powers. There were periods of unemployment and this he added was not the experience of a few but was the common lot for tens of thousands of workers, and particularly so in domestic workshops.[200] These conditions were soon to take a toll upon the slop worker's health.

Kingsley in *Alton Locke* reported that no matter how fit a man was within a month of sweated labour he would be but a mere shadow of his former self and have all his clothes in pawn.[201] At the Children's Employment Commission of 1843, Dr Watts reported that lace runners could not survive on their wages and consequently turned to prostitution. Those that were married had no time to attend to their families or suckle their babies; consequently, they gave their babies and infants Godfrey's cordial a concoction of treacle and opium. Those that did not die an early death, Watts noted, grew up sickly, idiotic or with poor constitutions.[202] Sweated labour increased the working day and many embroiderers toiled day and night, with little sleep, working by candlelight, which affected their eyesight. The Ophthalmic Institute records published in the *London Illustrated News,* of January, 1844 confirmed that out of 669 patients, 81 were poor needlewomen an 'evil arising out of a grinding system.'[203] This may have been an underestimate, as it was well recorded that Ayrshire whiteworkers, risked blindness, by relieving their sore eyes by bathing them in whiskey, after a gruelling work shift. Ayrshire work, the forerunner of Broderie Anglaise used for caps, collars christening robes, and children's clothes was so popular that the firm of Samuel and Thomas Brown employed a staff of 2,000 in 1857 and 20-30,000 outworkers in Scotland and Northern Ireland.[204] According to Barbara Morris a statistical survey in Scotland in 1869 showed that wages varied from a penny to four pence an hour, and the most experienced could earn from 10d to 1s 4d a day, working from 7.00 am to midnight.[205]

Purvis argues that as most women made their own clothes they were accustomed to the needle, which enabled them to enter the dressmaking or millinery trade, though as many could not support

[200] Blythell, *The Sweated Trades,* pp.10-11
[201] Kingsley, *Alton Locke,* p.xii
[202] Pinchbeck, *Women Workers,* p.212
[203] Barbara Morris, *Victorian Embroidery,* p.37
[204] Synge, *Antique Needlework* p.142
[205] Barbara Morris, *Victorian Embroidery* p.37

themselves by this trade they entered into prostitution.[206] A century later Simone de Beauvoir denigrated government and their culpability as to the reasons why women moved into prostitution 'it is often asked: Why does she choose it? The question, rather: why has she not chosen it?' What she meant by this was, that prostitution was not entered in to because the woman was full of vice for when no longer integrated into society morality becomes an abstract issue. Rather it was condemning of a society in which prostitution was the least repellent occupation[207] We need, however, to be aware of the terminology utilised in the nineteenth century, especially the term prostitution. Mayhew's reports mentioned prostitutes, but he categorised any woman that lived with a man out of wedlock as a prostitute. He emphasised and sympathised with needlewomen and took pains to show that not all of them were full of vice. One girl, interviewed by him was quoted as 'obliged to go a bad way' as she had gone to live with a man that promised to marry her, having then been jilted, she was considered a prostitute.[208]

Not all women resorted to prostitution; Mayhew interviewed one seamstress, who was often employed as a mantle maker. The highest rate she could get for making cloaks, was 5s each, but as these had to be embroidered she could barely manage to make two a week. From that, she had to deduct 6s for a girl helper, who worked day and night each week and around 6d for her tea. She had to provide her own silks and candles and she estimated each cloak cost 3d in silks and 5d in candles. She was left that week with earnings of 2s 7d. Her rent was 2s 6d a week, and since her husband had died two years previously she had to rely upon the eldest son's earnings of 3s a week to keep five. They lived she said on bread for the best part of the week.[209]

The circumstances of those in sweated labour was well known and publicised not only by Mayhew but also the novelist Charles Kingsley, who argued that the government were authors of the system by taking the lowest tenders for government contracts and that government prices were in every department half or less than the lowest living wage. Any government tenders for uniforms for the armed forces would go to the lowest bidder and would be let out again to journeymen, who would go to the cheapest market. Kingsley was scathing towards noblemen, colonels of regiments, who would make their own profit, given a budget for their regiments uniforms by the government they would then let out work to the cheapest contractor and pocket the difference, causing the pauperism

[206] June Purvis, *Hard Lessons* (Cambridge, 1989) p.32
[207] Simone De Beauvoir, *The Second Sex* (London, 1997) p.570
[208] Mayhew in E.P. Thompson and Eileen Yeo.(eds), *The Unknown Mayhew*, p.148
[209] Mayhew in Anne Humphreys (ed), *Voices of the Poor*, pp. 67-68

of men, the slavery of children and the prostitution of women.[210] Government provided considerable work for embroiderers, as each uniform bore embroidered insignia.

One example of government tenders was recorded by Mayhew, illustrating how wages for embroidering insignia for uniforms had fallen. Police and railway insignia, for which she used to be paid 5s-6s were now only procuring 1s - 1s 3d, and a cardinal's 2s 6d for which she used to earn 16s. She had stitched insignia for the police forces of Calcutta, Metropolitan, Thames, Liverpool, and Isle of Man, for the Penitentiary and Her Majesty's yachts. Prices of work varied according to the complexity of the insignia; for example she could earn 6s -7s per dozen for Metropolitan dress collars, of which she could stitch four to five dozen a day, earning 12s- 15s per week. At one time she recalled she could earn as much as 29s, but work was then higher paid, now she worked from four in the morning until ten at night for half the wage. She reckoned that there were only about 200 women performing similar work.[211] The government, Kingsley wrote, were not merely party to sweated labour but the originators of the system, 'instrumental in destroying the living wages of the working man.'[212]

Governments were equally culpable in tarnishing childhood, and far too slow in responding to commissioned reports. For example, Anthea Callen claims that the domestic workshops were infamous for exploiting child labour. Such workshops did not attract the same attention or public sympathy as the factory, which were regulated under the Factory Acts. In some cases women worked in groups paying children, 1d, a week to keep their needles threaded.[213] Ivy Pinchbeck asserts that as soon as a child was old enough to hold a needle they were put to work and that might be at the tender age of four, often working fifteen hours a day as reported to the Children's Employment Commission in 1843. In cases where the government tried intervention, by setting up cottage schools, the social conditions prevalent in the domestic industries were such that they became little more than workshops where the bible was read out to children as they worked.[214]

Some factory owners did provide education, provided it did not interfere with the working day. According to Marion Johnson, small lace firms employed children from the age of five to work at lace running or tambouring. In Belper alone, 150 children between the ages of five and nine were employed for such work in 1833. Apparently the employers

[210] Kingsley, *Alton Locke*, pp.38-39
[211] Mayhew in Anne Humphreys (ed.), *Voices of the Poor*, p79
[212] Kingsley, *Alton Locke*, p.xiii
[213] Callen, *Angel in the Studio* p.98 and in Parker *Subversive Stitch* p.98
[214] Pinchbeck, *Women Workers* pp 232-233

did not 'object to children under twelve years of age working only ten hours a day and going to school for two, which they achieved by having a certain number of extra children. Furthermore, Johnson continues, this educational method was found quite acceptable by employers, one advertising that,

> *Girls bought to lace making make good wives being clean and handy with the needle; most girls have been to Sunday school and can read, morals are good – to better than their neighbours. ... If the girls would come to work an hour earlier in the morning they could learn to write in the evening. (Hours 7am-8pm in the summer, 8.00am–9pm in winter).*[215]

What little education they did receive was largely ineffectual. As Lawson and Silvers demonstrate at a sewing school set up in Manchester in the early 1860's for unemployed girls between sixteen and twenty-three, most of whom had been to factory schools, only 199 out of 963 could read and write.[216] One girl in a cotton mill in the 1880's reported that she was expected after eleven hours a day on the loom to attend weekly lessons on 'economical cookery' given by the mill owner's daughter. One lecture she recalled was on 'Three ways of stuffing a cod's head for a penny'.[217] In Kingsley's opinion education did little beyond amelioration, for as he commented, government feared increasing education for the poor as it would make them more consciously aware; they would be 'stretched to breaking out' and what then 'look at France and see'.[218]

Sweating clearly caused poverty and, as Schmiechen argues, it took work away from those once satisfactorily employed.[219] An opposing viewpoint was that voiced by one of Mayhew's embroiderers who stated there was plenty of work, but finding it was difficult. Three years previously she had been able to earn 15s/16s per week, which had now reduced to the region of 2s. She knew of one 'gold hand', an embroiderer who specialised in gold work, who used to earn 10s a day, but could no longer find work. As she indignantly stated the work must have been there with each new season of fashion and therefore wondered as to whether embroidery was being done in house, or in the prisons.[220] Another needlewoman complained to Mayhew that the schools were

[215] Marion Johnson, *Derbyshire Village Schools, in the nineteenth century* (Newton Abbot, 1970)p.108

[216] John Lawson and Harold Silver, *A Social History of Education in England* London, 1973) p.278

[217] June Purvis, *Hard Lessons* Cambridge, 1989) p.36

[218] Kingsley, *Alton Locke,* p.xv

[219] Schmiechen, *Sweated Industries,* p.191

[220] Mayhew in Anne Humphreys (ed) *Voices of the Poor,* p. 81

injuring trade, that 'Ladies' were taking their orders to the national schools and therefore needlewomen with families to support were left without employment.[221] Evidence therefore that not all embroidery was created under sweated labour and the embroidery schools and workshops set up were clearly having an effect on employment. Those training in schools or workshops were provided regular employment and, upon qualifying, might set up business for themselves.

Beyond the Sweated Trades

In contrast to the journeymen, an embroiderer that set herself up in business would obtain custom from milliners, tailors and saddlers as well as the general public. Such businesses often held exhibitions and sold embroidery materials and equipment.[222] There were also an ever growing number of firms specialising in ecclesiastical embroidery, to cater for the church building programme. Either of these commercial outlets might employ embroiderers, who would be formally trained in the workshop, training which otherwise would have cost her considerably. In their chapter on the dressmaking and millinery trades, Thompson and Yeo discuss the education received, and they define three levels of education: the apprentice, the assistant and the improver. The type of training received by the embroiderer defined the conditions and pattern of work. An apprentice was instructed in the 'art and mystery of the calling' and if food and board were provided a premium had to be paid by either her, her family or a benefactor.

If however she lodged elsewhere, no premium was paid, but the work she carried out was considered equivalent to tuition and she received no payment, the term of appointment, lasting 2-5 years. Assistants were hired and boarded with their employer; they were engaged by month, quarter or year, week or season. Improvers were taken for two years and were boarded by the employer for a premium; receiving no remuneration for her labour, as she was not there to be paid, but to be improved. The premiums paid by the embroiderer, parents, or frequently by a benefactor varied from £10 to £15.[223] Embroidery shops or ecclesiastical outfitters also had work supplied to them from outworkers frequently from another interesting category of embroiderer found within the lower middle classes, who purposefully withheld knowledge of employment. Pennington and Weston state the lower middle classes made up a substantial part of the home labour force,

[221] Ibid p. 73

[222] Pinchbeck, *Women Workers* p.290

[223] EP Thompson and Eileen, Yeo *The Unknown Mayhew, selections from the Morning Chronicle 1849-1850* (London,1971) pp.429-430

though how great a part is incalculable for several reasons. As Pennington and Weston argue, society refused to recognise their existence, their labour went unrecorded as the wife and husband conspired to keep her work secret to maintain respectability.[224]

As stated earlier, lower middle class women would not have been entered into the census reports as only her husband's occupation would have been entered.[225] Homework, as Pennington and Weston argue, was seen as a 'stop gap' for girls before they married and 'a bit of sewing' was respectable.[226] For a married woman to earn a living was in the nineteenth century considered a slight to the husband's responsibility.[227] This ideal was well recognised by Veblen who observed that 'If the wealth of her owner (father, husband) permits it, she is exempt from debasing menial tasks as well as from handicrafts'.[228] The lower middleclass were able to produce embroidery homework, carried out as Pennington and Weston term 'clandestinely', with a servant collecting and delivering work. The work itself did not have to be hidden, as no one would be surprised to see a lady embroidering in her 'leisure time'.[229]

The girls who entered into apprenticeships and training schemes were identified by Mayhew as the distressed gentlewomen, an important category in this study, as they were the focus of recruits for the embroidery schools established in the 1870's. Mayhew thought that the suffering of the distressed gentlewoman was heightened, for 'having been bought up in ease and luxury,' they felt their 'present privations doubly as acute as those who, in a measure, had been used to poverty from their very cradle.' Mayhew defined such gentlewomen as identifiable by the regularity of their features, which indicated that for many generations the family had not been used to labour for a living. A neatness and cleanliness distinguished her from labouring women, and she possessed a gentleness and plaintiveness in the tone of voice, which marked her refinement. He considered that though the room may be devoid of furniture it was untainted by an aura of poverty, and he was not 'sickened with that overpowering smell that always hangs about the dwellings of the poor.'[230] For these very gentlewomen, embroidery schools and societies were set up as away to help them, help themselves. Since the schools and societies operated on an altruistic basis, issues relating the notions behind the establishment of these institutions and the philanthropic attitudes of Victorian society require investigation.

[224] Pennington and Westover, *A Hidden Workforce,* p.18
[225] Pinchbeck, *Women Workers* p.290
[226] Pennington and Westover, *A Hidden Workforce,* p.19
[227] Roberts, *Paternalism* pp.1-5
[228] Veblen, *The Theory of the Leisure Class* p.53
[229] Pennington and Westover, *A Hidden Workforce,* p.21
[230] Mayhew in Anne Humphreys (ed), *Voices of the Poor,* p.71

Philanthropy as a Social Tool

Embroidery was undoubtedly a pastime considered suitable for young middle class women along with piano playing, and painting. For the middleclass, in the nineteenth century it was considered highly unrespectable to embroider for profit, though the making of trinkets for charity was socially acceptable. Charlotte Brontë depicts a scene in *Shirley* whereby the Jew Basket or Missionary Basket, a willow basket the size of a family clothesbasket, was conveyed monthly from house to house. The basket was filled with pincushions, needlebooks, card racks, and work bags, articles of infant wear made by ladies of the parish and sold by each household to its visitors. Brontë's account, whilst amusing, nevertheless portrays comparable social events, depicting unsuspecting gentlemen of the family or friends being sold embroideries, which they did not want, at exorbitant prices.

The proceeds were according to Brontë extracted by manipulative force, no doubt as each female possessor of the basket would want to achieve the best results within the parish. Each female contributor kept the basket one month, some making 400–500% above cost price for articles which were of little use to the menfolk. Competition amongst the females to sell was fierce, but equally fearsome for the menfolk, to part with money for which they regarded unnecessary items. As Brontë observed: 'feebler souls would prefer to see the prince of darkness himself at the door any morning, than that phantom basket, brought with Mrs Rouse's compliments, and please, ma'am, she says it's your turn now'.[231]

The middle classes were encouraged to make items for charity bazaars, and otherwise idle hands could be put to use, giving satisfaction that one might be helping the poor and it therefore provided a way to help and be helped. So commonplace were such bazaars that the Pre-Raphaelite painter, James Collinson (1825-1881) depicts one in *For Sale*, 1857 (see plate 3.1). Since the feature of the painting is a beautiful young girl, the innuendo is obviously that she too is for sale, so obviously bazaars presented an opportunity for young girls to be present in a public place. Charlotte Mary Yonge criticised bazaars as she saw a danger in these charitable efforts, warning her contemporaries, in 1877, that,

> *Unfortunately human nature does not recognise its own inferior work...Whether it can command a market price is really the only test. All that comes under the denomination of bazaar work, even when disposed of in private, but which good natured people buy when they had rather not, at some*

[231] Charlotte Brontë, *Shirley* (Middlesex, 1974) (reprinted first edition, 1849) pp.134-135

exorbitant price, "to encourage the child," to be rid of her importunity, or for the sake of the object, is all a sort of amiable illusion, and another form of begging.[232]

Far too much emphasis has been placed upon the restrictive leisure opportunities available to women, particularly by feminist historians, for as Veblen informs us, restrictions on leisure activities were strongly applied to males according to their social standing.[233] The only range of employment open to upper class men was in government, welfare, religious observance and sport.[234] Even which type of sport was strictly regulated; a gentleman may hunt and shoot but would not have been expected to participate in working class sports of cock fighting and dog racing. A gentleman's wife was not expected to work, as Veblen states,

Her leisure activity must be disguised under some form of work or household duties or social amenities, which under analysis serve little or no ulterior end than she does not occupy herself with anything that is gainful or that is of substantial use.[235]

Philanthropic ventures therefore provided an ideal opportunity for upper and middle class women to occupy themselves and relief from the ennui of life. Vicinus argues that during the latter half of the nineteenth century altruistic ventures grew by 'leaps and bounds in response to the growing recognition of widespread poverty, inadequate housing, and social dislocation brought about by industrialisation and urbanisation.' She claims that in 1893, half a million women were involved in philanthropic projects, of which twenty thousand were paid officials. Women, according to Vicinus were fulfilling one of their most important duties to other women and, as civilisation advanced, social interests widened and family duties diverged from the home, extending to the wider sphere and outside world. By the end of the century upper class women who did not participate in any philanthropic work were extremely rare.[236] Visiting the poor became extremely popular and it gave women the chance to be the flaneuse of society. Baudelaire coined the term flaneur after Hauseman's rebuilding of Paris following the accession of Napoleon III in 1850. It symbolised a period when the impressionists, the painters of modern life would wander the streets, observing life and

[232] Charlotte Mary Yonge, *Womankind* (London, 1877) p.223
[233] Veblen, *The Theory of the Leisure Class* pp. 23-42
[234] Ibid. p.22
[235] Ibid p.68
[236] Martha Vicinus, *Independent Women, work and community for single women, 1850-1920*, (London, 1985) pp.211-212

modernity yet remaining distant and detached from it. The flaneur was the observer of life, the 'passionate spectator who would move amongst the crowd, to be at the centre of the world and yet remain hidden among the ebb and flow of movement, a prince who rejoiced incognito. 'The lover of life makes his whole world his family ... Thus the lover of universal life enters into the crowd as though it were an immense reservoir of electrical energy.'[237] For women, visiting the poor allowed her to enter into domains hitherto unknown to her and view a side of life alien to her and, as Vicinus argues, charitable works gave women freedom to walk and move in areas that were previously forbidden.[238]

A possible different perspective on Victorian altruism, however, is provided by Polly McClean, founding director of The Funding Network and founder of the Build Trust, UK. Commenting on the power of philanthropy, as a modern day philanthropist, she supported smaller charities because it involved more human contact, the experience of loving humanity, and a way to change the world.[239] Comitini gives yet another perspective, on analysing Dorothy Wordsworth's *Grasmere Journal*, which showed that philanthropy was an 'internalised natural part of benevolent, middle-class identity' and that individual amelioration was 'at the heart of private philanthropy, both for the philanthropist and her object of improvement.' For Dorothy Wordsworth according to Comitini 'social amelioration' became 'her vocation: her feelings, duties, and beliefs', all corresponding to what she thought was her 'special feminine capacity to rationalise, sympathise, and normalise the social sphere she supervises.'[240] Such emotions equate with maternalism, but it is probable that upper class women would have identified with the matriarchal role, as complimentary to their husband's patriarchal duties.

Philanthropy carries connotations of maternity and paternity, which requires definition compared with matriarchy and patriarchy. David Roberts points out that though Victorians spoke of patriarchal principles and paternal government they never spoke of paternalism; further, they adhered to the principles of the 'Medieval English Constitution.' The English medieval gentlemen never spoke of paternalism, yet as Roberts points out, many historians have attested to the reality of both paternalism and the medieval English constitution as existing, though it was not named as such in the medieval period. The paternalist never doubted that God had created a hierarchical society and that it was the duty of the

[237] Charles Baudelaire, The Artist, Man of the World, Man of the Crowd, and Child in Jonathan Mayne (ed), *The Painter of Modern Life and Other Essays* (London, 1964) (reprinted first edition 1863) p.9
[238] Vicinus *Independent Women*, p.220
[239] Polly McClean, The Love of Giving in *Resurgence* issue 215 (London, 2002) pp26-27
[240] P. Comitini, 'More than Half a Poet: vocational philanthropy and Dorothy Wordsworth's *Grasmere Journals*' in *European Romantic Review* Vol. 14 issue 3 (London, 2003) pp. 307-322

wealthy to protect, guide and help the lower ranks, maintaining a firm moral superintendence. An important element within paternalism was therefore to know and be known by those he governed. Veblen argues that as population expands, human relations grow more complex, the process of evaluation and selection develops into a system of rank, titles, degrees and insignia such as heraldic devices, medals and honorary decorations.[241] This was most certainly the case with the new wealthy industrialists such as Wardle and department store owner Liberty to be examined in the ensuing chapters, each sought a coat of arms, each gained knighthoods and each demonstrated paternal characteristics in the organisation of their businesses.

The scene was therefore set for philanthropic embroidery ventures; on one side of the social spectrum embroiderers were suffering appalling conditions, whilst on the other side upper class women suffering from the ennui of life, required a purpose. The workforce was available, as were the governors and governesses of those ventures; all that remained was the availability of business enterprise to bring those ventures into a viable and profitable outlet. That outlet stemmed and blossomed from the success of Berlin Wool Houses, fancy repositories and exhibitions.

Berlin Wool Houses, Fancy Repositories and Exhibitions

Embroidery as an art form was in need of a renaissance as by the 1850's there were deteriorating standards leading to a lack of innovative design and harsh colouring. Wool work on canvas was, and still is, commonly referred to as tapestry, a misnomer as tapestry is woven rather than stitched. Nevertheless, Mayhew records an embroiderer as stating that she had once been employed in tapestry work, which had by then been superseded by Berlin patterns. Prior to the Berlin patterns she stated, one had only the outline drawing which the embroiderer 'had to shade off' according to their own judgement. Many, she stated, were not fit for the purpose, as it was highly skilled, the apprentice having to learn to paint and draw and 'we never...thought of giving a lesson in it under 5s.'[242] Berlin woolwork superseded this type of wool work, where the pattern or picture was printed onto the canvas, rather akin to painting by numbers and therefore removing any skill or dexterity by the embroiderer.

Berlin woolwork consisted of graphs of coloured squares, which had to be transferred to a blank canvas, via the counted thread technique, leaving some dexterity to the embroiderer. An amateur embroiderer could simply follow the pattern using tent stitch, which consisted of entering the needle through one hole and taking through the next hole diagonally across. This

[241] Veblen, *The Theory of the Leisure Class* p.46
[242] Mayhew in Anne Humphreys (ed), *Voices of the Poor,* p.80

was a highly repetitive, monotonous method for copying the colours printed onto the canvas. Many of the designs were inspired by the romantic paintings of the Pre-Raphaelites, medieval subjects such as castles, ruins, chivalry and romance inspired by animal paintings by Landseer, birds by Audubon and Lear's depictions of Queen Victoria's spaniels. Other themes used parrots and biblical scenes, patterns ranged from overblown roses to cabbages. The finished result was quite thick and heavy and therefore utilised for pictures, firescreens, bell pulls, cushions, slippers, purses, furnishings and book covers. Berlin woolwork was the very type of work detested by Morris and Ruskin, showing neither sense of aestheticism nor design, the very type of work, which still, today, denigrates the status of embroidery as an art form. Nevertheless, Berlin Wool Houses, along with Fancy Repositories and Depots, spread the popularity of embroidery, increasing its commodification, as they not only sold patterns, but often sold work by professional embroiderers as worked examples for the customer to follow.[243]

Fancy Repositories provided a further useful and commercial outlet for embroiderers as they sold a mixture of items, usually, as the name suggests more ephemeral items, such as toys, purses, pincushions, embroidery materials, decoupage kits, paper flower making kits and other items for the hobbyist. Both Fancy Repositories and Depots sold finished items, taking embroideries on a sale or return basis, thus achieving the highest possible price. The retailer adhered to the age old practice of deciding how much the customer could afford by negotiation. Fancy Repositories would try to sell the stock, which they acquired on a sale or return basis, taking a percentage of the sale price. They would therefore adjust the selling price according to that which they thought the customer could afford. Nevertheless, some fancy good businesses achieved a high turnover, and according to Emma Wilkinson in 1856 she had issued from her 'establishment upwards of 60,000 sq. yards of traced and perforated muslin for embroidery.'[244]

If the few trade directories examined are representative of the entire nation, then an extraordinary number of fancy repositories existed in the 1870's. In Sheffield, there were six Berlin Wool Dealers and fifteen Fancy Repositories in 1872. Buxton, Derbyshire, accommodated one Berlin Wool & Fancy Repository, two Fancy Repositories and six Fancy Bazaars; Bakewell had three Fancy Repositories.[245] By 1898, the number of Fancy Repositories in Sheffield had increased to thirty-one.[246] However, it should be noted that when searching directories, the names and addresses of these specialist retailers were rarely repeated in subsequent directories, an indication that

[243]Lanto Synge, (ed) *The Royal School of Needlework, Book of Needlework and Embroidery* (London, 1986) p.66

[244] Barbara Morris *Victorian Embroidery p.38*

[245] White (ed) *Directory of Sheffield and District 1872* (London 1872)

[246] Kelly (ed) *Sheffield District Directory, 1898-1899,* (London 1899)

fancy repositories were short term businesses. Since maiden women operated many of these businesses, it would seem feasible that businesses closed upon marriage or death. In the 1890's, Birmingham had twenty-two Fancy Repositories, with Misses Sanders and Alderson, a 'Berlin Wool & Fancy Repository advertising, 'All kinds of needlework and a variety of useful presents always in stock,' and Jones and Willis advertised as 'Embroiderers' from 79 Edmund Street, with works at Porchester Street.

This is an interesting fact, for it would appear that Jones and Willis had a workshop separate from the retail outlet and were therefore developing manufacturing combined with buying and selling of commodities. The same directory lists Misses F. & F. Hardy, in Ashbourne, as a Berlinwool & Fancy Repository, Dig St. advertising crewel silks, art needlework, and embroidery.[247] There are most certainly discrepancies in trade directories for according to *Bennett's Directory* in the 1890s, Buxton had five Fancy Repositories and one Berlin Wool Depot,[248] yet *Bulmer's Directory* of 1895 does not list any Fancy Repositories under Buxton. The same directory lists ten Fancy Repositories in Chesterfield, one in Glossop, and only one in Derby, which was advertised as 'art needlework'.[249] It seems improbable that Chesterfield be endowed with ten and only one in Derby and therefore questions the reliability of such directories, drawing the conclusion that there were more retail outlets than those recorded in the directories.

Most surprising were the findings in *Sutton's Directory of North Wales* in the small Victorian spa town of Llandudno, nineteen fancy repositories existed in the main street, Mostyn Street, three advertised as selling Berlin wool. Llandudno had at the time a population of 6,000 though the population rose dramatically in the tourist season to 14,000.[250] Nineteen fancy repositories in the small town of Llandudno indicates the leisure activity of those on holiday. So popular was embroidery that even the more serious and upmarket journals covered the subject widely.

The *Artist* and *Art Journal* were full of articles on embroidery, including 'agony aunt', type columns answering reader's queries and offering suitable advice. *The Artist,* October 1886, congratulated the success of the opening of M. S. Bezirdjian's studio and his efforts to popularise the Arabian and Persian style of decoration in England, stating that tracings of over 100 patterns were in course of production. Patterns which would do much 'to lift the art of embroidery out of that horrible fancy needlework and teapot cozy groove into which, in the hands of the Philistines it is so apt to fall.'[251] Key factors in promoting embroidery, however, were exhibitions where the public

[247] Bennett (ed) *Bennett's Business Directory for Derbyshire* (Birmingham, 189[-]) p.5
[248] Ibid. pp. 21-23
[249] Bulmer (ed) *Bulmer's History and Directory of Derbyshire, 1895* (Derby, 1895) p.78
[250] Alfred Sutton, *Sutton's Directory of North Wales* 1889-90 pp. 7 -126
[251] 'Art Trades' in *The Arts,* 1 October, (London 1886) p.330

could handle, purchase and gain inspiration from embroidery. Exhibitions were utilised by individual embroiderers, groups and societies, but more importantly, the world famous expositions provided an ideal forum for the great designers of the day.

Exhibitions received commercial exposure, though not all exhibits received good press for as in 1876, a lady visitor to the Exhibition of the School of Art Embroidery announced in *Art Journal* that upon seeing a notice in the *Times* on Thursday, she rushed to see the exhibition on Friday. The designs she observed were not equally good or well executed. The school [The Royal School of Art Needlework] she reported had deviated from its path of harmonious colouring and graceful form,:

> *I saw at the end of the room a gaudy piece of work in crimson and yellow, with a heavy maize coloured worsted fringe, the centre occupied with fat gilt pineapples. It was gorgeous, tinselled having plenty of needlework, but very little Art. Doubtless, the school is obliged to execute orders, but it seems a pity to degenerate style.*

She was disappointed in the Queen's box at the Albert Hall, as the work was not art needlework. She thought the designs carried out in appliqué were mostly heavy and awkward in character. She did however praise Morris' dado and wall hanging, Bodley's curtains and Atcheson's designs, as in her opinion they were well suited to embroidery, more so than the figures of Crane and Burne-Jones.[252]

Mrs Bury Paliser reporting in *Art Journal,* 1877 on The School of Art Needlework's 'Exhibition of Work not sold at Philadelphia', stated that 'Its first object is highly praiseworthy in providing work befitting their position to ladies in reduced circumstances - so different from the degrading suggestion of 'ladies helps'. The Ladies Work Society, which flourished under the guidance of Princess Louise, she informed, differed from South Kensington School of Art as the embroiderers could walk home, thereby saving money. More importantly, the embroiderer could maintain anonymity, by sending her work to Sloane Street and their names were only known to the ladies who formed the committee. Mrs Paliser then noted that the Royal Irish School of Art Needlework had determined to hold a loan exhibition.[253] *The Artist* announced a decorative art exhibition to be held in Dublin during the first week in February 1881, under the direction of The Royal Irish School of Art Needlework. Prizes of £1 to £3 were to be awarded to amateurs,

[252] 'Notes of an Exhibition of the School of Art Embroidery' in *Art Journal* (London, 1876) p.173
[253] Mrs Bury Paliser, 'The School of Art Needlework' in *Art Journal* (London, 1877) p.213

depending on the category of embroidery, which ranged from crewelwork, silkwork and church embroidery.[254]

The Royal School of Art Needleworks exhibition in Philadelphia, 1886, caused much excitement and stimulated the founding of The School of Art Needlework in the United States at Pennsylvania Museum in 1877 (now The Philadelphia Museum of Art). By 1893, they had created the museum's department of textiles, lace and embroidery, the forerunner of the present day Department of Costume and Textiles.[255] Exhibitions had great effect upon American embroidery, the formation of similar arts and crafts organisation, but in particular the formation of philanthropic ventures, to be discussed further in chapter seven. Unfortunately, the popularity of exhibitions was also the cause of their demise, since embroiderers were apparently unable to sustain this impetus.

International exhibitions, which had fared so well, were finally to lose public interest. In the 1889 exhibition 221 textiles were shown of which 91 focussed on embroideries, mostly those from the 1888 exhibition, though there were newcomers: Langdale Linen, and two London shops, Maison Helbronner and Jonathon Harris. The later employed the Royal School of Art Needlework to embroider a chair back using linen from their factory in Cockermouth, Lake District.[256] Finally the 1899 international exhibition was a financial disaster, as there were apparently too many embroideries; and of the 120 items shown most had been exhibited before and, there was it was criticised, insufficient new work shown.[257]

The reason for this apparent demise of embroidery's popularity will be discussed in chapter seven, but first the study needs to examine how embroidery reached international status, exhibited at world expositions, was written about in journals and became a commercially viable product.

[254] *The Artist, journal of home culture. (London, 1881)*p.23

[255] D. Blum 'Ecclesiastical Embroidery c. 1896 attributed to Walter Crane'. in *Bulletin – Philadelphia Museum of Art* Vol. 86, Spring (Philadelphia, 1990) p.17

[256] Ibid. p.68

[257] Ibid. p.70

CHAPTER 4
Morris & Co. – The Family Firm

Morris & Co. was formed in 1875, an enterprise which originated from the firm Morris, Marshall and Faulkner & Co. founded in 1861. The company, guided by the innovative William Morris, produced high quality fashion and household items of which embroidery was a key product. His business operated until the 1940's and therefore can be considered successful. For a small business to compete with large firms, as Morris did, Lloyd-Jones and Lewis attribute to five interrelated factors: strong personal and family commitment to the firm, operation of market networks, use of skilled labour and craft techniques, and the establishment of market niches.[258]

The business dimensions of the firm have been examined by Harvey and Press, but there is also a need to evaluate the role of the individual, and his development of social networks which provided the firm's design concept, and ultimately customer contact. William Morris' firm owes much of its success to consultation, or rather negotiation with the customer, which Church defines as the firm becoming the mediator between product and consumer.[259] Morris' social connections provided an excellent foundation at the commencement of his business, a time when ecclesiastical embroidery could be exploited to the full. Reputation and quality were key selling points for the company's embroidery products, and this was related to the use of skilled embroiderers, both inworkers and outworkers and the employment of highly talented designers who worked for the company on a commission basis. The design and skill capabilities of the company was matched by its marketing strategy, which celebrated its reputation for quality and inserted itself into the market through established networks and the use of exhibitions.

From the outset of the firm, in 1861, the embroidery department was one of the most successful departments and remained so until the beginning of the twentieth century. It will be shown that both inworkers and outworkers were employed on the embroidery side of the business, supplying two retail outlets and exhibitions, which gained many private commissions. According to Mackail, Morris's friend and official biographer, as early as 1861 his wife Jane and her sister Bessie Burden stitched embroidery as well as employing the services of several

[258] Roger Lloyd Jones and Myrddin Lewis, 'Personal Capitalism and British Industrial Decline, the Personally Managed Firm and Business Strategy in Sheffield, 1880-1920' in *Business History Review*, Vol.68, Autumn 1994, p.369

[259] Church, 'New Perspectives' p. 413

women.[260] Eventually, Morris passed the management of the embroidery department to his daughter May, a period for which there is some documentation to be discussed later in the chapter. The company essentially operated as a family firm; the initial members were close friends and family, Morris, Burne-Jones, Rossetti, Maddox-Brown, Marshall, Webb, Faulkner and his sisters, Kate and Lucy, along with Morris' wife Jane and her sister Bessie.[261] When the company eventually employed staff for the workshop, their wives and daughters were often employed and were treated with a paternalistic nature, almost as part of an extended family, or rather the 'poor relations.'

Morris incorporated as far as possible medieval ideals of work, discussed in chapter two. He espoused Pugin's words on the gothic, adopted Carlyle's ideals appertaining to the 'Captains of Industry' and advocated Ruskin's ideals on the working environment. Perhaps more importantly he championed opposition to the system which had 'trampled down Art and exalted commerce into a sacred religion'.[262] Morris' political involvements introduced his work to a wider audience appealing to both the thinking middle and working classes. His political views were well known, as he was a founder member of the Socialist League and toured Britain lecturing on art and socialism. His views provided a platform to market his products and eventually gave rise to the Art and Crafts Movement.

Art and Commerce

When Morris opened his lecture on *Art and Socialism*, in 1884, he pointed out to his audience that there were times in history when art held supremacy over commerce.[263] That 'system' which trampled down art 'divided England into two peoples, living street by street and door by door, people of the same blood, the same tongue, and at least nominally living under the same laws, but one civilised and the other uncivilised.'[264] He wanted to achieve better working conditions for mankind, that 'it was right and proper that all men should have work to do' which would be 'worth doing and be of itself pleasant to do ... under such conditions as would make it neither wearisome nor over-anxious.'[265] Morris deplored the way in which the industrial revolution had changed people's lives, machines he thought could have been used to minimise 'repulsive

[260] MacKail, *The Life of William Morris*, p.158
[261] Ibid. pp.151-152
[262] William Morris, 'Art and Socialism' in GDH Cole (ed) *William Morris, Selected Writings*, (London, 1948) pp.625-626
[263] Ibid. p.624
[264] Ibid p.625
[265] Ibid. p.640

labour', to give pleasure and add life to the human race, but they had in his opinion been utilised to intensify labour thereby adding 'more weariness yet to the burden which the poor' had to carry.[266] A more detailed examination of his beliefs on the effects of machinery is carried out in chapter seven, particularly the way in which his teachings have been interpreted. His ideas on the work process are important, because Morris' mission was to win back Art, which he called the pleasure of life and to win back Art to daily labour.[267] To bring art and pleasure back into working life was Morris' primary objective when he founded the firm, which he organised around his ideal of the medieval family firm. According to his friend and fellow artist, Walter Crane, Morris described himself as an artist working with assistants, distinct from the manufacturer who simply directed a 'business from a business point of view'.[268] Art, industry and commerce combined pleasurably and gratifyingly with his own educational experience, and through the intellectual stimuli of his artistic companions, he developed the ethos and commercial contacts for his business venture.

William Morris, son of a wealthy discount broker, entered into Marlborough College in February 1848 at the age of 14 where he remained until Christmas 1851.[269] Marlborough College was one of many colleges to open in quick succession to provide education for the new middling classes. The college had an excellent collection of books on archaeology and ecclesiastical architecture and according to Mackail, upon leaving college Morris felt he knew most of what there was to be known about the English gothic.[270] Yet, the school was of a poor educational standard and finally after a rebellion from the pupils against the schools ethos, Morris left. He was sent to a private tutor, the Rev. F.B.Guy who was to become Canon of St. Alban's,[271] and therefore when he started his business he had useful contacts for the firm in ecclesiastical wares, especially for embroidery and stain glass.

In 1853 Morris went up to Oxford, where he was to meet his most intimate and life long friend, Edward Burne-Jones.[272] Morris and Burne-Jones talked into the early hours about the works of Chaucer, Tennyson, Keats, but it was Carlyle and Ruskin who made a lasting impression on them. The many friends he made at university, particularly Charles Faulkner and Peter Marshall, were to become founders of the Morris

[266] Ibid. p.629
[267] Ibid.p.635
[268] Walter Crane, *William Morris to Whistler*, p.27
[269] MacKail, *The Life of William Morris*, p.15
[270] Ibid. p.17
[271] Harvey and Press, *William Morris, Design and Enterprise p. 15*
[272] MacKail, *The Life of William Morris*, p.28

business enterprise. In 1854 Ruskin's *Edinburgh Lectures* introduced Burne-Jones and Morris to the Pre-Raphaelite painters, whose style was to influence the firm's designs.[273] Morris and Burne-Jones had originally intended a career in the church but, in 1855, each decided against ecclesiastical careers, Burne-Jones deciding to become an artist and Morris an architect. Morris entered the offices of the London architect, G.E. Street, where he met Phillip Webb who was also to become a lifelong friend. Morris stayed at Street's for only nine months, for under the influence of the artist Dante Gabriel Rossetti, he decided to become a painter, a career that was to last for only two years.[274]

In August 1856, Morris and Burne-Jones rented unfurnished rooms at 17 Red Lion Square, London.[275] Mackail recorded in an understated manner how they began designing furniture in medieval style to be made by a local carpenter, which they painted themselves, in order to furnish their new home. Mackail might have illustrated this part of their lives more, for unmarried young men in their early twenties, designing furniture for their home seems rather enterprising, especially the interest shown in textile furnishings. With a thorough distaste of the Berlin woolwork on the market and requiring textile furnishings, Morris began designing his own panels and experimenting with embroidery. He had a frame made up from an old pattern and worsted dyed by a French dyer, and he mastered the method of 'layering and radiating' stitches so as to cover the ground entirely.[276]

The servant of Morris and Burne-Jones at Red Lion Square, nicknamed Red Lion Mary worked for them from November 1856 to spring 1859, and her duties besides keeping the house clean, involved, delivering messages and embroidering hangings for the walls of the lodgings.[277] The only extant embroidery from this period designed by Morris is "If I Can" stitched in 1857, (see plate 4.1). The embroidery depicts repeating patterns of fruit trees and birds in flight taken from *Froissart's Chronicle* 'Dance of the Wodehouses' and adopted Jan van Eyck's motto 'Als ich Kann'. Parry describes the embroidery as having unorthodox flat and padded stitches[278], referring to the fact that the long and short radiating stitches on linen which were to become fashionable were unusual at a time when embroidery tended towards tent stitch on canvas. Morris taught himself embroidery by unpicking antique works he obtained from around the world. He was aware of the techniques of

[273] Christine Poulson, *William Morris,* (London, 1996) p.13

[274] Ibid. p.19

[275] MacKail, *The Life of William Morris*, p.115

[276] Ibid. p133

[277] Linda Parry, *William Morris,* (London, 1996) p27

[278] Ibid. pp234-235

Pugin and Owen and their ideas on decoration, construction and the prominence of the gothic style for interiors. Furthermore, he was certainly aware of the Tractarian movement and its influence on the church building programme.

The experimentation with embroidery was to become a full blown project upon his marriage. In 1859, Morris married Jane Burden and instructed his architect friend Philip Webb (1831-1915) to build the Red House, at Bexleyheath.[279] Morris taught Jane the art of embroidery, the pair of them unpicking old embroideries to discover the medieval techniques used. The Red House soon became a weekend retreat and open house for the Pre-Raphaelites and Morris' bohemian friends, all helping with the decoration of the house for which he had very fixed ideas.[280] Decorating the home became a focus of everyday life. Furniture was made and decorated and various wall hangings were embroidered onto blue serge, in coloured wool to decorate the walls. Unwittingly they were producing household items, which would later be produced on a commercial basis.[281] The seed was sewn; the decoration of the Red House provided the impetus, the friends coming together to discuss and exchange ideas fed the imagination and the foundation, of Morris, Marshall and Faulkner & Co. (henceforth MMF) evolved.

Due to the Anglo-Catholic revival, which called for new and elaborate furnishings, business for ecclesiastical furnishing manufacturers was booming, Morris and his friends recognised this and ceased the opportune moment for a new and innovative company. Their combined knowledge of the medieval, Morris's embroidery skills, Burne-Jones' skill with stained glass and Rossetti's contacts with the rich and famous paved the way. Rossetti was famous as an artist and through his wealthy clientele able to bring in most of the contracts for the firm. Webb left Street's offices to set up his own architectural practise in 1859 and was able to recommend MMF to clients for whom he was building houses.[282] Contracts with other firms came about mainly from contacts within 'the family' giving rise to new 'family' members and long lasting business friendships, leading to further contacts. Manchester textile manufacturer, John Aldam Heaton exhibited at South Kensington, 1862, seeing the work of MMF and recognising the excellence of their work, recommended the firm to benefactors of Bradford Cathedral, then a parish church under extension and renovation. He maintained a long lasting relationship with Morris supplying textiles, which Morris used for

[279] Parry, *William Morris Textiles*, p12
[280] MacKail, *The Life of William Morris*, p.164
[281] Ibid. p.149
[282] Harvey and Press *Design and Enterprise* p.28

embroidery.[283] According to the Wardle Memorials, by 1870 Heaton was
supplying Morris with,

> *an excellent coarse serge, dyed to quiet but rather*
> *characterless colours which were only a makeshift and*
> *could scarcely be used without some additions of positive*
> *colour, only to be given by embroider.[284]*

MMF were innovative for the era, as prior to the company
architects of the new churches would have to go to one firm for
ecclesiastical embroidery, another for stain glass windows, and another
for furniture whereas MMF offered to design all under one roof.
Furthermore, the company was offering a co-ordinated design concept as
designers could liaise not only with each other but with the client or
architect and harmonise their designs. There was an enormous demand
for glass, tiles, altar cloths and other ecclesiastical furnishings, which
could not be met by the existing upholsterers of Gothic manufacturers. In
the first year the firm was commissioned to furnish two of Bodley's
churches; St. Martins, Scarborough and St Michael's in Brighton.[285]
Before long commissions were coming in from all parts of the country.

MMF was largely financed by family capital, with a loan from
Morris of £400 and £200 from his mother, (see balance, sheet, appendix
4.1).[286] Morris was by the standards of the other partners extremely
wealthy. When he became of age in 1855 his mother gave him 13 shares
in Devonshire Great Consuls (copper mines), which provided an income
with dividends of £741 in 1855 and £715 in 1856.[287] Each partner bought
shares in MMF and in payment, the partners could draw cash or
equivalent in products from the firm additionally receiving 10% royalty
paid on reused designs. Their payments were not equal, and were scaled
according to their contribution.[288] Morris and Burne-Jones accordingly
received larger remuneration, the payments to Morris in 1862, (see
balance sheet, appendix 4.1) was more than all the other six put together,
and in 1863, Rossetti's payments were around £6; Marshall £8; Brown
£23; E.B. Jones £30; Faulkner £63; Webb £86 whilst Morris earned £169.
(see balance sheet, appendix 4.2)[289]

[283] Harvey and Press, *William Morris, Design and Enterprise* p.49

[284] Ibid.p.79

[285] MacKail, *The Life of William Morris*, p151

[286] Hammersmith and Fulham Archives Department, DD/235/1, MMF & Co., Minute Book, 1861-1874.

[287] Harvey and Press, *William Morris, Design and Enterprise* p23

[288] J. Davidson, 'William Morris, Eminent Victorian Businessman' in *Interior Design* Vol. 67, Oct. (New York, 1996) p.32

[289] Hammersmith and Fulham Archives Department, DD/235/1, MMF & Co., Minute Book, 1861-1874.

The artists were aware of the market opportunities yet failed to realise full potential due to their alternative and various business interests. An ever-increasing demand was placed upon Morris's time and he was virtually running the firm single-handed.[290] Morris was, by 1875, a family man, with failing dividends from Devonshire Great Console and required a living wage to support his family, Morris proposed to take over the firm in the name of Morris & Co. From the very start he played the leading role in managing the firm. Rossetti attended very few meetings and became resentful of Morris, accusing the partners at playing at business.[291] His resentment probably had more to do with the fact that he was in love with Morris' wife, later to have an affair with her and already living a 'demi-monde' life.[292] The break was not entirely amicable with all members, but nevertheless, Morris succeeded in acquiring sole ownership of the company. Faulkner continued offering financial advice, Maddox Brown and Burne–Jones stain glass designs and Webb contributed to design embroidery and furniture.[293]

In 1865 a manager was appointed due to the growing demands of the partner's other commitments. Warrington Taylor was employed until his illness and death in 1870, at which point George Wardle, a family friend of Morris and clerk to the firm, was promoted to manager. Employing a manager to handle daily affairs would have satisfied Morris' urge to constantly explore new avenues, as he moved from one project to the next, from embroidery to weaving and eventually carpet manufacture. He found time to visit Iceland, translate the Icelandic sagas, write *Guenevere,* a proliferation of poems, *News from Nowhere* and later gave over 150 socialist speeches. As Morris' interests changed he gradually passed control to management, especially towards the end of his life when he became more and more absorbed with his new company Kelmscott Press.[294] So, although Morris will be criticised in chapter seven for not pioneering design, he ran an extremely successful company which afforded him time to spend on his own projects. He must therefore be congratulated for making a significant contribution to the marketing techniques which promoted his company.

Developing Sales

There were five key means of developing sales which need to be examined. Initially suppliers of ecclesiastical work, the firm's reputation

[290] MacKail, *The Life of William Morris,* p.180
[291] Ibid. p.180
[292] Jan Marsh, *Jane and May Morris, a biographical story 1839-1938* (London, 1986) p. 50
[293] Mackail, *The Life of William Morris* p.180
[294] Poulson, *William Morris* p.114

led to commissions for secular work, mainly gained through networking. Sales amassed through the companies growing reputation for high class work and the development of new products with a branded image. In addition the willingness of the firm to provide small work tailored to particular needs, which were retailed through shops and sales were expanded by reaching a wider audience through exports, exhibitions and direct mail out. From the outset, MMF marketed their reputation as artists to gain secure orders for the company.

Dante Gabriel Rossetti and Ford Maddox Brown were already established as famous artists and Webb who had left Street's office to set up his own architectural practise was gaining recognition. Since its formation in 1861, the company published a prospectus which was issued to potential customers. They advertised themselves as 'Fine Art Workmen' and stated that,

> *The Growth of Decorative Art in this country, owing to the efforts of English Architects, has now reached a point at which it seems desirable that artists of reputation should devote their time to it ...it is believed that good decoration, involving rather the luxury of taste rather than the luxury of costliness, [the work carried out] will be found to be much less expensive than is generally supposed.* [295]

In April 1861, Morris wrote to his former tutor and friend the Rev. Guy, asking him for contacts to send the prospectus.[296] In that same letter to Guy, Morris stated that his new home, The Red House would be ready in a month to show painted cabinets and embroidery. His home was to become a show house for guests invited to dinner, with the intention of promoting the firm's work. A costly method of promotion, as Warrington Taylor, Morris's manager instructed him to reduce his wine consumption down to 2.5 bottles a day, as he was spending one sixth of his income on wine.[297] Rossetti and Burne-Jones also had their homes decorated by the firm and Webb as an architect was able to obtain commissions from his clients. Networking, reputation and high profile commissions, such as the Green Dining Room in South Kensington Museum in 1867, established the firm in the public arena very quickly.

In order to maximise profits Morris expanded into the upper middle class market, professional people, or members of the manufacturing and mercantile community. As the popularity of the firm grew and turned more to secular work, Morris was aware of cash flow problems and he

[295] Mackail, *The Life of William Morris, pp155-156*
[296] Norman Kelvin, *The Collected Letters of William Morris* Vol. 1 (Princeton,1984) pp. 36-37
[297] Poulson, *William Morris* p.48

would demand consultation fees, although staff were instructed to use discretion so as not to offend the wealthier clients. If an estimate exceeded £500, advances were required as the work progressed, to ease the problem of cash flow and additional charges were made for visiting the property. By the late 1880's Morris charged fees for personal visits, 5gns in London and £20 elsewhere. The charges were waived for well known or useful customers, who might promote the firm's work. Morris & Co. never discounted prices and prompt payment was always requested whatever the customer's rank or standing. Sums unpaid after one month from delivery of the account were subject to an interest rate of 5% per annum. This was unusual for the upper classes who expected long term credit, and annual bills.[298]

There was tough competition in the early days. According to George Wardle, it was not until 1866 that the firm declared a profit, and returns and profits were so small before the late 1860's that the firm could not repay the £600 start-up loans made by Morris and his mother, (see appendix 4.2). With such strong competition in the nineteenth century, Roy Church questions how decisions were made prior to research and development techniques, as to what should be produced and for whom? How he asks did entrepreneurs and managers gain information about consumers, how was it employed and what effects did it have upon product price, quality, design or style? One method Church realises is by negotiations between firms and consumer, which would often affect the outcome of production and design.[299] Morris frequently acquired design commissions from clients, by negotiation. Many large commissions were received by the firm, especially from clients of his friend and architect, Webb, for panels to cover the walls of new houses. Often customers requested the design to be drawn and part worked with the intention that the women within the household would work it.

The first commission of this type came from the engineer Sir Isaac Lowthian Bell for his house at Rounton Grange, Northallerton, Yorkshire, designed and built by Webb in 1872-6. Morris & Co were commissioned to furnish the house, which included a commission to provide embroidery. Burne–Jones, who frequently designed for the firm, produced five panels, using the theme of Chaucer's Romaunt de la Rose, he outlined the composition and individual figures whilst Morris designed the background and other decoration. The embroidery consisted of silks, wool and gold thread on a linen ground, worked by Sir Bell's wife and daughters Florence and Ada Phoebe. [300] Burne-Jones' accounts of 1874-

[298] Harvey and Press, *William Morris, Design and Enterprise,* p.168
[299] Roy Church, ' New Perspectives', pp.405-435
[300] Parry, *William Morris Textiles* p.18

1876 give a total of £340 for the panel designs.[301] Many families may not have the skills to stitch such panels and therefore Morris employed the services of a freelance embroiderer, Catherine Holiday.

Catherine worked independently from the embroidery school taking orders directly through Morris rather than May. Employing a freelance embroiderer enabled him to diversify and produce embroideries at the top range of the market. Luxury items would inevitably uphold the company's reputation, whilst simultaneously stimulating the sales of kits for those that could not afford such expenditure. Morris saw Catherine's embroidery whilst at lunch with her and her husband, Henry Holiday, the painter, later to become Sir Henry Holiday. Morris asked Catherine to execute some large designs for him, and saying that the colouring could be left to her, providing her with artistic licence and individuality. In Holiday's book *Reminiscences* he recalled how Morris said 'You know Holiday, I'd back your wife for heavy sums against all Europe in embroidery'.[302]

Morris corresponded with the Holidays frequently, and in October 1877 he wrote to Henry Holiday enclosing a cheque for £50 for a tablecloth stitched by Catherine, with a promise of another £40 when it was sold. Morris was expecting to sell the cloth for £100,[303] which suggests that the firm would only be taking 10% commission. The letter dated the 24 October mentions a coverlet that Catherine had just commenced; Morris received the completed coverlet on 4 December, so obviously the coverlet took 5-6 weeks to make. On the 6 December he wrote to Catherine stating that he had sent £60, presumably to Henry, and would send the rest when it had sold, though he doubted that he could ask more than £120 for it.[304] One can therefore deduce from this fact, that if the firm took 10%, Catherine would for one coverlet have earnt £108 or £14 per week. A highly lucrative employment considering the average wage for an unmarried woman was 8s per week and those in the sweated embroidery trade were fortunate if they earnt 3s per week, as shown in chapter three.

If Catherine was able to maintain the impetus for 52 weeks a year, she could have been earning over £700 pa. compared with Morris whose income from the firm had increased substantially from about £300 in 1870 to about £1800 in the early 1880's.[305] Morris was worried that he could not sell the coverlet for so much and stated that he might forgo his profit on it. He does not appear to realise nor consider the financial loss

[301] Parry, *William Morris* .p.241
[302] Kelvin *The Collected Letters of William Morris*, p.355
[303] Ibid. p.402
[304] Ibid. p.417
[305] Harvey and Press, *William Morris, Design and Enterprise,* p.123

he was making, as we know, from several of the letters, he was giving Catherine the cloth and silks in addition to his own time in designing and tracing the cloth. According to Davidson large houses near central London could be rented for £120 a year,[306] so Catherine's work does seem to be exceptionally expensive. Correspondence, reveals that Morris did however ask Catherine to make some smaller, cheaper items such as cushions that would turnover faster.[307]

Small orders were made either through the Oxford Street shop or direct to May Morris which might have an impact on the firm as to what the market required. Quoting Butsch, Church notes that 'consumers participate in shaping new products and practices which corporations in turn shape into profits and mass culture'.[308] The following example indicates one such example as the customer requested different colourways via a letter to May, dated 14th February, 1893 from Helena Wolfe, Grand Hotel Pump Room, Bath the tone of the letter suggesting that it came from a lady's maid, was addressed to Mrs Sparling, May's married name:

I like the little screen very much, but Mrs Hudson wanted it for the drawing room in the new house which she is going to decorate with the blue linen embroidery like that which Mrs Morris worked for her, she thinks that if the same pattern was put on blue silk to match the blue linen, it would be better also she would prefer it worked with the finest twist silk. Mrs Hudson is very fond of that little bookcase with the birds worked in bright red, which you started, do you remember? She would like the same kind of colouring on the little screen, without any white + she thinks it would be better not to use the "old" stitches but the more modern ones. Mrs Hudson says she would be glad if you could let her have this soon as she wants me to get it done soon, for the new house which will not belong before it is finished. I shall like working the little screen very much, especially the old fashioned stitches + I hope I shall be able to do it nicely.[309]

From the formation of Morris & Co. Morris set out to achieve a signature look and Harvey and Press argue that his success was due to the

[306] Davidson, 'William Morris', p.82

[307] Kelvin *The Collected Letters of William Morris*, p. 417

[308] Church, 'New Perspectives', pp.405-435

[309]NAL, Pressmark 86.CC.3, Special Collection, Day-book concerning work done by May Morris and her assistants for Morris & Co. 1892 Nov. -1896 Nov.

fact that he created a 'distinctive house look'. Comparing Morris & Co. to Liberty, Laura Ashley and Habitat, who all had a recognisable signature look, but 'the Morris look was probably the first to become instantly identifiable by a large sector of the population.'[310] The firm of Jeffrey & Co. printed Morris' wallpaper, and as early as 1871, their logbooks showed increasing numbers of 'Art' patterns. By 1884, 'Morrision' was a recognisable style throughout the trade,[311] and, though the term branding was not utilised, Morris had created precisely that. The 'Morrision' look particularly permeated through to embroidery designs and it is only relatively recently that experts, in particular, Linda Parry of the Victoria and Albert Museum, have begun to distinguish the embroideries designed by his daughter May Morris and manager/designer Henry Dearle from Morris' own designs.

By 1870's the firm was becoming highly fashionable amongst the better off members of the middle class. On the building of Bedford Park estate in London, laid out by Norman Shaw in 1878, the writer Moncure Conway noted that 'the majority of the residents have used wallpapers and designs of Morris'.[312] The 'Morris look' was also entering contemporary novels; one of the earliest was an American novel – Annie Hall Thomas's *Maud Mahon* advised to 'Make your walls artistic without the aid of pictures' by turning to 'Morris Paper'. By now according to Davidson 'Everyone from Oxford tutors to Oscar Wilde had to have at least a piece of the Morris aesthetic to the extent that the look was satirised in Punch[313]

Of course the majority of sales came from the firm's shop, in Oxford Street. Davidson believes that Morris was the leading supplier of art needlework transfer patterns and embroidery kits.[314] Morris also broke from convention by labelling goods with names, dimensions and prices, quite unconventional for the time,[315] providing a measure from which the customer could make a choice. Initially he supplied Liberty and Debenham & Freebodies with textiles and embroidery kits until there were management disputes. As time went by, he increasingly competed with Harrods and Liberty. Morris consistently urged manufacturers to keep prices down 'and encouraged his embroiderers to work on small items such as cushion covers and fire screens,'[316] which would increase cash flow.

[310] Harvey and Press, *William Morris, Design and Enterprise* pp. 81 -82

[311] Hoskins, 'Wallpaper' in Parry, (ed) *William Morris*, p.204

[312] Harvey and Press, *William Morris, Design and Enterprise*, p. 120

[313] Davidson, 'William Morris: Eminent Victorian Businessman', p.82

[314] Ibid. p.82

[315] Ibid. p.82

[316] Ibid. p.83

In 1877 a shop was taken at 264 Oxford Street (later renumbered 449) in a new block of buildings on the corner of North Audley Street in the fashionable West End of London. Frank and Robert Smith, two brothers, later to become junior partners of the firm, managed the shop.[317] It was so successful that, in 1882, the shop was extended to provide more display space. In 1882, Morris exhibited at Manchester Fine Art and Industrial Exhibition and later that year rented a shop at 34 Dalton Street, a prosperous shopping area of Manchester, opening in January 1883 as 'cabinet makers, upholsterers and general house furnishers'. Additional premises were rented shortly afterwards in nearby Brazenose Street for cabinet making and upholstery and, in 1884, the retail side transferred to Albert Square where the firm traded as 'Art Decorators, Art Furnishers, Manufacturers and Designers.[318]

Exhibitions exposed the firm's profile to a wider audience. MMF rented two stands at the South Kensington International Exhibition in 1862 at a cost of £25. One stand displayed stain glass and the other decorative furniture and embroideries.[319] Some criticism was received in the press, such as *The Builder*. Nevertheless the firm were awarded two medals and sold goods worth £150 in addition to generating the firm's first commissions. The firm did not exhibit at the U.S.A. Philadelphia exhibition in 1876, though Morris' and Burne-Jones' designs were exhibited by the Royal School of Art Needlework where' according to Parry, they made a great impression.[320] After the success of the 1862 exhibition, the firm circulated an updated list of their work was sent to prospective clients in 1863 with an accompanying letter informing that the firm 'were able to supply all kinds of embroidered hangings for both domestic and ecclesiastical embroidery.' The catalogue for the 1862 exhibition does not mention embroideries, but magazines and newspapers indicate that there were several and both Webb and Burne-Jones account books list embroideries.[321]

Morris & Co. exhibited at the Foreign Fair in Boston, 1883, organised by George Wardle who rented a large stand 45 feet by 30 feet divided into six compartments, each featuring a particular class of products. Wardle produced a protracted guide to the exhibition, which took the visitor through the various 'rooms' deploying the art of persuasion to sell the products. (See Appendix A for a description of the embroidery on sale).[322] During the 1888 exhibition, 45 embroideries were exhibited including those by: The Leek Society, The Decorative

[317] Harvey and Press, *William Morris, Design and Enterprise* pp. 122 - 123
[318] Ibid. pp.138 to 139
[319] Harvey and Press, *William Morris, Design and Enterprise* p.48
[320] Parry, *William Morris Textiles* p.19
[321] Parry, *William Morris* p227
[322] Harvey and Press, *William Morris, Design and Enterprise* p.139

Needlework Society, The Donegal Industrial Foundation, Jane, Jenny and May Morris, Catherine Holiday, Una Taylor, Mary Buckle, Mary Gemmel, Mary Newall Mrs Aldon Heaton (wife of furnisher) and Mrs Walter Crane who was singled out for praise by several journals.[323]

Brochures were effective in reaching clients who could not come to London, and were used as a way of advertising new products. In October 1882 two brochures were produced for advertising and sent to existing and potential customers. The first dealt purely with carpets; Hammersmith carpets being described as 'works of art'. A second catalogue was more comprehensive, listing the main products and services offered with a brief description of each, 'Uniqueness, beautiful design and colouring, hand manufacture, were presented as the desirable features of Morris products.'[324]

Such was the success for the firm in Britain that Morris decided to export to America, though he was reluctant to send embroideries due to their vulnerability, as indicated in correspondence. Catherine obviously wrote to Morris suggesting that they sent embroideries to America, as Morris was by this time exporting the company's goods to several agencies in the States. In December 1879, he replied to Catherine, opposing the idea as he warned her that the embroideries would become damaged.[325] However, Morris conceded a few years later and sent embroideries to America. A letter dated 20 February and calculated by Kelvin to have been written in 1889 indicates that Catherine had asked Morris if she could exhibit in the Arts and Crafts exhibition. He replied that he had only two pieces named by her and thought that the rest were in America, in which case he would try to get them back for her. However, he feared they may be too dirty to exhibit, as those he sent the previous year had come back soiled after only two months.[326]

Morris recognised the growing mass commodity market in the USA and Germany and agents were employed to sell in the United States and continental Europe. According to Harvey and Press, the generally high level of import duties exasperated Morris, complaining of 'almost prohibitory tariffs'.[327] In 1878 he appointed agents Cowtan & Tout in the U.S.A. which by 1883 passed to Elliot & Bulkley in New York, who supplied some of the leading stores. Morris exported carpets, wallpapers, cretonnes, damasks, dress-silks, embroidery silks and crewels. Soon United States manufacturers began copying his designs, leading Morris to publish the names of his authorised agents, and warning that 'no others

[323] Parry, *Textiles of the Arts and Crafts Movement*, p.68
[324] Harvey and Press, *William Morris, Design and Enterprise*, p.138
[325] Kelvin *The Collected Letters of William Morris* p.547
[326] p.36
[327] Harvey and Press, *William Morris, Design and Enterprise* p.139

can supply the goods we make'.[328] His marketing concept relied heavily on the uniqueness of his wares. Since Morris was, as noted above, only receiving 10%, on Catherine's embroideries, then organising sale of goods through agencies in America would appear by today's standards to have very low profit margins; but small mark ups and high turnover were typical for Victorian retailers, as will be discussed in chapter six. Morris was therefore not unusual in only marking up 10%. He was, however, unusual in the fact that he was not an unscrupulous businessman and his social principles remained paramount, refusing to sell to undesirable customers.

Socialism versus Capitalism and the Democratisation of Art

Warrington Taylor, Morris's business manager, once lost a good contract for decorating a church because he had written on the estimate:

> *To providing a silk and gold altar cloth: Note - In consideration of the fact that the above item is wholly unnecessary and inexcusable extravagance at a time when thousands of poor people in this so called Christian country are in want of food - additional charge to set forth above, ten pounds.[329]*

Morris probably would not have disapproved, since after setting up the Society for the Preservation of Ancient Buildings (SPAB), that which, he termed his 'anti-scrape' philosophy and extremely strong moral principles, led him to refuse orders for embroideries and stain glass, in instances where he thought the church was restored against medieval gothic principles.[330] Morris therefore put his principles before profit, taking a great risk, for ecclesiastical work provided the initial business for the embroidery department.

The larger than life Morris was probably his own best marketing tool. Rossetti once said that his 'very eccentric and independent attitude towards his patrons seem to have drawn patrons around him.' His eccentricities and explosive temper, his dislike of serving 'the swinish rich' [331]and his unwillingness to compromise with customers, seems to have been accepted as part and parcel of dealing with Morris. There was obviously another side of his personality that endeared his friends and clients to him as many became lifelong friends. Certainly he remained

[328] Ibid. p.139

[329] Thompson, E.P. *William Morris, Romantic to Revolutionary* (London, 1977) p. 249

[330] Harvey and Press, *William Morris, Design and Enterprise,* p.224

[331] Poulson, *William Morris,* (London, 1989) p.91

dedicated to achieve perfection in whatever task he was performing. More importantly, Morris was famous in his own day as a poet, and had much public acclaim for his published works. In 1877 Morris turned down the offer of Professor of Poetry at Oxford and, upon Tennyson's death in 1892, he declined the position of Poet Laureate.[332]

However, Morris was an advisor to the South Kensington Museum, instructing the museum as to which items to purchase and the instigator of SPAB, The Society for the Protection of Ancient Buildings. Morris, in other words' moved in the right circles. His fame and popularity also spread to the working classes when in 1877 he wrote *The Manifesto to the Working Men of England* and in 1882 declared himself a socialist and joined the socialist movement. Morris was able to pay his employees above average and spent at least 25% of his income and even more of his time on spreading the socialist gospel. He travelled through Britain speaking at or chairing up to 105 political meetings a year.[333] He may have become popular with the working class though Lenin in *Lenin in Britain* wrote that Morris was 'a philistine, who belonging to the best of his class, eventually struggles through to socialism, but never quite sheds his bourgeois conceptions and prejudices'.[334]

Morris's lectures on art and socialism made him popular throughout England with all social strata. He said that the working classes saw the prophet in John Ruskin 'rather than the fantastic rhetorician, as more superfine audiences' did,[335] a comment which was probably equally applicable to him. The ethos of the firm and Morris's views on commerce and art are important to this study, as the next two chapters will show the impact he created on embroidery as a commercially viable product, an art product which could be available in every home. He believed that art was being crushed to death by the 'money-bags of competitive commerce.'[336] He denounced the 'devil take the hindmost system' insisting that 'so long as the system of competition in the production and exchange of life goes on; the degradation of the arts will go on'.[337] Morris was an ardent admirer of Ruskin's ideology, who stated in *Unto this Last* that business men should recognise the true social purpose of business, that individual gain should never be a goal in itself and that the price of goods should reflect the cost of production.

[332] M. Horton, ' William Morris, Victorian England's Mediaeval Artisan' in *Piecework,* Vol. 7 issue 1 pp.12 - 17
[333] Davidson, 'William Morris' p.83
[334] A.L. Morton, (ed.). *Political Writings of William Morris* (London, 1979) p.20
[335] William Morris 'Art and Socialism', *p.633*
[336] William Morris, ' Art under Plutocracy', *1883* in Morton, A.L (ed.). *Political Writings of William Morris* (London, 1979) p. 66
[337] William Morris, 'Art under Plutocracy' p. 65

Profit was not the 'object of life to a true merchant', whose real purpose was 'to understand the very root qualities of the thing he deals in'. The merchant, Ruskin believed, should apply all his energies to producing or obtaining his wares in perfect state, and distributing them in perfect state, at the cheapest possible price to where they were most needed.[338] Five years earlier, in 1877, Morris had urged an audience of designers and craftsmen to educate the general public whose taste in general was set on shoddy, mass produced goods made by manufacturers competing for cheapness rather than excellence. He urged his audience to educate the public,

> *so that we may adorn life with the pleasure of cheerfully buying goods at their due price; with the pleasure of selling goods that we could be proud of both for fair price and fair workman ship; with the pleasure of working soundly and without haste at making goods that we could be proud of.*[339]

Shops, said Morris, were full of useless items called luxuries, commerce creating slaves to produce 'infamies' and 'foolish and not over happy people' to buy and harass themselves with it encumbrances. Shops were full of 'a mountain of rubbish', 'toys of fashion', which when the first gloss had worn off would be seen to be worthless even by the frivolous Whereas a work of art no matter how humble would live long and as long as a scrap hung together it would be valuable and instruct each new generation. He urged people to strip themselves of encumbrances to simplify life, for in buying these toys of fashion they were buying the lives of men.[340] 'The beginning of social revolution' Morris believed had to be 'in the foundations of the rebuilding of the Art of the people, that is to say of the pleasure of Life.'[341] William Morris and how he set about achieving those objectives will be revisited in chapter seven *The Rise and Fall of Art Needlework*, as Morris is culpable for both the rise and fall of Art embroidery. Prior to this objective, though, it is essential to examine the operation of the embroidery school.

The Embroidery Department

Initially the majority of contracts came for the firm's stain glass, and the embroidered alter cloths and vestments. In the early days family

[338] Harvey and Press, *William Morris, Design and Enterprise* p.150

[339] William Morris, ' The Lesser Arts, 1877' in Morton, A.L (ed.). *Political Writings of William Morris* (London, 1979) p. 51

[340] Morris 'The Art of Socialism' pp. 628-629

[341] Ibid. p.642

members worked the embroideries: Morris' wife Jane, her sister Elizabeth (Bessie) Burden, Faulkner's sisters, Kate and Lucy, Burne-Jones's wife, Georgiana, Mrs George Wardle, wife of the manager, Mrs George Jack, wife of the furniture foreman and Mrs Campfield, the glass foreman's wife. Jane and her sister Bessie managed the out workers.[342] No wages appear in the accounts for 1862 and 1863 for the embroiderers, and Parry suggests that the wages were included in those given to their husbands.[343] Since in the early days the embroidery members were 'family' it probably never occurred to the women to demand their own wages, when they were satisfied to simply contribute to the running of the business. The first empirical evidence for the existence of embroidery outworkers appears in a letter from Morris to his wife Jane whilst she was away, recuperating; in 1877 Morris wrote:

> *Miss Marshal writes bothering: says she only got 13s/ for 8 days work at Bessy's & so was obliged to give up working there: of course she lies; but she clearly didn't intend working there: am I to give her more than £2 for the table-cover (less the floss silk) which she has just sent in? She says you gave her that for it & had done an eighth of it yourself. I suppose Bessie will be able to give her the chair-back she asks for: she wants more silks too. Why didn't she ask for all this before you went [?]*[344]

There are several implications in this letter, but most importantly, it appears that Morris' wife, Jane and her sister Bessie were managing the outworkers and in addition Bessie was managing an embroidery department with inworkers. It is obvious from this letter that Miss Marshall was in temporary employment at Bessie's, against her will, or else she was trying to exploit the situation, under the assumption that she might earn more as an outworker. She was paid 13 shillings by Bessie for 8 days work, which would appear to be comparable to Catherine Holiday's remuneration and compatible with the Royal School of Art Needlework who paid their embroiderers 12-29 shillings per week depending upon their grade.[345]

Evidently, Morris let Jane and Bessie manage both the finances and staff, which is evident in a letter of reference dated 28 February 1880

[342] Marsh, Jan, 'The Female Side of the Firm'. in *Crafts,* no.140 May/June 1996, pp43-45

[343] Parry, *William Morris*, p226

[344] Kelvin, *The Collected Letters* p. 420

[345] NAL Accession no. 43.A.2(J) *Vice Presidents Report to HRH The President and the Council, The Royal School of Art Needlework for 1875*

written by Morris to George Hector Croad, first secretary to the new London School Board stating that:

> *Miss Elizabeth Burden, who is a candidate for the post of superintendent of [the] Needlework of the School Board for London, has been employed by me for some years as an embroideress, and an arranger of such-like work: She is a first rate-needlewoman, and in general matters well educated: while doing work for me, she had to keep troublesome and complicated accounts concerning designs, materials, & wages, which she carried through competently & with great accuracy. I have no doubt that her careful business habits combined with her complete mastery of the theory [of] & practise of all kinds of needlework would fit her well for discharging the duties of the place she is applying for.[346]*

Parker cites Anthea Callen, who argued that from Morris, Marshal and Faulkner, through to the Arts and Craft Movement, traditional sexual division of labour was maintained;[347] but according to Morris' friend and colleague Walter Crane, the woman question never appeared to be asked. Morris had once said that if the economic question was settled so would all other questions:

> *He evidently ... thought that with the disappearance of commercial competitive struggle for existence and what he termed artificial famine caused by monopoly of the means of existence, the claim of women to compete with men in the scramble for living would not exist. There would be no necessity for either man or woman to sell themselves, since in truly cooperative commonwealth each one would find some congenial sphere of work.[348]*

Brunton reiterates Lynne Walker's words that the Arts and Crafts Movement did provide opportunities for women in paid employment, often outside the home, in the public sphere, where often women gained independence, both financial and personal.[349]

[346] Kelvin *The Collected Letters* pp. 561 - 562

[347] Parker, *The Subversive Stitch*, p.180

[348] Walter Crane, *William Morris to Whistler*, p.12

[349] Jennie Brunton, 'Annie Garnett: The Arts and Crafts Movement and the business of textile manufacturers' in *Textile History*,32 (2) pp217-238

Certainly by 1885, under Morris & Co. an embroidery department existed, over which Morris placed his twenty-three year old daughter May in control. May operated from her drawing room at Kelmscott House and was responsible for large commissions, producing estimates, invoices and supervising the embroiderers employed. May, instructed and trained friends and apprentices, including Mary de Morgan, the actress Florence Farr under her married name of Mrs Emery,[350] Lily Yeats, sister of the then aspiring young poet, Maude Deacon and (Mary) Ellen Wright.[351] Apprentices reaching a high standard might be promoted to assistants, teachers or even designers as in the case of Ellen Wright, who joined Morris & Co. from a nearby school, aged 17, and exhibited hangings in her own name. Later in her life Ellen recalled how the needlewomen worked a full day at Hammersmith Terrace, with an hour for lunch, which was eaten in the dining room and how Morris would stroll along in the mornings, from Kelmscott to check progress.[352] He showed a certain amount of paternalism towards his outworkers, by organising events for his workers, a tactic which remains popular with firms today, the organisation of events in the name of 'team spirit'. Ellen recalled how on boat race day the embroiderers and their families were invited to a garden party, so they could watch the race from the riverbank.[353]

This account suggests that there were more embroiderers than those already mentioned. The new breed of chivalrous businessmen, 'The Captains of Industry', quickly adopted garden parties and day trips for workers and their families. Events such as these were, according to Roe, seen as bringing the social classes together in loyalty, to a common cause, 'cherishing as their chief glory, the glory of work well done.'[354] The irony is that 'Captains of Industry' little realised that patriarchy, by its very nature, can only operate on a hierarchical level, raising the question as to whether their actions were altruistic or a form of work control. Certainly Morris does not appear to have had much patience with the embroiderers as he wrote to Jane in March 1876, reporting that the embroidery ladies had given him 'such a turn of it this morning I thought I should have been both walked & talked off my legs.'[355]

When May took over the embroidery side of the business, the only extant accounts recorded by her, show wages solely for the embroidery department, those working from May's home. It is therefore highly probable that the outworkers were dealing directly with the shops. Unfortunately few accounts remain and those which exist perhaps tell us

[350] Jan Marsh, *Jane and May Morris, a biographical story, (London, 1986), p225*
[351] Ibid. *p.168*
[352] Ibid. *p219*
[353] Ibid. *p219*
[354] F.W. Roe, *Social Philosophy of Carlyle and Ruskin* (New York and London, 1921) p.114
[355] Kelvin, *The Collected Letters of William Morris* p. 288

much by what they omit, in particular that the inworkers and outworkers accounts were separate and the inworkers were mainly working on commissioned pieces rather than general retail stock. One account book from 1892–1896 entitled Mrs Sparling's day book (May Morris's married name) began in November 1892 with order number 1363 for Mrs Munro Longyear dated 30 May 1892 for two 'Fruit Garden' portieres in damask silk 8' 8" x 4' 6". Along side are two further dates, 25 April 1893 and 28 June 1893 June, which one might presume was the completion date. Directly below orders for November, two portieres are entered one £95 and one £85, this is very probably Mrs Longyear's portieres, being the price for finished items.

A later entry, 19 January 1895, for the Countess of Rostyn for a quilt, 6' x 7' 6", lists the fabric costing £6.10.0; starting work = £5.0.0; design = £3.0.0; working monogram = £3.0.0; bringing the total cost to the Countess to £11.10.0. It was estimated that it would take 7-8 days for the quilt to be prepared in readiness for the Countess to embroider. Apparently, orders were dealt with through the shops as indicated by a letter dated 25 January slipped inside the day book. The letter from Sheldon, about whom little is known but who may have been managing the shop, stated that he was glad to send an order for Lady Rosslyn's quilt (note spelling differences) and that he had added an extra £1 on top of May's estimate of £11.15.0.[356] Her account book lists the individual items made and their design. Table 5.1 indicates the total items made, between November and April. It becomes apparent that May and her assistants were in charge of the commission pieces and making items for stock with any available spare time. They were certainly not producing sufficient to stock several shops.

The 29 embroideries made in November in Table 5.2 included 1x2 Portieres, 1Altar Frontal and Super, 10 cushions, 1 workbag, 1 mantle border, 28 panels and 4 mats.[357] The first two are finished items, but all others are marked 'all started' meaning that the pattern was traced and a small portion embroidered, to indicate the stitches and colouring to be used. The item would be sold with silks to be utilised, in other words, 'kit' form.

[356] NAL Accession no. 86.CC.31 Day book concerning work done by May Morris and her assistants, 1896 Nov. mainly for Morris & Co. 1892 Nov
[357] Ibid.

Table 5.1: Embroideries made November 1892 – April 1893

Month	Made to Order	Made for Stock	Total Items Made
November, 1892	16	13	29
December, 1892	10	6	16
January 1893	4	5	9
February, 1893	18	4	22
March, 1893	11	4	15
April, 1893	11	10	21

Table 5.2 Detail of Embroideries made in November 1892

Two portieres	£95
	£85
Altar Frontal& Super Frontal	£18
Workbag	£1.5.0
Cushions	£1.4.0
Myrtle panels	17.0
Tulip panels	11.0
Tulip cushions	£1.4.0
Rose cushions	£1.2.0

The following entry records the time taken and wages for LY [Lily Yeats] EW [Ellen Wright] and MD [Maude Deacon or Mary de Morgan] to complete the Kelmscott hangings for Hammersmith Terrace:-

```
LY    work  11 week         £14 .17 .0
EW          1 wk 1 day          19 .3
MD          1wk 1day     ..     19 .0
                            £16 .15 .3
P+M+T   [pricking, marking and tacking?]
LY    4hrs          say          3 .0
EW    27hrs
MD    2               }say      15.00
                            £17 .13 .00
designing MM [May Morris}  8½ hrs.[358]
```

The last entry for May Morris indicates that she did not charge for her time in designing but the other embroiderers were paid for their

[358] Ibid.

labour; there is no additional mark up, or charge for materials, so this hanging was evidently charged at cost only as it was for the family home at Hammersmith Terrace. The matching bed coverlet finished, a year or so later, was worked by Jane, with some help from Mary de Morgan.[359] From the above evidence, it is obvious that the embroidery department managed by May were producing larger commissioned pieces, and in their spare time preparing smaller items part worked for stock. There are insufficient items to stock the firm's stores and to compete with the department stores as mentioned earlier.

Therefore, it must be deduced that outworkers provided the bulk of embroideries. Since the records for outworkers no longer exists, the thesis turns to examine the embroidery society and school formed by Thomas Wardle of Leek. Wardle worked closely with Morris and the Royal School of Art Needlework and set up his embroidery department taking their example, which will therefore provide further insight as to how Morris & Co. operated.

[359] Marsh, *Jane and May Morris, p225*

CHAPTER 5
The Leek Embroidery Society

> The principal manufacture at Leek is that that of sewing-silk, for which this place is widely and justly celebrated ... and various descriptions of art embroideries are largely produced.[360]

B y 1900, the small market town of Leek in North Staffordshire had become nationally famous for its individualistic style of art needlework, which was produced by the Leek Embroidery Society, formed in 1879. The society displayed its designs and goods, developed through its own embroidery school, at some of London's major exhibitions. The attributes of Leek will be examined to determine whether clustering of industries in the manufacture of silk produced advantages providing a pool of transferable skilled labour. In 1900, there were at least six retail outlets in Leek selling embroidery.

In addition to the Leek Embroidery Society shop, there were four fancy repositories and one depot for art needlework, the later being a repository where women could send their embroidery on the condition that they would be reimbursed after a sale had been completed. This chapter will examine the origins and development of the embroidery society and the role of its founder, Thomas Wardle (1831-1909) described in the *Dictionary of Business Biography* as a silk dyer, printer and promoter of the silk industry.[361]

Finally, the chapter will examine the practise of the Royal School of Art Needlework (RSAN) of which the Leek Society was an affiliate, combining extant evidence from both sources it is possible to achieve an informed opinion on the way in which embroidery schools throughout the country operated. Prior to that, however, five interrelated themes appertaining to Leek and the Wardles need to be examined. The attributes of Leek and the reasons why a small market town in the heart of England should become famous for embroidery, which had the ability of selling to London department stores, needs to be assessed. Secondly, the entrepreneurship of silk dyer Thomas Wardle and his networking with Morris and the Pre-Raphaelites, it will be argued, played a significant part in promoting the company. Thirdly, his wife Elizabeth contributed by forming a society and an embroidery school. The reasons why Wardle's wife Elizabeth (1835-1902) established educational facilities which commercialised art needlework, it will be argued, were motivated by factors concerning matriarchy, maternalism and the need to be needed.

[360] *Kelly's Trade Directory Staffordshire,* (Staffordshire, 1900) p.223

[361] Christine Woods,' Sir Thomas Wardle', in Jeremy, David, J.(ed.) *Dictionary of Business Biography* Vol. 5 (London, 1986) p.661

Fourthly, there will be an exploration of how the society and school were operated, paying particular emphasis upon the need to educate workers in embroidery skills. Finally, the chapter will assess the development of distinct designs by the school and society, as this elevated Leek to a position of national reputation by the end of the nineteenth century. Central to the success of the Leek Embroidery Society was the creation of distinct designs, of which many were influenced by Indian design. Wardle was an astute businessman, and the development of branded products, representing the individualistic style, was a key feature of his ability to develop market networks for the sale of his products. The conflicts between commerce and art it will be argued were rooted in the method of production and display.

Leek, its Attributes and Resources

The town of Leek become famous for its silk embroidery threads and embroideries produced there, to such an extent that department stores, such as Liberty, Debenham and Freebody, forerunner of Debenhams, widely advertised Wardle's wares. In order to understand it in salient terms, the attributes of such a small market town in the heart of Staffordshire need to be examined. Leek, a small historical market town, in the North Midlands became industrialised for the manufacture of silk in the nineteenth century. Silk was produced in Manchester and Stockport, and the neighbouring town of Macclesfield is still renowned for its past silk industry, whilst little is known of production in the small neighbouring village of Tideswell, Derbyshire. Research on clustering silk manufacture in North Midlands requires further investigation as the author holds samples and evidence of silk made in Tideswell.

Clustering is a concept in historical research into the regional growth of industries, the word cluster, defined by Wilson and Popp as a 'wider agglomeration of industries that may be connected by common products, technologies, markets (either supply or demand) or by institutional frameworks'.[362] Wardle's connections with Morris, the British and Indian governments and Leeks geographical location, played a major factor in the foundation of an additional 'clustered' industry, the Leek Embroidery Society.

A key factor in the formation of clustered industries was the availability of a labour resource, a pool of skilled workers and artisans. At a regional level, Staffordshire became industrialised in the production of glass, porcelain, ceramics and silk, all deploying the knowledge of Huguenots fleeing from Europe where production had originated. Whilst

[362] John F. Wilson and Andrew Popp (eds) *Industrial Clusters and Regional Business Networks in England, 1750-1970*, (Aldershot, 2003) p.3.

the main migration of the Huguenots was to London and the Spitalfields area, growth of industry in the north and employment opportunities, encouraged the spread of Huguenots to Staffordshire. The growth of the silk industry, particularly in Spitalfields where the Huguenot population was extensive, owed much to the prohibition on silks entering Britain from France in 1698 and India and China in 1701. The prohibition on French imports was lifted in 1826 allowing imported silk to enter with an 'ad valorium' tax of 35%, and in the same year the duty on foreign thrown organzine (silk thread) was reduced to 5s. per lb.[363]

By 1860, the tax on silk had fallen to 15% and was finally abolished under Cobden's Treaty of that year. Consequently, imports of foreign silks of a superior quality flooded into Britain, doubling in the first year from £3,343,761 to £5,908,629[364]. The bulk of these imports presumably went straight to the affluent London market, forcing many silk manufacturing companies in London out of business; yet silk manufacturing in Manchester, Macclesfield and Leek correspondingly grew. The reasons for such expansion may have been due to a combination of factors, the migration of Huguenots to Staffordshire potteries, an improved canal transport systems, the related silk ferret industry and more importantly the quality of water essential for dyeing. Spitalfields in 1825 employed around 60,000 people working 24,000 handlooms; free trade reduced these figures to around 4,000 operatives, working 1200 looms.[365] In 1809, there were nine silk manufactures in Leek, which over the next 20 years grew to 15[366] and by 1871, 32 factories and 136 workshops existed.[367] Leek specialised in silk ferrets (ribbons), sewing silks, twists, silk ferret shawls and silk handkerchiefs. When Samuel Bamford passed through Leek in 1842, he noted that the young girls working in the 'silk smallware line' were neatly attired, many wearing 'costly combs, ear-rings and other ornaments of value, showing that they earned sufficient wages, and had imbibed a taste for the refinements of dress.'

He observed in his journal that these young females sat at 'their elegant employment, producing rich borderings and trimmings, in good, well-aired conditions.'[368] Four decades later, this trade in silk small wares still provided substantial employment for Leek. By 1887 heavy braids had become fashionable for men's suits and women's costume and by 1901 the census shows that 1,567 people were employed in the

[363] William Page (ed) *Victorian History of the County of Stafford Vol.1*, (Oxford,1968) p.206
[364] Ibid p.209
[365] Lasenby Liberty, 'Spitalfields Brocades' in *The Studio*, Vol. 1 1893 p.20
[366] Page. *Victorian History of the County of Stafford*, p.209
[367] Burchill, F. 'The Leek Textile Unions' in *A History of Trade Unionism in the North Staffordshire Textile Industry* (Staffordshire, 1971) p.16
[368] Chaloner, W.H. (ed) *Passages in the Life of a Radical* (London, 1967), p.110

manufacture of fancy goods.[369] Earlier in 1841 the census showed that 2,025 people in Leek and outlying areas were employed in the silk industry. By 1851, the numbers employed had doubled to 4,000, and by 1861 4,253 were employed, mainly women and children.[370] This indicates therefore that employment figures doubled between 1841 and 1851, yet between 1851 and 1861 only an additional 253 were employed; therefore, in real terms the numbers employed in the silk industry had proportionately fallen, due to mechanisation. The evidence submitted in chapter three however must be born in mind, the unreliability of census reports and failure to acknowledge outworkers in the finishing off trades.

One of the other chief manufactures at Leek was florentine buttons, made by stitching over a wood, bone or iron mould.[371] This industry was devastated by 1875 due to growing competition from Birmingham, using Mathew Boulton's metal button making mechanisation and, by 1884, only 300 women and children in Leek managed to earn a living from the button trade.[372] The demographics of Leek were such then that the town was endowed with generations of female skilled labour, in a successful silk manufacturing area with a need to find similar related employment, a need which was to be recognised by Thomas Wardle who fully utilised the resources available.

Thomas Wardle, Entrepreneurship and Networking

Wardle entered into his father's dyeworks in 1862, opening his own dyeworks in 1880 at Churnet and Hencroft, Leek.[373] A relationship was formed in 1875, when Wardle was introduced to William Morris, a relationship that was to change the future of both men and their respective careers; it was to Wardle that Morris turned to for assistance with developing natural dyeing techniques, raising the question as to why he is so rarely mentioned in history books. His presence in the embroidery retail field has been overshadowed by Morris and therefore largely ignored, a fact that this book hopes to rectify.

Elizabeth's brother George Wardle, coincidentally also Elizabeth's maiden name, introduced Morris to Thomas. George was working at the time as a draughtsman/designer for Morris, later to become manager of Morris & Co., and he was aware that Morris was experiencing problems achieving certain colours with natural dyes, and that Thomas Wardle had a reputation for the 'art' and 'science' of dyeing. For the next two years,

[369] Burchill, F. 'The Leek Textile Unions' p. 39
[370] Page, *Victorian History of the County of Stafford* p.209
[371] White, *White's Directory of Staffordshire* (London, 1851) p.721
[372] Page, *Victorian History of the County of Stafford* p.209
[373] Woods, 'Sir Thomas Wardle' p.661

the two men corresponded and Morris made numerous and protracted trips to Leek,[374] where he worked together with Wardle, where Morris commented he was 'taking in dyeing at every pore.'[375] It is highly probable that during this period they spoke about embroidery. There was certainly an awareness by Wardle that Morris employed embroiderers, for on one visit to Leek, Morris left 'floss and sewing' behind, and wrote to Wardle, in 1877 declaring that he was 'rather torn in pieces' by his embroiderers, for his forgetfulness and their lack of thread.[376] Embroidery was not their only commonalty.

Wardle was of like mind with Morris's concerns over building preservation as only three days before Morris had written to him asking for suggestions of names of suitable people to join the Society for the Protection of Ancient Buildings (SPAB).[377] Wardle was a founder member of SPAB along with Thomas Carlyle, the great writer of his time, who advocated the 'Captains of Industry' needed to provide better conditions for their workers. The fact that Wardle was aware that social reform was necessary, coupled with the knowledge that both Morris and the Royal School of Needlework employed embroiderers, led to the formation an Embroidery Society in Leek, two years later, in 1879.[378] It is perhaps appropriate here to mention some of Wardle's contacts and attributes, as it accounts for his networking and promotion of embroidery, in addition to silk production and promotion. As discussed in an earlier chapter, embroidery schools were opening all over the country and other groups were changing from ecclesiastical work to the new aesthetic secular style, yet no other town achieved the prestige attained by Leek. Wardle held a high profile within nineteenth-century society, through networking and social contacts. His contacts were not simply through mercantilism or scientific research; he moved in ever increasing prestigious circles and he was a friend of the Pre-Raphaelites, especially the artist Rossetti, as well as Mark Twain, Baden-Powell and Eliza Lynn Linten.[379]

In 1887, he was elected chairman of the Silk Section Committee of the Manchester Jubilee Exhibition, where he was soon promoted to President of the Silk Association of Great Britain and Ireland, a post he retained until his death. He set up the Ladies' National Silk Association, which consisted of titled Ladies whom he encouraged to mount exhibitions to promote the silk industry. Wardle wrote numerous papers

[374] MacKail, *William Morris*, p.325
[375] Kelvin, *The Collected Letters* p.292
[376] Staffordshire Records Office, hereafter (SRO) D618 transcript of 61 letters from William Morris to Wardle of Leek, 13 April 1877
[377] Ibid.
[378] Anne G. Jacques, *Leek Embroidery*,(Staffordshire, 1990) p. 13
[379] Woods, 'Sir Thomas Wardle' pp. 663-4

and he was an advisor to governments and the South Kensington Museum and was eventually knighted in 1897 for his services to the silk industry. He was a polymath; to name just a few of his activities, he held fellowships of the Chemical, Geological and Royal Statistical Societies, the Imperial Institute, a council member of the Palaeontographic Society, Cambridge Appointment Board and an examiner for City and Guilds of London Institute.[380] Though Wardle wrote prolifically on geology, he was better known for his work on promoting the silk industry. One method of achieving this goal was to form the Leek Embroidery Society. His ideas naturally came from his close association with Morris and knowledge of the embroidery business, though it will be argued he was also an innovator and entrepreneur.

John Wilson states that it is the commercialisation, the emphasis on innovation, rather than the invention itself, which sets the entrepreneur apart and he quotes from the economic theorist Schumpeter, that the entrepreneur's prime function was:

> *to reform or revolutionise the pattern of production by exploiting an invention or, more generally, an untried technological possibility for producing a new commodity or producing an old one in a new way, by opening up a new source of supply of materials or a new outlet for products, by reorganising an industry and so on.*[381]

Innovation, a key to the act of entrepreneurship, as Coleman states, is not simply about the spectacular major breakthrough. Rather, the short or medium term activity involved in 'the continuous adaptation of the technical and/or organisational structure of an existing business to small changes in the market for factors and final products' was equally entrepreneurial.[382] Wardle learnt several techniques deployed by Morris. However when it came to design, he was not a copyist but an innovator producing a very original and identifiable style. In short, Wardle produced a branded product, in a fashionable contemporary design in aesthetic art colours, which he developed, and a product that looked good with the new aesthetic interior developed by Liberty to be discussed in the next chapter.

Wardle printed fabric specifically for embroidery, many of which were patented. Distinctive colouring and designs became a trademark representing a desirable object and 'Leek Embroidery' a brand name. Wardle developed an embroidery kit, whereby lengths of material were

[380] Ibid.p.663
[381] Wilson , John, F. *British Business History* (Manchester, 1995), p.56
[382] Payne, P.L. *British Entrepreneurship in the 19th Century,* (London, 1974) p.13

printed in order to be embroidered and sold complete with silk threads and needle. Kits were part worked which lessened the price, making the embroidery available to a wider audience, encouraging repeat purchases, which were sold through Liberty, Pearsall's, Maison Hebronner and Morris & Co.[383] Methods of hand-block printing inspired Liberty to sell lengths of cotton with a single colour outline pattern, and sold with Wardle's 'art silks'.[384] Not all embroidery patterns were printed this way. According to an article in *Ladies' Field*,

> *One of Lady Wardle's daughters has a cosy little studio, reached by a winding flight of stairs and overlooking the tennis court at the back of the house. Here with a most ingenious apparatus recalling a familiar instrument of torture in a dentist's operating room, she traces the designs and by the aid of this contrivance punches tiny holes following every line of pattern ... where it shows clearly, and is not liable to be rubbed out by handling.[385]*

Patterns were designed by Wardle and later his son Tom Wardle junior contributed. Designs had a distinct Indian influence, especially after his visit to The gateway to India Bombay in 1886, where he saw the Ajanta cave drawings.[386] The society made a wide range of items from cushion covers, tea-cosies, place mats, firescreens to pictures, mainly on silk, although other fabrics were used. Embroidery was worked with 'art' colours, the new aesthetic, naturally dyed silks and never those dyed with aniline dyes. Silk floss was used, which is a thread, barely twisted, therefore wider than a tightly twisted thread which covered the ground to be embroidered quickly. Natural dyes provided a means of fine gradations of colour by using long and short stitches, not only could area be covered quickly, but gradations of colour meant shading for leaves and flowers were easily achieved, and in a natural manner. Shading and gloss of the silk was finally uplifted and made exotic by the addition of gold thread imported from China or Japan, couched around the outline of the pattern. The final result, and the method of working, were so utterly different to Berlin woolwork that the method immediately became popular.

Wardle was an astute businessman who had developed a innovative product, a product which required marketing. He needed to expand the market, the aesthetic dress lent itself more to finer, softer and easier care

[383] Parry, *Textiles of the Arts & Crafts Movement* pp.114-116
[384] V&A publication (no author) *Liberties, 1875-1975* Exhibition Guide, (London, 1975) p.11
[385] *Ladies Field* October 22, 1898 p.198
[386] Jacques, *Leek Embroidery*, p.18

fabrics, though silk was still the major choice for dress or mantels. French silks considered to be of the finest quality, provided major competition, hence, the need to promote silk in order to keep his factories open, a task in which Wardle succeeded, as they remained trading until 1968. Product diversification was one answer, and since the tusser was a coarse brown silk containing 'slubbs' Wardle decided it would lend itself better to home furnishings, which were in the nineteenth century heavily braided. In addition, skilled labour was available in Leek for as stated earlier the town had artisans for the making of braids. Wardle devised a method whereby the edge of the fabric was embroidered and the ends left tasselled or fringed. Needlework kits already devised by Morris were a very obvious choice for Wardle as he could supply threads and silk marked out with the pattern and part worked by an embroiderer in Leek for the amateur to follow.

Wardle was a skilled designer, a successful dyer and producer of sewing silks, with a wife highly skilled in embroidery. There were many factors at play, particularly market forces ensuring the time was ripe for a new embroidery product. Wardle designed a product which would be seen by anyone who entered department stores, who promoted Wardle's silks. Liberty in particular displayed Wardle's manufactures as his oriental designs of which he had extensive knowledge, suited Liberty's concept. As with all marketing a need or want has to be identified or created. Church poses an interesting question when he enquired as to how entrepreneurs and managers gained information about consumers prior to research and development techniques. What should be produced and for whom?[387] Wardle had an immediate need to promote sales of his silks and reach a wider audience, the provision of embroidery kits enclosing small pieces of silk combined with thread enabled him to supply to the lower middle class, not just the very wealthy. The obvious channel for him was to exhibit the product, to glean public appraisal, and assess the viability of production; therefore he required embroiderers and his wife Elizabeth and her friends fulfilled this role, by providing sufficient embroideries to exhibit.

Elizabeth Wardle and the Formation of the Embroidery Society

Elizabeth's motives it will be argued were far more complex than her husband's, and that there existed a complexity of interrelated issues. Elizabeth's fourteenth child, (only nine survived to adulthood) was born in 1877, when she was aged 42. With a lifetime of bringing up so many children, the need to be needed must have been inculcated, yet there may

[387] Roy Church, 'New perspectives', p.430

possibly have existed within her the necessity for some life of her own, which to a great extent she obviously found in her embroidery. She had been embroidering ecclesiastical work for some twelve years, much of which was stitched in traditional eighteenth and nineteenth century style, where a group of women sat embroidering and chatting together.[388] This traditional method provided them with feminine space, a chance to catch up on gossip as well as employing what would otherwise be idle hands. Thomas' growing commitments and his many activities added to the fact he was a workaholic, would indicate that he was increasingly away from home.

Thomas moved within aesthetic circles, though he was not a bohemian. Rather he appears in every sense the businessman and a suitable candidate for Carlyle's Captain of Industry designation. He socialised with eminent members of society and most of his friends appeared to be of like minds in their social awareness and paternalistic attitude to their employees. Wardle was a fair employer and tried to improve conditions for his employees. He probably discussed these attitudes with Elizabeth but most certainly encouraged her in her philanthropic ventures. The couple had since their marriage been leading lights in Leek society, donating many gifts to the church. Therefore, the notion of an embroidery school would have appealed to Wardle's paternalism and would provide suitable employment for daughters of his workers.

Marguerite Dupree comments on the fact that in the nineteenth century the factory owner's authority extended from the factory into the neighbourhood. Hierarchy within the factory was replicated within the neighbourhood, the factory thereby becoming the nucleus of social life, as well as a centre of production. The development of 'deference and employer paternalism' she states was the social relationship which converted power relationships into moral ones, by ensuring a hierarchy.[389] It will later be shown that the school operated as a business and yet the Wardles purported at the time that it was a philanthropic venture. As such, Elizabeth was colluding with her husband's notion of hegemony. It gained and maintained a reputation for Elizabeth as a respectable matriarchal citizen of Leek, establishing a leading role within that society on par with her husbands. Stana Nenadic however argues that in the nineteenth century, business owners were expected to 'observe certain conventions of behaviour whereby the public integrity of the firm was built on the public integrity of the family.'[390]

[388] Jacques, *Leek Embroidery*, p.8

[389] Maguerite Dupree 'Firm, Family and Community' in *Industry and Business* p. 54

[390] Stana Nenadic, 'The Small Family Firm in Victorian Britain' in *Business History* Vol. 35 no.4, p. 86

Benevolent and philanthropic ventures deployed by Elizabeth are recorded in her memoriam reprinted from the *Leek Post*, 13 September, 1902. Elizabeth was secretary of the Church Missionary Society, President of the Ministering Children's League, and raised funds for the support of wives and families of soldiers at the front. She was President of the Local Fund for the Soldiers and Sailors Families Association, which came to fore at the outbreak of the Boer War in 1899, for which she raised £942 which was distributed among 31 wives and 16 members in Leek, and 10 wives and mothers in the outlying district. It was stated, that the church and institutions in Leek had never had a more 'zealous advocate helper' than Lady Wardle. It was recorded she had a 'broad-minded disposition, and an abhorrence of narrowed ideas in public life, [which] allowed her to support all movements of a general and philanthropic character.' Lady Wardle was also a member of the Technical Instruction Committee. The memorial records that her work with the art of silk embroidery became famous throughout England and the continent adding that she was a clever designer and colourist of embroidery.

Elizabeth advised Empress Frederick of Germany, from whom she received a framed portrait in recognition of her assistance, corresponded with royalty and was favoured with a visit from the Princess of Wales whilst opening the Technical Institute at Leek.[391] It appears therefore that over the years Thomas' work in the silk industry and Elizabeth's with the Leek Embroidery Society and school elevated their social position. In the early days however it provided Elizabeth a role within Leek and a raison d'etre, for when Thomas asked her to experiment with the new silk floss, she was recovering from a complete breakdown following the birth of her fourteenth child, and apparently was unable to read or write.[392] Elizabeth made a rapid recovery and threw herself into this new venture, wholeheartedly, supported by the fact that one year later, she had organised sufficient work to exhibit. Elizabeth's connection with embroidery would have been typical of the era, initially a group of women stitching together, blossomed into religious fervour with the massive church building programme discussed in chapter two.

The church building throughout Britain between the 1840s and 1860's affected Leek and during this period four new churches were built and the old Parish Church of St. Edwards underwent renovation.[393] In 1863/4 Cheddleton church, near Leek, underwent a major alteration programme, designed by the great architect G.G. Scott, with windows by

[391] Nicholson Institute (hereafter, NI) Box C: Pamphlets and Correspondence Relating to Lady Wardle and the Leek Embroidery Society, several letters, from various royal households.

[392] DG. Stuart, *The History of the Leek Embroidery Society,*(Keele 1969). P.8

[393] Anne Jacques, *The Wardle Story* (Leek, 1996), p.55

William Morris, Burne-Jones and Ford Maddox Brown, and a triptych by MMF. Whether the Wardle's came into contact with some of the Pre-Raphaelites at that time remains uncertain, but certainly they did not meet Morris at this stage. The important factor regarding Cheddleton church is that it is the first record of Elizabeth's embroidery. She donated four alms bags and other family members donated sedilia cushions, all much acclaimed by the *Leek Times*.[394] At Meerbrook, in 1873, Elizabeth supervised around twenty ladies in the stitching of an altar cloth designed by the architect Norman Shaw.

At St. Luke's church in Leek, she managed a team of ten stitching architect Sedding's frontal and Superfrontal and at Ipstones several pieces by the architect Scott.[395] Elizabeth was therefore well accomplished to act under the directions of some of Britain's great architects, highly skilled in the art of needlework and well practised in supervision, therefore able to form a society to promote tusser silk, was a natural progression. The society initially stitched ecclesiastical wares but in order to promote silk to a wider audience, the society began producing domestic wares.

The Leek Embroidery Society and Marketing Concepts

The notion of an embroidery society came to Wardle at a time he was experiencing problems with new silk floss and requested his wife to embroider with the thread to discover whether more twist was required. Elizabeth found that by using long and short stitches, ground area could be covered quicker, without the thread snagging but more importantly shading was possible by gradations of colour rather than the stark contrast given by aniline dyes.[396] She had a superb eye for colour and the shading worked well with the new aesthetic colours Wardle was producing. Wardle realised the method was the perfect solution to hide the slubs in tusser silk and set about printing designs onto the silk, which the embroiderer could follow.

The tusser silk was woven in India, which Wardle printed with Indian designs, and due to its subtle colours of natural dyes it was ideally suited to aesthetic art needlework. Elizabeth had been stitching for some twelve years with a group of friends, mainly ecclesiastical pieces for local churches.[397] Therefore, Wardle had the ideal group at his disposal. Rather than pay embroiderers it must have occurred to him that if the women formed a society and exhibited work, the status of that work would be

[394] Ibid. p.56
[395] Ibid. p57
[396] Ibid. p.50
[397] Ibid. pp50-51

elevated. The Leek Embroidery Society was formed, with Elizabeth at the helm and the Leek annual prize giving of art classes in 1881 provided an ideal opportunity to promote the society. Fifteen of the new tusser silk embroideries were exhibited, consisting of a mantel border, a pocket-handkerchief bag, seven chairbacks, three curtain borders, three unfinished pieces and some studies in oriental designs.

To supplement the exhibition eighteen pieces of previous ecclesiastical work were included along with eight pieces sent from Morris's shop and forty-three pieces from the Royal School of Art Needlework,[398] proving from the outset valuable connections had been accomplished. The *piece de resistance* in Wardle's marketing strategy was to invite Sir Philip Cunliffe-Owen from the South Kensington Museum, now the Victoria and Albert museum (V&A), to award the prizes.[399] Wardle would have met Cunliffe-Owen due to his growing fame with natural dyes and sericulture and, in 1878, Wardle was invited by the Secretary of State for India to supply information for the development of sericulture; although his research was to take eight years to complete, his initial results were shown at the Paris International Exhibition that year.[400] Following the prize giving at Leek, Cunliffe-Owen wrote to Thomas providing the first record of Elizabeth's wishes for a permanent embroidery school:

> *considering the remarkable success which has attended the Leek School of Art Embroidery it has proved itself worthy of being permanently established as an institution ... to found the Leek School of Art Embroidery, to provide a suitable home for it, to have a foundation for the maintenance of the same, including the payment of a mistress, would be a great and good work. It would enable classes of females to attend schools of an evening; it would afford them the example of never having an idle moment and further would help to revive the great silk trade, and one branch of it, embroidery, which would respond to the growing taste for the same amongst all classes of society. I do not despair that you will find some noble-hearted citizen who will come forward with £5000 to found as a permanent establishment that which under Mrs Wardle's active and organising mind would become a model throughout the country. From Leek would*

[398] Ibid. p.51
[399] NI, Box C Lady Wardle box
[400] NI, Box A, Wardle, T. *Monograph of the Wilds Silks and Dye Stuffs of India, Illustrative of Specimens exhibited in the British India Section of the Paris Universal Exhibition of 1878*, London 1878

go out teachers for the numerous schools of art needlework and embroidery which would spring up throughout the United Kingdom.[401]

The Leek Embroidery School

The above letter raises an interesting issue, for it would appear the exhibition was held to promote the work of the Leek school as opposed to the Leek society. Debate arises as to whether the school and society were one and the same or whether they were separate entities. The debate is confused for as Anne Jacques states the terms were used indiscriminately, and in her opinion Elizabeth's friends who stitched ecclesiastical embroidery together formed the society, and it was a natural progression to form a school, whereby the experienced members helped instruct pupils.[402] Stuart states that the confusion arose with contemporary accounts, for the *Leek Times,* September 1881, records a forthcoming exhibition by the Leek school and later in November reports on the same exhibition attributing work to the society. Stuart argues that there were two separate bodies, whose membership overlapped, the society handling the commercial side of the business and made into a private company in 1885-1886 to produce the facsimile of the Bayeux Tapestry.[403]

Strengthening the argument that the society and school were separate entities is a photograph taken in 1888 in the Nicholson Institute, of Elizabeth and some of her pupils who appear to be very young and as such, would not have been sufficiently skilled to perform work of the quality suitable to be exhibited.[404] Several photographs, letters, magazine and newspaper records survive from which we can deduce the running and organisation of the Leek Embroidery Society and the Leek Embroidery School. *The Ladies Field* recorded the Leek Embroidery Society was open to commissions; the work 'executed chiefly by girls educated under the superintendence of Lady Wardle.'[405] In an article in *The Studio* Kineton Parkes reported on the work of the embroidery society, stating the society's 'own department the Leek School of Embroidery' was 'wholly occupied in producing examples of domestic and ecclesiastical embroidery.'[406]

Initially the members of the society worked from their own homes, but soon a property next to the Wardle's home was acquired, at 56 St.

[401] NI Box C: Lady Wardle box
[402] Anne Jacques, *Leek Embroidery* (Staffordshire, 1990) p.13
[403] Stuart, *The History of the Leek Embroidery Society*, p.6
[404] NI, Lady Wardle Box C.
[405] *The Ladies Field* October 1898 p.244
[406] Kineton Parkes, 'The Leek Embroidery Society' in *The Studio* Vol.1, 1893 p. 136

Edwards, which became a shop and workplace for the society and according to Kelly's *Trade Directory* the society employed a secretary, Nelly Lowe.[407] The shop sold items made by the society, kits, materials and silk threads and became a place where classes were taken.[408] Funding for a permanent school was never forthcoming but lessons continued from the shop and evening classes within local institutions. The girls were taught embroidery after which they were employed to perform simple work such as stitching a small portion of the embroidery kit, for the amateur to follow. Those who were talented might have been chosen to fill in background work whilst the more skilled may have been invited to join the society and have the honour of their work being exhibited. In other words, only the most experienced and talented were allowed to be members of the society and invited to exhibit work of the very highest standard, to promote the style of Leek.[409]

Embroidery schools were already opening with increasing rapidity throughout the United Kingdom, many of which would have been affiliated to the Royal School of Art Needlework (RSAN). Since the records of the RSAN have been lost, the number of schools affiliated to them remains unknown. No record exists as to whether they paid for their lessons but since affiliated to RSAN it is probable that the same system was deployed and that the girls paid a fee for their lessons and if employed after their training, would be paid according to their grade. This conclusion is drawn, due to evidence in a letter from Cunliffe-Owen to Elizabeth asking her to take a resident pupil, the terms being £3 per week for board and tuition, or £75 for six months.[410] Further, the society employed a professional embroiderer, Miss Bishop a cousin to Thomas, who was in financial need.[411] The Wardles thereby fitted the general trend discussed in chapter three, whereby almost every Victorian family had to look after family relatives forced to support themselves, and the Wardles were no exception.

The Leek Embroidery School as with the RSAN claimed philanthropic attitudes; an article in *Queen* magazine, 1885 stated that the Leek Society existed for the 'encouragement of embroidery and the development of it as an art for ladies whose time was not money to them and who did not expect to gain a livelihood by it'.[412] Yet the society deployed commercial aspects evident by the fact that it employed professional embroiderers paid according to the profit realised from the

[407] Kelly's *Directory of Staffordshire* (London, 1900) *p.232*

[408] Stuart, *The History of the Leek Embroidery Society*, p.9

[409] Jacques, *Leek Embroidery*,p.15

[410] NI Lady Wardle Box no. C.

[411] Jacques, *The Wardle Story*, p. 54

[412] NI, Lady Wardle Box no. C. cutting from *The Queen,1885* (no page number)

items sold. A further contradiction is found in an article in the *Queen* in 1885 which advertised a mail-order system whereby 'any lady writing to the society under the name of Mrs Wardle, Leek' would 'receive a small parcel containing samples of the embroidery and all information about the price of the materials and charges for work done.'[413] By the term non-profit making then we might assume that after the embroiderers were paid, the profits were ploughed back into the society, to purchase materials, and to employ more embroiderers. Though it was stated in Elizabeth's memoriam, after her death it was found that she had regularly,

> *devoted nearly half of the profits of the embroidery society to the assistance of many charitable institutions... and in some years ...her gifts in this direction had largely exceeded the profits of the society.*[414]

This practise was not unusual in the nineteenth century. For, as Alistair Owens observed, unlike the twenty first century, where the emphasis tends towards maximising profits, the small family firm in the nineteenth century was focussed on providing employment, expertise, self-sufficiency and power not for 'the avid pursuit of profit.'[415] As these were family firms, they could be altruistic, which was not possible when a firm was controlled by share holders.

Anne Jacques, a relative of the Wardles, produced a local history publication in which she stated that the known names of embroiderers and pupils of the society numbered around fifty, in 1885.[416] According to Jacques, Elizabeth also taught evening classes and taught friends' maids, who became outworkers when they married.[417] The outworkers had plenty of scope for selling their wares, for as mentioned earlier, there were several outlets. According to Kelly's there existed The Leek Embroidery Society shop, 56 St Edward's Street; Moorbank Art Depot, art needleworkers, 2a Market Place; (Mrs) Mary Bradwell, fancy repository, 17 Britannia Street; (Misses) Lydia & Gertrude Johnson, fancy repository, 9 Stanley Street; George Henry Oliver, fancy repository, 10 Stanley Street and (Mrs) John Stevenson, fancy repository, 19 Market Place.[418] To supply so many retail outlets suggests that many taught by the school and Elizabeth's evening classes went on to become outworkers. In addition to the Leek shop owned by the Wardles, Thomas needed to supply his shop in London, and Anne Jacques agrees it would

[413] Ibid.
[414] NI, Lady Wardle Box C
[415] Alistair Owens, 'Inheritance and the Life-Cycle of Family Firms in the Early Industrial Revolution' in *Business History* Vol.44 No. 1 p. 24
[416] Jacques, *The Wardle Story*, p.54
[417] Jacques, Ibid. p.53
[418] Kelly's *Trade Directory* pp. 229-234

have been impossible for the school and society to provide sufficient work without paid help.[419]

Conflicts-Commerce versus Art

Wardle decided in 1882 to open a shop at New Bond Street, London, which he asked his friend William Brough to manage. Brough was from a silk manufacturing company in Leek, J.J. Brough, Nicholson and Co. but no longer worked for the family firm. The shop consisted of eight departments to include: textiles, batiks, paper hangings, pottery, Delft and De Morgan tiles, furniture and a department for Leek embroidery. Wardle and Brough advertised the shop as 'Indian Art Drapers, Embroideries and Decorative Furnishers', and as with Morris & Co. embroidery was listed second, which exemplifies the importance of embroidery in the nineteenth century. To advertise the new shop, they drafted a letter to send to prospective customers, a popular method, described in the previous chapter and deployed by Morris & Co., which today would be termed as direct mail-out and target marketing. After describing the artistic fabrics, the letter informs,

> *We shall have associated with us the Leek Embroidery Society, which is now so widely known. The embroidery branch, under the superintendence of a lady of experience, we will, we are sure, be a great convenience to our lady customers.*[420]

The shop closed in 1888, due to poor management. Brough broke the agreement not to undersell Liberty, which caused bad relations, with Liberty threatening to withdraw a special order for which Wardle had built a dedicated plant, with specially ordered dye vats. Wardle had asked Brough to negotiate agencies in towns such as Bristol, Brighton, Clifton and Exeter, though Brough never carried out these instructions. The final cessation of the business seems to be caused by poor book-keeping, stock-control, and general miss-management, leading to a complete breakdown in the relationship between the former friends. Thomas was too busy with all his other work and Brough obviously had little interest in running a business.[421] After closure of the shop Wardle managed to set up an agency with Debenham & Freebody to sell Leek embroidery at Wigmore Street and at 7 St. George's Road, Glasgow in

[419] Jacques, *Leek Embroidery*,p.15
[420] Jacques, *The Wardle Story* pp.73-88
[421] Jacques, *The Wardle Story* p.73 -88

1882.[422] *The Glasgow Evening News*, in March 1892, reported that each month fresh patterns arrived, velveteens marked out with the pattern which were wonderfully easy to carry out, despite their 'effectiveness'.[423]

A search of museums reveals that relatively little Leek embroidery exists, which might seem surprising when they were supplying so many retail outlets. One of the main reasons for this is that the secular items were in the main household items which would wear out over time, there were however extant ecclesiastical embroideries in use at the time of writing, but an exhibition at All Saints Church in Leek visited by the author, attracted few. The reason for lack of visitors in the main has psychological reasoning. Secular embroideries are discussed in terms of beauty and art, but ecclesiastical works are difficult to appreciate due to the widespread lack of understanding of iconography. Furthermore, the general public might make a special point of visiting a museum to see William Morris embroidery, but the ecclesiastical embroidery is in the wrong place, the church. Objects in the church cannot be appropriated in the same way as a museum object, where they become fetishised symbols, representing 'the other', 'the past', 'the empire', but above all they are commodities which can be bought and sold. Not so, with ecclesiastical pieces, which belong to the church and not the state, stitched by women of the parish.

Secular embroideries, especially the larger finer exhibition pieces were designed by Wardle, his son Tom, Morris and several architects, all male. Exhibited pieces were attributed to the designer and the Leek Embroidery Society, the embroiderer therefore remaining unacknowledged. Exhibiting under a collective name, such as the Leek Embroidery Society, psychologically diminished the importance of the work, for it is, in the mind, no longer a work of art. The dominant ideology within the production of art is that the artist has freedom, an ability to create without responsibility and we idealise the angst of the artist. Until recently, that ideology cannot be fulfilled if given the notion of a group of women stitching together. As well as the kits sold, women could buy Leek silks and stitch their own designs in the Leek style, yet it would never be classified as art for as Cheryl Buckley states the designs produced by women were used by the family in the home rather than for profit within the capitalist marketplace. 'At this point capitalism and patriarchy interact to devalue this type of design; essentially, it has been made in the wrong place - the home, and for the wrong market - the family'.[424]

[422] NI, Lady Wardle Box C, cutting form *The Lady*,7 February, 1888 (no page number)

[423] NI, Lady Wardle Box C, cutting from *Glasgow Evening News, March*,1892 (no page number)

[424] Cheryl Buckley, ' Made in Patriarchy :Toward a Feminist Analysis of Women and Design' in Margolin, V. (ed) *Design Discourse* (Chicago, 1989) p.253

Similarly the method of production at the embroidery school prevented the girls from producing art. Braverman tells us that certain concepts of control had been essential features of management, these being:

> *the gathering together of the workers in a workshop and the dictation of the length of the working day; the supervision of workers to ensure diligent, intense, or uninterrupted application; the enforcement of rules against distraction (talking, smoking, leaving the workplace, etc.) that were thought to interfere with application; the setting of production minimums; etc[425].*

Such were the conditions in Victorian schools. At the Leek embroidery school, the embroiderers had no freedom of expression, for in order to produce a brand image the embroiderers were told which stitches and colours to use.

Elizabeth's motives for running the society and the school it has been argued were initially to support her husband's endeavours to promote silk. She did not have any inclination to maintain the 'brand' look, unlike May Morris and Henry Dearle who kept the 'Morrision' look so alive, that only relatively recently have experts begun to recognise the different designers. When the society exhibited at the Arts and Crafts Exhibition in 1893, Kineton Parkes made very different remarks to those made the previous year and denigrated the work of Leek and the Royal School, by merely stating they were reproductions, but eulogised at great lengths about the work of Morris & Co. and individual embroiderers.[426]

We have further acknowledgement of Elizabeth's failing interest in the Leek 'branded look', for in 1885 she along with friends began stitching a replica of the Bayeaux tapestry now housed in the Reading Museum. This was a massive undertaking being 230 feet in length and stitched by 35 women, most of whom were friends rather than the embroidery school. Furthermore, the friends were domiciled throughout Britain and therefore each section was stitched independently. [427] Further evidence of Elizabeth's waning interest is her failure to cease the opportunity to obtain a permanent school of embroidery, within the educational facilities provided at Leek.

The Nicholson Institute opened in 1884 to house the library, art gallery, museum and lecture theatre. It was also home to the School of Art and in 1889 the Technical and Science Department was opened at a cost of £10,000 and received annual grants from the Science and Art

[425] H. Braverman, 'Labour and Monopoly' in *Monthly Review Press* p.90

[426] Kineton Parkes, 'The Arts and Crafts Exhibition, 1893' in *The Studio* Vol. 2 1894 pp.10 -27

[427] Stuart, *The History of the Leek Embroidery Society* p.13

Department, South Kensington.[428] Since both Thomas and Elizabeth were on the technical and science committee and considering Thomas had lectured on several occasions that design training was essential in reviving the silk industry this was the ideal opportunity to change the course of history. The embroidery school they had supposedly longed for could have had the ideal home.

They were supposedly by this time entrenched not only in other matters but also in their respective paternalistic and matriarchal roles. After Elizabeth's death in 1902 the society seems to have dwindled away, though Lydia, her daughter and a Mrs Clara Bill kept the society going for some years with commissions for ecclesiastical work still arriving. They eventually sold the shop in 1930, which continued to sell embroidery materials until WWII.[429] With such longevity and considering the society and school received such acclaim it seems surprising that Elizabeth never realised her proposal for a school with firm foundations based on her knowledge of the Royal School of Art Needlework.

The Royal School of Art Needlework and its Association with Other Schools

The Royal School of Art Needlework (RSAN) was established in 1872 as a philanthropic venture for the tuition and employment of 'necessitous gentlewomen'. The altruistic aims were extended to their associated printer, The Ladies Printing Press. Its objective was to restore 'ornamental needlework to the high place it once held among the decorative arts, and to supply suitable employment for poor gentlewomen'.[430] Two documents survive from the period, one a book written by the president, Lady Marion Alford on embroidery, but more importantly the president's report of 1875, from which it is possible to glean a great deal about the organisation and working methods deployed by the school.

The Organising Committee comprised of HRH Princess Louise, The Marchioness of Lorne, the Hon. Mrs. Percy Wyndham, and Lady Marion Alford. The report states that 403 orders had been received in the previous year for completed work and 1,065 orders in the prepared work department.[431] At the beginning of 1875, the school employed 88 workers and 12 staff. That figure had increased to 110 workers and 20 staff, by the end of the year. The workers were divided into departments

[428] Kelly's *Trade Directory* 1900 p.223
[429] Jacques, *Leek Embroidery*, p.45
[430] D. Blum 'Ecclesiastical Embroidery' pp.16-21
[431] NAL. Pressmark 43.A.2 (J) *Vice Presidents Report*

with a Head of Department and a forewoman or assistant to each. There were six departments: a general workroom, the prepared work department, a department for pricking and pouncing designs to be worked, a department for appliqué and goldwork, the upholstery department and the Artistic Room which stitched designs by artists and designers such as William Morris, Walter Crane and others. The wage system was divided into four tiers, decided by how many inches could be worked within an hour, without rushing. First class work was valued at 10d per hour, second at 9d, third at 7.5d and fourth class at 6d.

This scale of diminishing merit, Lady Alford thought, was fairly adjusted as each embroiderer had hope of moving to the next class. She regretted more could not be paid to each as few workers resided near to the school and, therefore, locomotion, omnibus or rail swallowed a significant part of their hard earned gains. Lady Alford was however pleased to announce that the working day was to be reduced from eight hours to seven.[432]

The women and girls employed had to fulfill certain criteria, and these 'were poverty, gentlebirth and sufficient capacity to enable them to support themselves, as well as to be sufficiently educated to teach others.' However the school was not entirely philanthropic; each learner paid £5 for 9 lessons of 5 hours and when qualified took her place within the workrooms for 7 hours a day.[433] In other words, this area of endeavour was not for the desperately needy, but for those of 'gentlebirth' who had fallen upon hard times and needed to earn subsistence. The RSAN advertised embroidery lessons given to amateurs in their own home at a cost of 10s 6d. for one hour or 15s 6d. for two hours, plus expenses, however if detained beyond the arranged time an extra 2s 6d. for each additional quarter hour. Two pupils could be taught together, and for every pupil beyond that half the amount was charged.[434] Embroideries from the RSAN were criticised for being too expensive, to which Lady Alford responded, that,

> *it must be remembered that the enterprise is not merely commercial. It is also avowedly, if not primarily, one of social beneficence. The prices are, in fact, carefully fixed on the lowest scale which experience shows to be compatible with the maintenance of the institution.*

Lady Alford admitted that the school could be undersold by other establishments and its prosperity depended upon the sympathy which

[432] Ibid
[433] Callen *Angel in the Studio,* p.98 and in Parker *Subversive Stitch* p.99
[434] NAL. 43.A.2 (J) Vice Presidents Report

could be 'awakened among the purchasing classes'. As Callen states this patronising attitude implied that even when practising a profession, women had to be given tolerant charitable assistance. [435]

The RSAN utilised over 100 designs by Burne-Jones, Morris, Lord Leighton and Walter Crane, stitching pictures, screens and upholstery and in great contrast many accessories such as: tennis aprons, folding screens, kettledrum doyleys, photograph frames, bellows, opera cloaks, piano panels, babies head flannels, and knitting pockets.[436] Designer's services were employed as the school taught only the practical side, not design, a major criticism of the school which was not rectified until the turn of the century, when Mr Paul Townsend was appointed to give two evening classes per week, of two and three quarter hours each and a Miss Parsons took two others. Townsend, because of his sex and reputation, received £1 1s; whilst Parsons received 5s for the same work. In 1908 she was rewarded with a pay rise for being an excellent teacher receiving 7s 6d per attendance.[437]

A report, 'Furniture and Decoration at the RSAN' in *The Artist*, of 1884, commented that RSAN maintained its reputation 'despite caprices and the fickleness of fashion'. A high standard was observed in both design and thoroughness of fashion, with a new room for furniture annexed to the school, both open to the public.[438] This same report offers one piece of valuable information, that the RSAN had by 1884, branches throughout the country.[439] Writers on the history of embroidery seem reluctant to acknowledge that the RSAN had branches throughout Britain, claiming little evidence exists, whereas this thesis opposes that viewpoint. The surviving documents on the Leek embroidery school include a label or book plate with the inscription 'Leek Embroidery Society. Branch of the Royal School of Needlework, South Kensington. Mrs T. Wardle, Honorary Superintendent'.[440] The RSAN had several branches in the provinces mostly established in department stores and, according to Barbara Morris by 1880 there was a school in Glasgow, agencies in Liverpool, Manchester, Leeds, Norwich, Birmingham and Newcastle.[441]

The Furniture Gazette, August 1880 reports that Messrs. Bragg & Co. of Pilgrim Street had 3 rooms filled with work from RSAN. Other showrooms were devoted to ancient and modern oriental embroideries from Turkey, Persia, Cyprus, Bulgaria, Greece and other eastern

[435] Callen, *Angel in the Studio*, p.102

[436] Synge, *Antique Needlework*, p147

[437] Callen, *Angel in the Studio*, p.102

[438] 'Furniture and Decoration at the Royal School of Needlework.' in *The Artist, journal of home culture,*(London, 1884) p.89

[439] Ibid. p.89

[440] Jacques, *Leek Embroidery*, p.31

[441] Morris *Victorian Embroidery*, p116

countries. A teacher from the school was sent to give lessons at Braggs, and the whole enterprise, the report continued was under the patronage of eminent ladies, Duchess of Northumberland, Countess of Ravensworth, The Countess Percy, Lady Ridley and Mrs. Albert Grey.[442] Reluctance to acknowledge that the schools were all affiliated is because there is little evidence to support whether the groups had any financial links, or simply united with a common aim. Yet evidence to support this claim for affiliation, can be deduced from The Ladies Work Society and the Decorative Art Needlework Society established c.1875. Both societies were affiliated to the RSAN, not as schools but as commercial societies which sold embroidery from which they deducted a commission.[443] The Ladies Work Society was affiliated to the RSAN, to provide an outlet for those trained at the school, yet not securing a position within and for those that left the school upon marriage.

Embroideries were worked at home; each embroiderer could submit twelve articles for sale. Commission taken was high, being 2 ½ d. per shilling nearly twenty-five percent. The Decorative Art Needlework Society did give lessons to amateurs, and was known for restoring and copying antique needlework. The *Magazine of Art*, 1880 reported that the President of RSAN had extended her patronage to The Decorative Art Needlework Society, 'and in this sense the society may be regarded as linked to the parent school at South Kensington'. However, the magazine points out each society was distinct from an administrative viewpoint, any connection was found in the 'common cause which all the Art Needlework Schools have at heart.' Furthermore, the 1883 register of the Decorative Society stated that it was established by ladies who had held leading positions with RSAN.[444]

The success of the school even extended abroad, where an agency was set up in the Museum of Fine Arts, Boston. Teachers were sent from RSAN to provide tuition which cost $5 for six lessons, $8 for twelve, and private lessons for $2 per hour. The classes met regularly Tuesdays and Fridays, with a special session on Wednesdays for those who only attended once a week. A large exhibition was held to inaugurate the opening with ancient Middle Eastern embroideries and according to *The Furniture Gazette,1880*, three rooms of modern work from RSAN.[445] The school also mounted a display at the Philadelphia exhibition 1876 at a cost of £2000. As Ewles states they were well rewarded as it engendered many prospective customers. It led, indirectly to the formation of the Decorative Art Society in New York, whose founders

[442] Ibid. p117
[443] Callen, *Angel in the Studio*, p.110
[444] Ibid. p.110
[445] Ibid p.115

included Louis Tiffany (1848-1933) and the embroiderer Candace Wheeler (1828-1923) to be discussed further in chapter seven. The RSAN soon had agencies in Philadelphia and Boston and teachers were sent out from England to instruct in the art of 'Kensington Embroidery.'[446]

The RSAN was still in operation at the time of writing, mainly copyists of old designs and repairers of antique embroidery. The school failed in teaching design to any great extent, relying too heavily upon the input from great designers such as Morris and Crane. They failed to meet the challenge posed by Pugin to create design schools, to train women in the art of design. This is a criticism not only of the school, but one which can be equally applicable to Morris and Crane, each of whom had wives and daughters who were sufficiently educated to be trained in the art. Yet schools of design were established following the Ewart Committee Report of 1835 to discover Britain's lack of commercial success with foreign rivals, which concluded that poor manufacturing and design standards were major contributing factors. The Manchester School of Art and Design opened, for males, in 1838 in the basement of The Royal Manchester Institution, the present City Art Gallery. The education for women came about in response to growing social problems of widowed and unmarried middle class females for whom work was a financial necessity.

A school for women was opened in 1842, to teach drawing and painting, in the hope that they would achieve better prospects than offered by the many charitable organisations producing embroidery in sweatshops. By 1844, the school offered classes for females in ornamental art, and it was not until 1872 that the embroidery department was officially opened, though Bell believes that embroidery may have begun some time previously. Ada S. Davies was appointed as a visiting lecturer and she specialised in ecclesiastical embroidery and was employed as an embroiderer at the outfitters Browns.[447] In an article entitled 'Art Work for Women' in *Art Journal,* 1872, it was reported that teaching was 'universally admitted to be woman's special work' that it was 'natural' to expect women to teach drawing, painting and music.[448] Of the one hundred and seventeen art schools in Britain with 20,133 pupils enrolled, only three schools were superintended by women, out of three hundred and thirty-eight art classes with an attendance of 10,000 only five had women teachers.[449]

[446] Ewles, 'Embroidery' p.76

[447] Carol Bell, *The Manchester School of Embroidery* (Manchester, 1988) pp.2-19

[448] 'Art Work for Women' in *Art Journal* (London, 1872) p.65

[449] Ibid p65

The main reason, *Art Journal* commented, was for want of training,[450] with three million women compelled to work, *Art Journal* recommended they would be happier and more useful if trained. Women, the journal reported out numbered men by 1 million and three out of six million women were required to support themselves and relatives dependent upon them. [451] In another article in the same issue of *Art Journal*, J.Stewart argued on the difficulties of employment for women. The design schools, were 'under the delusion' of producing designers, those that went into industry, thought they were underpaid until they realised they were not special. It was in Stewart's opinion a question of supply and demand and too many ill qualified were entering the profession. Most women found employment not as workers but as teachers and authorities in art and Stewart argued the majority of women entering design schools failed, tarnishing the reputation of the school.[452] It was not only the design schools which failed women, but also the department stores, due to the need to mass produce a hand-made product.

An insight into the lives of embroiderers is shown in the records of Liberty department store indicating that the embroidery department operated on Adam Smith's principles of 'division of labour'. Barbara Morris reported on Mrs Sparks (b.1884) who worked for Liberty from 1897 to 1910. At the age of thirteen she sat an exam which enabled her to apply for the job. She worked from 8.30am-7.00pm Monday to Friday and 8.30-1.00pm Saturdays for 2s 6d per week, rising to 4s after one year. In the latter part of her career she was sent to visit country houses to measure and fit gowns. She reported that there were five fitters per room where she worked, twenty girls to each table, one table for sleeves, one for bodices, one for skirts etc. Much hand sewing was involved on frilled and ruched taffeta and by the time she left in 1910 her salary was 1 guinea.[453] Another employee was a Miss Amy Kotze who at age twenty-three in 1907 earned 15s. p.w. working from 8.30–6.00pm drawing designs for embroidery, on trains of dresses and starting work for embroiderers to follow. When she finally left Liberty's she made a dress for Mrs Pankhurst and set up on her own as a dressmaker.[454] Another Liberty employee described the embroidery department;

As well as the head lady, there were seven embroidery hands, four junior hands and five apprentices in our workroom. Each apprentice was put to work beside a hand.

[450] Ibid.p.102
[451] Ibid. p.103
[452] J.Stewart 'Art Decoration, a suitable employment for women' in *Art Journal* (London, 1860) pp.70-71
[453] Barbara Morris, *Liberty Design* New Jersey 1989 p.54
[454] Ibid. pp.54-55

Too much talking was discouraged We young people made twisted and plated cords, covered small buttons and embroidered larger ones, made tassels and embroidered collars and cuffs. The materials we handled were beautiful. Mostly silk, crepe de Chine, and Liberty's own 'Tyrian' silk, plain or patterned.[455]

The need to mass produce in order to supply demand encouraged working methods akin to Adam Smith's (1776) pin manufacture, whereby, with division of labour, more items could be manufactured than could be produced by one person.[456] Having discussed how department stores overcame the difficulties of mass producing hand-made items, it needs to be examined why department stores engaged with a handmade product. In the age of mechanisation, and mass consumption the alternatives they utilised to supply demand which they themselves created, requires investigation.

[455] Watt, Judith Costume in Calloway, Stephen *Liberty of London, Masters of Style and Decoration*, London, 1992 p.150
[456] Adam Smith, *Wealth of Nations*, (Oxford, 1998) pp.12-13

CHAPTER 6
Selling The Orient: Department Stores and the
Rise of Liberty

Liberty is unique and is positioned at the forefront of cutting edge fashion. It is still innovative, still seeking and collaborating with the best designers of today. Liberty celebrates originality and embraces a spirit of creativity. The ethos of Arthur Liberty still applies, Liberty continues to immerse and feed the senses while engaging imagination.[457]

The department store Liberty was the leading protagonist of selling eastern embroidery, specialising in Indian and Japanese embroideries, sending buyers around Europe searching for new and exiting work and setting up philanthropic embroidery workshops in Constantinople and Greece. The East gave a *raison d'être* for Liberty department store and therefore it is imperative to this chapter, whilst examining the marketing practises of Liberty, to investigate the ideology of imperialism and its fetishised images. Said's notion of the West creating ideologies of the exotic East, the constructed belief of 'the other' will be compared to the two way process which occurred with the growth of commodification.

The East had since the beginning of trading routes played a central role in influencing design changes. With the significant resurgence of interest in Far Eastern manufactures, the East began producing merchandise which was believed to be nineteenth century Victorian taste. However, they were producing goods to suit the eclectic style in bright gaudy colours, the very style artists, designers and aesthetes deplored. Eastern standards deteriorated in order to supply the mass market with cheaply produced goods hence store owners such as Liberty were increasingly forced to forage for innovative products to entice the middleclass bourgeois customer. During the 1870's the attention given to arts and crafts of the East dominated the arts scene in Britain, reaching almost fever pitch proportions with the aesthetic shopper. By 1882 for example Lucy Crane (1842-1882) sister of artist and illustrator Walter Crane (1845-1915) proclaimed there could be few houses without some specimen of Oriental embroidery, whether Indian or Japanese,[458] indeed the interest extended beyond embroidery from interior decor, furniture and ceramics to shawls and fans. The foundations for this popularity lay in the semiology of Oriental embroidery as fetishised sex, an argument which will be supported by Said's theories and by examining the writings of Emile Zola (1840-1902) who studied department stores and shopping.

[457] WWW.liberty.co.uk/store_info/history.asp
[458] Lucy Crane *Art the Formation of Taste* p. 149

Liberty's shop in Regent Street opened in 1875, and it is interesting to note that of the seven departments advertised, embroidery was listed second after silks, followed by furniture, carpets, porcelain, curios and miscellaneous.[459] Liberty created its own brand look setting the style, rather than following trends, tempting the senses by creating an ethos of exoticism and sensuality associated with the orient. Over 125 years later, that image which Liberty created still exists and the oriental room continues to supply embroidered hangings, furnishings and accessories. Liberty manufactures of the nineteenth century are now highly collectable particularly, silverware designed by Archibald Knox, which command high prices in the auction houses. Liberty mounted embroidery exhibitions on a grand scale, supplied kits and materials by mail order and ran his own embroidery school, which made items for sale or by commission.

Other department stores quickly followed suit, though some such as Debenham and Freebody chose to sell English antique embroideries to gain a sector of the market. This chapter will examine the business practise of Liberty, its advertising and marketing policies, which in the main were carried out through holding publicised exhibitions instore. Each exhibition was focussed on specific ranges of goods, for example dress, Christmas gifts, textiles or furnishings and each exhibition, had an accompanying catalogue. Embroidery exhibitions were frequently held and by examining the catalogues of those exhibitions, the quantity of embroidery sold will become obvious to the reader. From the outset Liberty employed top designers but it will be argued that the foundations of Liberty's success lay in its originality. The store was at the cutting edge of fashion, it fed the senses with imagination. Liberty created the atmosphere, the excitement and sensuality of the Oriental bazaar within the store, therefore the cultural dimensions, especially those of a political nature require assessment for they were utilised as a successful marketing strategy by Liberty.

Commodity Fetishisms and Bi-Lateral Trading Routes

Said argued, when embourgoisement in the nineteenth century led to sex being institutionalised, authors such as Flaubert (1821-1880) were able to cultivate the notion of harems, veils and dancing girls with licentious sex, daydreams to relieve his bored bourgeois characters. Said suggested that for Flaubert the Orient was a place with 'sexual promise, untiring sensuality and unlimited desire.'[460] Said constructed the notion of the Occident versus 'the other', the Orient through a study of these

[459] Alison Adburgham, *Liberty - A Biography of a Shop*.(London, 1975) p.42
[460] Edward Said, 'On Flaubert' in A.L. Macfie (ed) *Orientalism, a reader* (Edinburgh, 2000) p.109

nineteenth-century literary texts. Such a construct implies superiority of the West over the Orient and, for Said, the Occident created the Orient in order to hold authority over it.[461] Said's argument suggests that Oriental wares carried fetishised notions, so that by purchasing oriental embroidery for the home the bourgeois housewife, as with Flaubert's characters was adding the spice of the harem into the home. Arthur Lasenby Liberty (1843-1917) articulated such sentiments through the layout of the store, the merchandise sold and his marketing concepts all indicating that he understood the psychological marketing concepts and principles required in order to entice and captivate his audience. The embroidery catalogues produced by Liberty were not illustrated, yet portrayed the exoticism of the Orient or as Ross states 'Traces of the colonial narrative are ... perceptible in the Orientalist fantasy and the whole eroticised display of Asian products'.[462]

Stuart Hall agrees with this concept of commodity fetishism, but he argues that it had more to do with imperialism. He argues that as commodities and images of English domestic life flowed to the colonies, the raw materials and images of 'the civilising mission in progress' were bought into the home.[463] Hall raises an interesting argument, for this ideology is utilised in advertising for the department store Liberty, where according to the catalogue for embroidery, purchases would be helping the needy in Constantinople[464] an issue supported by empirical evidence later in the chapter. John Mackenzie raises the argument, that 'when regard for eastern arts is viewed in its entirety, its relationship with imperial power becomes less a matter of Said's 'flexible positional superiority' and more a reflection of Victorian doubt and apprehension 'suffused with a yearning for transcultural inspiration.'[465] This latter argument sits well with the idea that eastern influences were popular, due to a nostalgic need to look towards the past and great civilisations, an issue which was discussed in chapter two. So, if Lucy Crane was correct and every middleclass home had eastern embroidery, it begs the question, was it bought for fetishised sex, was it Hall's philanthropic imperialistic benevolence or Mackenzie's apprehension and yearning? In order to examine these possibilities there is a need to do as Mackenzie suggested and examine the influence of eastern art in its entirety.

Trading with the east occurred during the medieval period, knowledge of techniques in glass, metallurgy and ceramic production

[461] Edward Said, *Orientalism, Western Conceptions of the Orient* (London 2003) p.3

[462] Ross introduction in Zola *The Ladies Paradise* p. xiv

[463] Stuart Hall, 'The Spectacle of the Other' in Stuart Hall (ed) *Representation: cultural representations and signifying practices* (London, 1997) p.240

[464] NAL pressmark LIB 8 *Eastern Art and Other Embroideries* p.4

[465] Mackenzie, *Orientalism*, p.133

having been bought many centuries before by the Romans into Britain. The seventeenth-century European religious wars brought about the Huguenots migration to Britain which developed production and manufacturing knowledge. With the advent of The East India Company in the seventeenth century and the slave trade multi-lateral trading began with a vengeance. By the eighteenth century, the importation of tea, coffee, chocolate and tobacco, encouraged new products, afternoon tea, coffee houses, and entertaining changed the British way of life. Chinese porcelain tea services were imported to accompany tea, both totally new commodities in eighteenth-century Britain. The impact of such new consumer products eventually changed the culture of Britain, the partaking of afternoon tea encouraged a new type of visiting and the need for the home to appear welcoming. The advent of rooms set aside for visitors came at the same time as imports of Chinese hand painted wallpapers and silks in Chinoiserie style.

The rococo or chinoiserie style was utilised for interior design, adopted by Chippendale for his furniture and by Spitalfields for textiles. Though fashion trends changed to the neo-classical style, in the 1780's it was relatively short lived and rococo and chinoiserie were revived in the Victorian period, absorbed within eclecticism. The eclectic style merged every and any design together, not only within the room but two or three characteristics of various periods might be incorporated within a piece of furniture, thus a room might contain elements of Tudor, baroque, rococo and neoclassicism. This eclecticism was the very style that the Arts and Crafts movement rejected.

By the nineteenth century Britain was the greatest empire ever, the largest trading nation, colonising 25% of the world's landmass and exporting 40% of its manufactures, but all this was to change. By the late nineteenth century, with economic competition from America and Germany and loss of Britain's industrial lead, politicians looked towards economic revival through free trade. It became imperative for Britain to trade with the continent, especially India, the jewel in Britain's crown. India was a prime target, particularly in the field of textiles, as discussed in chapter two, and with this aim, allegiances with India were strengthened by Disraeli's positioning Queen Victoria as Empress of India in 1876. The two way trade that operated between the East and the West, though commercially viable, introduced goods of poor quality. In the nineteenth century in order to profit from Britain, India and China began exporting cheap manufactures of gaudy colours loved by the Victorians. These commodities Walter Crane argued were 'consciously prepared for the European market.'[466] So it was of particular importance

[466] Walter Crane *The Claims of Decorative Art* p.137

that the opening of Japan occurred in the 1850's, at an opportune time in Britain's commercial climate. This period coincided with the opening of trade routes at a time of intensified trade and improved shipping technology.

Japan provided opportunities to entrepreneurs such as Arthur Lazenby Liberty (1843-1886) who founded the department store, Liberty, but more importantly Japonisme gave rise to ideologies and design changes which augmented Britain and the western world's modernisation. There was a paradoxical and dual process of modernisation, for Europe, with enhanced simplicity of design, and the forerunner to postmodernism, and for Japan it meant the opening of a new world, the genesis of industrialisation. More importantly, in the context of this thesis, art and commerce were to become inextricably linked.

Over two hundred years of isolation was broken when, following a revolution in 1868, Japan renewed contact with the Western world. The opening of Japan to trade gradually followed in the ensuing years, which provided Britain with export/import arrangements at a time when markets outside the British Empire were sought. To celebrate, an exhibition of Japanese art was held at Kensington Museum in 1854 from which Henry Cole, the museum's director recommended purchasing many of the Japanese works of art.[467] A limited commercial treaty was initially signed with Britain and America in 1858, and ten years later import restrictions were lifted, allowing Japanese goods to flood the European market. English homes and shops were already awash with oriental goods, from vases, rugs, furniture and cushions, especially from Persia, India and China, thus the new Japanese products were received with enormous excitement. The popularity of Japanese wares was endorsed by the art establishment which contributed to the craze for Japanese wares. Felix Braquemond (1833-1914) found artwork by Japanese artist, Hokusai, whilst unpacking some china, which happened to be wrapped in Hokusai's prints. In Japan some prints were not of value, and even used as packing material, but in France and England, the Japanese style as reflected in woodblock prints had a great impact on the Impressionist painters. In particular, the British artist James McNeil Whistler (1834-1903) was one of the greatest advocates of Japonisme, influenced by the impressionistic style of the Japanese prints, as illustrated in his paintings, particularly portraits of women.

Experimentation with Japanese art, but more importantly the inclusion of vases and kimonos within Whistler's paintings, the softer colours, encouraged the public's desire for anything oriental. Whistler was commissioned to paint many women in high society and in doing so,

[467]Adburgham, *Liberty - A Biography of a Shop* p. 13

as with artists since time immemorial, provided his props. The majority of his portraits of women used similar props; the women were dressed in loose fitting aesthetic dress, holding Japanese fans with Japanese vases placed at the side. His paintings became famous with the public, spreading the notion of Japonisme as a fashionable commodity. Whistler's popularity spread unfortunately not for his impressionistic style, for that kudos was attributed to the French impressionists, but more for the infamous liable court case with Ruskin. His impressionistic paintings of the Thames, Ruskin denounced as a pot of paint thrown at the canvas, Whistler counteracted and argued that it had taken him a lifetime to perfect the technique. The outcome of the libel case made history; Whistler won but had to pay court costs of half a pence. His fame was secured, his paintings well known and hence it could be deduced that his portraits of women with Japanese accessories promoted the market for Japanese wares. Whistler became one of the greatest exponents of Japanese impressionism and 'art for art's sake'. The artistic influence, pressurised the commercial market and Japanese warehouses sprung up around London, and stores opened oriental departments including, Liberty, William Whiteley's, Debenham & Freebody and Swan & Edgar. It is highly doubtful Whistler would have acknowledged his contribution to the commercial world, as Liberty who had struck up a friendship with Whistler whilst employed at Farmer & Rogers, during 1862-3 said of him,

> *Whistler, always pretended that he valued my critical judgement, and certainly we had feelings of sympathy on the Japanese Impressionist side of things ... but no man I suppose, was ever more independent of advice or less patient with it.*[468]

Lucy Crane discussing Japanese art proclaimed that Indian, Turkish, Cretan and Maltese embroideries were kindred in spirit and intention, never representing nature literally but changing, arranging, conventionalising.[469] But Japanese art, she remarked, was 'different in spirit and intention - wonderful force and life, like nature's own, the blossoming tree, poise and flight of birds, swirl of running water, as true as Indian but with different aims.'[470] Japan and its art inspired artists for as Marie Conte-Helm argued,

[468] Mervyn Levy, *Liberty Style, The Classic Years 1898-1910* (London 1986) p.21 and Adburgham, *Liberty - A Biography of a Shop*, p. 28
[469] Lucy Crane *Art the Formation of Taste* p. 150
[470] Ibid. p. 149

Japan seemed a mysterious and paradoxical place. The unspoilt beauty of the country likened to' fairyland' by so many authors. The image of Japanese woman-hood, small, fragile, gentle and ever-serving - complemented the physical attraction of the surroundings. Add this to universal aestheticism and love of nature affecting all levels of society and Japan seemed paradise itself.[471]

This notion of femininity or as Conte-Helm describes it 'Madame Butterfly-ness' contrasted well to Japan's warrior class the Samurai who adhered to a code of honour which was likened to the conduct and chivalry of Europe's medieval knights. The military elite from the twelfth century wielded great influence, commanding loyalty and respect from retainers and commoners.[472] So, not only did the art and design fit the ideologies of the time but they carried notions of the romantic, chivalrous past. Many other factors came into play, which changed the course of commercial history and none more so than the arrival of Japanese in London.

In the year 1872, *The Builder* announced the arrival of the Iwakura Mission, a Japanese delegation and their tour of Europe which included a visit to London.[473] This delegation included a group of Japanese leaders sent to examine Western technology with a view to adapting elements to their own product systems. The Iwakura Mission came to Britain to examine production methods in order to compete industrially. The mission proved a two way learning process. Kiri, the documenter recorded that both poverty and religion played major roles within industrialised communities, a recurring theme in this thesis. He records these inevitable dangers, as processes Japan would have to expect in order to advance.[474] Britain absorbed Japanese art, this was the moment for modernisation. Designers wanted to move forward not repeatedly look back to the past. They were enthralled by Japanese art, the abstraction of detail, they admired Japanese impressionism rather than realism, its simplicity and quality, effects we should not underestimate, for they were to be long lasting.

Japan's intention was not to Westernise, but to modernise. The Japanese government decided to choose the best model in each field of technology and administration, which would make Japan commercially competitive. The Japanese thought European industry was relatively

[471] Marie Conte-Helm *Japan and the North East of England, from 1862 to the present day* (London, 1989) p.53
[472] Ibid. p.1
[473] Ibid. p.130
[474] Ben Thorne *The Iwakura Mission in Britain 1872* http://sticerd.lse.ac.uk/dps/is/IS349.pdf p.1

more advanced, due to its division of labour, and in order to study this,[475] the delegation visited most cities in Britain.[476] In the nineteenth century this mission with over 100 delegates and an entourage of secretaries, and servants touring Britain's factories must have seemed rather strange to the factory worker and would have attracted a great deal of interest in the Japanese way of life. Even the wealthy found the experience intriguing. As Mackenzie proclaims, Oscar Wilde had thought that the whole of Japan was pure invention, and that the Japanese people were, 'simply a mode of style, an exquisite fancy of art'.[477]

The arrival of the Iwakura mission bought about commercial and industrial changes, a two way process: for Japan, commercialisation, and for Britain modernisation, in art and design which permeated through to socio-cultural changes. Whilst the image of Japan was transposed to Britain, designer Christopher Dresser (1834-1904) was transposing Japanese ideals into modern design. He was appointed by the British government, the first commissioned designer to pay a state visit to Japan in 1876-7 to view indigenous craft and design.[478] In his design book, Dresser encouraged students to 'study affinity and migration of races by ornament.' He traced how influences had spread from one part of the world to another, he traced characteristics from Central Asia in Persian art, Moorish in Spain, and Celtic designs he found in several countries.[479] As David Taylor argues, by comparing Greek anthemion and other leaf ornaments used in Japanese art Dresser 'contributed to remove the false hegemonic barriers between Western and Oriental art in general. He encouraged a more serious study of Japanese art, which in turn helped dethrone historicism and to modernise art in the West.'[480] Interestingly, there are other implications here, for if Dresser was trying to purge historicism from design, which meant Victorian eclecticism and representational images, by comparing Japanese with Greek, he was encouraging the ideology that Japan's roots lay with the Greeks as did the Europeans. In other words, ancestral connections legitimatised the relationship, a notion which will be returned to shortly as it was a key feature in Liberty's marketing concepts. Dresser's input into the commercial world has been under-played until the twenty-first century, when his input was finally acknowledged by a major exhibition and accompanying literature at the V&A museum. With hindsight his designs

[475] Conte-Helm *Japan and the North East of England*,p.14
[476] Akiko Ohta *The Iwakura Mission in Britain 1872* http://sticerd.lse.ac.uk/dps/is/IS349.pdf p.14
[477] Ohta *The Iwakura Mission in Britain 1872* http://sticerd.lse.ac.uk/dps/is/IS349.pdf p.328
[478] Paul Warwick Thompson, 'The Forward' in Michael Whiteway (ed) *Christopher Dresser - a design revolution* (London, 2004) p.7
[479] Christopher Dresser *Japan its Architecture,* pp.324-344
[480] Halén Dresser *Japan* pp. 127-128

were too progressive for the nineteenth century, his designs being comparable with those of the Bauhaus of the early twentieth century.

Nevertheless, Dresser made an impact on embroidery designs in the nineteenth century. He devoted a chapter on Japanese embroidery in *Japan, its Architecture, Art and Art Manufactures,* 1882 where he stated that embroidery was carried on as a manufacture and it seemed never to be practised by ladies as an accomplishment, and that as in Europe it was men that designed the pattern to be stitched.[481] This suggests that in principle there was the same division of hierarchy, men as designers, woman as executor, yet it implies that the creation of that work carried greater status. Embroidery was not deployed as a leisure pursuit, but was a mode of manufacture employing male and female staff.

Dresser described Japanese embroidery and the techniques used, commenting that the large number of banner squares arriving in Britain did not convey the full nature of Japanese embroidery. The Japanese, he informed his readers usually mixed embroidery techniques with weaving, dyeing and printing, effecting art characters, which as Dresser acknowledged did not occur in Britain.[482] Designers such as William Morris warned about trying to imitate Japanese art which he considered 'so disastrously common among us ... the Japanese are naturalists deft beyond all others in mere execution of whatever they take in hand.'[483] Due to designer, Dresser, artist Whistler, and the department store Liberty, Japonisme became firmly established in the world of art and commerce. The two disciplines became intertwined and with the assistance of the media such as, *The Builder,* Japonisme became the latest craze upon which retailers were the first to accommodate 'the band wagon' and Liberty department store was the most successful. Liberty catered for the aesthetes in society and their endorsement of his products, their very association, had a symbiotic effect.

An aid to Liberty's success was his association with Oscar Wilde as none entered the gossip arena more forcibly than Wilde. When Liberty was asked if he had any influence over Wilde, he replied, 'Indeed, yes. My art fabrics were produced before he became celebrated. I gave him his opportunity and he helped me mightily with mine, through the publicity he commanded.'[484] Wilde both overtly and covertly had an impact on Liberty, overtly due to his tour of English towns lecturing on 'The House Beautiful', the same year in which Liberty won a gold medal in Amsterdam for new furnishing fabrics.[485] Covertly, due to his fame,

[481] Dresser *Japan, its Architecture,* pp. 443-444
[482] Ibid. pp. 443-444
[483] William Morris, Textiles p.34
[484] Stephan Calloway, (ed) *Liberty of London, Masters of Style and Decoration* (London 1992) p40
[485] Ibid. p40

the mockery received in Punch magazine and the satirisation and caricature of his personality within the opera *Patience*. The songs from Gilbert and Sullivan's operettas trickled down to the music halls, giving advertising to the Liberty department store. Punch consistently satirised the aesthetes, their bohemian lifestyles, and their love of blue and white china, their dress codes and their manners. One directly, plate 6.1 addressed Liberty, entitled *Felicitous Quotation*,

> *Host (of Upper Tooting, showing new house to friend) "We're very proud of this room, Mrs Hominy. Our own little upholsterer did it up just as you see it and all our friends think it was LIBERTY!"*
> *Visitor (sotto voce). "OH, Liberty, Liberty, how many crimes are committed in thy name!"[486]*

The caption refers to the suburban, middle class, trying to emulate the bourgeoisie, whilst not recognising the minimalist order required, rather adhering to the earlier Victorian notion of clutter. Probably one of the best advertisements for Liberty came from Gilbert and Sullivan who commissioned all the costumes for Patience (1881) Iolanthe (1882) and Mikado (1885) to be made from Liberty's fabrics, in Liberty's workrooms. Nearly all the programmes for the operettas advertised Liberty Art fabrics, which led to commissions for dressing up parties and amateur dramatics.[487] The love of dressing up was fed by the notion of romanticism and a return to medieval chivalry, that which was lacking in reality could be reenacted for one evening and as discussed in chapter two such parties were popular with Queen Victoria and Albert and later generations of Victorians. Gilbert and Sullivan provided excellent source material for costumes, made by Liberty's dress department.[488] *The Mikado* and *Patience* gave satirical songs and those that had not seen the Iwakura, would hold an image of Japan, through stage productions. One particularly popular source for both costume and *Punch's* satirisation came from two popular verses from *The Colonel and Patience* by Gilbert and Sullivan:

> A Japanese young man
> A blue and white young man
> Francesca di Rimini, miminy piminy'
> Je-ne-sais-quoi young man!

[486] George du Maurier *Punch* October 20 1894 in Stephan Calloway, (ed) *Liberty of London, Masters of Style and Decoration* (London 1992) p.12
[487] Morris, *Liberty Design* p.50
[488] Calloway, *Liberty* p.38

A pallid and thin young man,
A haggard and lank young man,
A greenery-yallery, Grovesnor Gallery,
Foot-in –the-grave young man[489]

This particular section made direct comparison to the lively Japanese young man compared to the thin lank aesthete. Though these verses made particular reference to the aesthetes and their pallid complexions, the whole operetta directly satirised Oscar Wilde. Covertly the opera bought to the public's attention, bohemian lifestyles, Japonisme and blue and white china. Additionally, the reference to 'greenery-yallery' related to Liberty's Umritza Cashmere, described in *The Queen* as having 'tints of green that looked like curry.'[490] The title 'Greenery-Yallery' soon became attributed to a type of embroidery, which consisted of scraps of fabric, patch-worked together and embroidered over in a 'hotch-pot' manner, a style of embroidery quickly adopted by lazy hands. The publicity given to Liberty with his association with aesthetes such as Oscar Wilde and Gilbert and Sullivan were to prove beneficial in promoting his commercial image.

Building a Commercial Image: The Rise of Liberty

The oriental influence set a fashion which Arthur Lazenby Liberty exploited to develop his business. Liberty developed public relations with the rich and famous in society, which helped market the image of his company and the high quality goods which it sold. He devised marketing and strategy which reinforced notions of a brand image and achieved the attractiveness of his products in the market place. Liberty was an entrepreneur, who developed a highly successful business in the late nineteenth century. Though other manufacturers were creating brand names, Liberty was exceptional in that his brand image was for art objects.

In 1862, Liberty went to work for Farmer & Rogers, import merchants and retailers who specialised in importing woven and embroidered shawls from India and China. Farmer & Roger bought a substantial proportion of the Japanese collection at the International Exhibition of 1862 held in Kensington, London, which was used to create the Oriental Warehouse opened next door to their main premises.[491] The young Arthur Liberty, aged nineteen, was employed as a sales assistant,

[489] Adburgham, *Liberty's* 1975 p.
[490] Levy, *Liberty Style*, p.23
[491] Morris, *Liberty Design*, p.7

and within two years was promoted to manager of The Oriental Warehouse which was the most profitable side of the firm.[492] After ten years employment there, Liberty asked to be taken into partnership, which was declined.[493] Consequently, Liberty decided to open his own store, with financial help from his father-in-law, and support from the art fraternity. Consequently, Liberty rapidly became famous with the wealthy elite of London society, making his way in the world by networking and socialising in circles beneficial to his business. Liberty's success was partly due to the fact that by the time he decided to open his own store, in 1875, he was already well known in London society.[494]

During his ten years in The Oriental Warehouse Liberty served the artistic and bohemian society, the aesthetes of London. Networking had given him a regular clientele, which moved from Farmer & Rogers to Liberty's store. As it has already been demonstrated, Liberty's connections with Whistler and Wilde played a pivotal role with publicity gained and his rise to the upper echelons of society. Liberty was the place to see and be seen, a venue where architects, designers, artists, aesthetes and society figures met. Customers that frequented the store were the Pre-Raphaelite artists, Rossetti and Holman Hunt, painters such as Whistler, designers William Morris and Walter Crane and the infamous Oscar Wilde. Networking could not have initially been easy for Liberty, for as with many of the new department store owners and industrialists, such as Wardle, socially they found both their upbringing and education a handicap. Liberty like Wardle overcame his social disadvantage by self education through travel, studying the arts, music and literature. To establish his position in artistic circles he became a founder member of The Art Club in 1863, and bought Moray Lodge, Kensington, with grounds bordering Holland House, where his extravagant parties rivalled those given by Mrs Princeps, his neighbour and leading hostess in the art world.[495]

Though networking obviously gave a good start to the business, the store's popularity was only increased as Liberty demonstrated acumen for business and it was he, who was indispensable to some of the great designers and artists of this period. Creating a symbiotic marketing process ensured the designer and merchandiser were closely linked in the name of quality assurance. This innovating strategy deployed by Liberty in his branding technique, was to place the Liberty name, not the designer's name upon the goods, creating a focus for the customer. For example, Archibald Knox and Christopher Dresser would impress the

[492] Adburgham, *Liberty - A Biography of a Shop*, pp.12-13
[493] Ibid. p.17
[494] Ibid. p.42
[495] Calloway, *Liberty,* p27

name Liberty upon their metal wares and likewise the textiles designed by Wardle, bore not his name but the name of Liberty, woven into the selvedge. The designer or the originator of the designs were, and still are easily identifiable, in other words a tudric pewter vase or mirror might bare the name of Liberty, yet it would be well known to have originated from a design by Knox. Designers though famous within their own time were rarely named and their designs were often moderated or corrupted by the manufacturing departments. Liberty set the standard by employing some of Britain's leading designers. Archibald Knox, designed silver wares, Christopher Dresser, tea services, vases and glasswares and Charles Voysey and Walter Crane designed wallpaper and textile. The architect and designer Godwin was appointed as dress designer, but he also oversaw commissions for house interiors employing a house design team to organise work in progress. Godwin commissioned goods to suit ordinary rooms, yet harmonise with exotic goods, an Anglo-Oriental style in the aesthetic taste.[496] Having seen Wardle's silks exhibited in the British India Pavilion at the Paris Universal Exhibition in 1878, Liberty commissioned him to design and print fabrics.[497]

Liberty's talent to dictate fashion, and provide quality art works, created the demand from fashionable people for the 'Liberty look'. He was creating a brand image, supply came before demand and in a perpetuating circle, the ethos of the store created a command for the goods supplied. To keep the momentum, Liberty constantly sought new sources of art work particularly of oriental material to satisfy the demand he had created. He shaped an image synonymous with art and especially commercial art colours. One problem he faced was that the East had begun to use the stronger colours of aniline dyes, believing them to be popular with Western society. The East was catering for the West's love of bright, harsh colours, but not only were some Eastern fabrics too delicate for the dyes but, it opposed the new art colours that artists, designers and aesthetes sought. Adburgham's hagiographical account, argues that Liberty's development of 'art colour' was premised upon his ability to persuade English textile firms to use traditional eastern dying techniques.[498] The problem with hagiographical accounts is that there is a tendency to impart inflated characteristics. As shown in chapter five Wardle and Morris had been working on dyeing techniques between 1875 and 1877, and it was Wardle who was the expert, and to whom Liberty turned. Barbara Morris observed that Liberty looked to Wardle who was already dyeing textiles for Morris,[499] thus Liberty moulded his business

[496] Calloway, *Liberty of London*, pp.12-13
[497] NAL pressmark 77.1 *Liberty's, 1875-1975 : exhibition guide* (London 1975)
[498] Adburgham, *Liberty - A Biography of a Shop* p. 25
[499] Barbara Morris, *Liberty Design*, p.

knowledge with the technical and commercial knowledge of Wardle. Liberty used the expertise of Wardle and later that of Edmund Littler of Merton Abbey, Surrey. By the 1890's Liberty had taken the entire production of Littler's firm, which he finally purchased in 1904.[500]

The designs used by Wardle were Indian inspired and printed with soft muted colours pleasing to the Aesthetic eye, and always given Indian names such as Salangore, Allahabad Marigold, Tanjore Lotus and Poonah Thistle. Many of the textiles were woven so that borders lent themselves to embroidery. Influential to Liberty's vitality and success was the incorporation of design and sale of embroideries, of oriental influence.

Marketing Embroideries, the Occident and the Orient

From its inception in 1875, the department store Liberty continually embraced a passion for embroidery. Some of the first embroideries sold by the store were produced by The Leek Embroidery Society and utilised to advertise Wardle's silk threads as the 'new art colours.' Liberty soon created a demand, which could not initially be met by European production, and so he began sourcing Eastern embroideries, supplemented by European antique embroideries.[501] He sold modern and antique embroideries produced in both the eastern and western world, and Art Embroidery was to become synonymous with the company name Liberty from the commencement of the company.[502]

Arthur Lasenby Liberty opened his department store Liberty, in 1875[503] at the height of embroidery's popularity and he, like Wardle, had a vested interest in protecting and promoting the silk trade. He was friends of Morris and Wardle and sold Wardle's embroideries[504] and, sharing their ideals, eventually opened his own embroidery school. Unable to satisfy the demand for embroidery, he imported oriental embroidery and as indicated by the catalogues of Liberty, embroidery was a popular item for consumers, how he secured sufficient quantities of embroidery is of intellectual worth.

Liberty engaged with the manufacture of embroidery, intrinsically a domestically produced commodity. His methods of overcoming the difficulties of supply will be examined along with his marketing methods, which served not only to increase demand, but also encouraged other department stores to compete for embroidery sales, due to the low set-up costs. Liberty looked abroad for embroidery in order to supply the

[500] WWW.liberty.co.uk/store_info/history.asp
[501] NAL pressmark 77.1 *Liberty* p.11
[502] NAL pressmark 77.1 *Liberty* p.11
[503] Adburgham *Liberty's, a biography of a shop* p.19
[504] NAL pressmark Lib 1 *Eastern Art Manufactures and Decorative Objects* (London 1881) p.47

market. Buyers were sent out to investigate foreign production, seeking sufficient quantities to be commercially viable for resale in the department store, in his words, the buyers were 'ransacking Europe'.[505] In the extant catalogues, the language used is symbolic of the paternalistic philanthropist, re-enforcing the ideology of the civilising power of the imperialists.

The catalogues provide valuable source material for discovering the attitudes of the day and Liberty's paternalistic nature and the marketing techniques deployed. The catalogue for *Eastern Art Manufactures* dated 1881 boldly states,

> *Artists and art critics are unanimously agreed that Eastern manufactures offer a means of decoration superior in colour and more varied and beautiful in design than the productions of Europe and, through great difference in the value of labour (his italics) at a much lower cost.*[506]

Liberty encouraged the notion that bargains could be found within his store, especially imported to suit customer demand. Later in the catalogue under the heading *Ancient Embroideries* it is reported that Persian, Indian, Turkish, Cretan, Chinese and Japanese embroideries were arriving at irregular intervals, ranging from temple hangings, ceremonial banners, vestments and 'all other adjuncts of Eastern luxury and pageantry'. Liberty, himself, pointed out that these items would be of interest to the antiquarian, artists and 'above all priceless for adaptation in interior decorations'.[507] He continued 'The whole of East is being ransacked for this work, and as it is impossible to reproduce it, the value has greatly increased. There is every possibility of present prices increasing.'[508] This short extract raises several implications. The persuasive discourse clearly persuades Eastern design as being superior to European design and lending itself more suitable for home furnishings. Further, it infers that the Eastern embroideries were cheaper than European, due to lower labour costs, whilst the price of the irreplaceable antique embroideries had increased and had every possibility of further price rises.

The rarity of these items is emphasised by the statement that the embroideries were arriving at irregular intervals and his buyers had to ransack the East in order to meet the demand in England. Liberty was increasing the desirability of the embroideries by emphasising their rarity

[505] Ibid. p.43
[506] Ibid. Lib 1 p.1
[507] Ibid. Lib 1 p.43
[508] Ibid. Lib 1 p.43

value, precipitating the fervour of excitement at a once in a life time opportunity to purchase. This process Leiss, Kline and Jhally call 'product orientated' whereby advertising in the period from the 1890s to the 1920s appealed to calculative rationality rather than sentiment, underlining price, utility and effectiveness of use.[509] They also categorise products into search goods and experience goods, the former being luxury goods such as clothes and jewellery where the advertiser needs to tell the purchaser as much 'hard' information as possible to persuade the customer to purchase.[510] This practise of delivering 'hard information' Liberty carried out with his philanthropic ventures commencing in the late 1870's proving that the company was innovative in its marketing techniques.

Opportunity for philanthropic enterprise arose when Eastern embroideries and silk fabrics were being mass produced pandering to the bright gaudy colours fashionable in the earlier part of the century rather than producing the more fashionable new art colours which adhered to natural hues. Therefore, the East had to be persuaded to return to the use of natural dyes, familiar in their indigenous embroideries. The only possibility of supplying the store with sufficient, cheaply made embroidery was to control production, design and colouring. The control of production, Liberty was fortunate to appropriate through a philanthropic venture, in the aftermath of the Russo-Turkish war, in the second half of the nineteenth century. A venture was organised in Constantinople employing over a thousand women and children to embroider goods which were shipped to England for sale in the store.[511] It must therefore be examined whether Liberty in endeavouring to prove his benevolence was in fact exploiting philanthropy, as a marketing ploy.

An 1881 catalogue informed the reader that a philanthropic venture had been set up in Turkey under the auspices of Lady Layard and Mrs Arthur Hanson, assisted by Sir Henry Layard, Lady Burdett Coutts, Lady Charlotte Schreiber and other distinguished philanthropists, so that they might ameliorate 'the destitution occasioned by the late war'. A depôt had been set up in Constantinople for the reproduction of the best traditions of Turkish embroidery, for which Messrs Liberty would act as an agent, selling the work in his store. The embroideries would take from three weeks to a month from the date of order, to be produced and returned from Constantinople. The catalogue informing the customer that no embroidery stock would be kept, and that all designs would be special and could not be 'vulgarised.'[512] Concern here is with Liberty's method

[509] Church, 'New Perspectives' p.411
[510] Ibid.p.415
[511] NAL Pressmark Lib.1 p.45
[512] Ibid. p.45

of deploying altruism as a marketing tool, by imploring the reader of the catalogue that they should not miss this rare opportunity to purchase, and in doing so would be helping those destitute in Constantinople. The British consumer could participate in alleviating the plight of the homeless in Constantinople.

Furthermore, acknowledgement of such support from titled Ladies would have strongly influenced the general public and Liberty's endeavours. Lady Burdett Coutts was one of the greatest nineteenth century philanthropists, known as 'queen of the poor' having donated over £3m to charities; the power of her endorsement of the project would have been immeasurable. The Russo-Turkish war according to Adburgham gave rise to interest in Middle Eastern embroideries and led to an American journalist reporting on her visit to the costume department, in January 1884 'The greatest interest has sprung up in Eastern embroideries, and that Liberty have imported the peculiar silk skeins and gold thread that will no doubt start a charming new departure in fancy needlework for feminine fingers.'[513]

A later catalogue of 1886, promoted Turkish embroideries yet the items listed were mainly Japanese with some Chinese and Portuguese items. Liberty was therefore utilising paternalism as a marketing tool, enticing the customer with attitudes of paternalism and benevolence, whilst in actuality selling the more popular styles from Japan and China. The entire introduction to the catalogue focuses purely and solely on the plight of the Turks. The catalogue entitled *Eastern Art and Other Embroideries* introduced a collection of modern Turkish manufactures. The embroideries were produced under the auspices of the Turkish Compassionate Fund founded by Baroness Burdett-Coutts to help refugees fleeing to Constantinople from Turkish European provinces to avoid Russian attacks in 1877-8.[514] The catalogue informs the reader that the Sultan 'entered warmly into the scheme and at Lady Layard's request directed a house belonging to the Turkish government to be placed at her disposal.'[515] The catalogue describes how over 1000 Turkish women had been found employment, though unfortunately it had not been possible to house them in one locality.

Materials were given to the women, so they could be worked at home and taken on certain days to Mrs Hanson who transmitted the work to Lady Charlotte Schreiber and finally to Liberty & Co. East India House. The catalogue proudly announced that they were desirous of promoting the project's success and in helping numerous women improve their social condition, whilst at the same time preserving beautiful,

[513] Adburgham, *Liberty - A Biography of a Shop* pp.56-57
[514] NAL press mark LIB 8 *Eastern Art and Other Embroideries* 1886, p.1
[515] Ibid. p.1

original and characteristic art.[516] It is therefore somewhat surprising that of the counted 111 items in the catalogue only six were Turkish, in other words Liberty was using the exhibition as a vehicle to promote benevolence, whilst profiting from selling the more popular Japanese embroideries. The word profiteering, rather than profiting, might be assumed by the cynic. Liberty may have been reflecting upon the political situation, in which politicians and the socially aware, were divided over the Russo-Turkish war. It is therefore imperative to have some understanding of the sentiments held within Britain of the late nineteenth century.

For many years, the miasma of political conflict had raged concerning whose side Britain should take in the Russo-Turkish war (1877-78). In a much simplified overview, Disraeli favoured Turkey as opposed to the ever expanding Russian Empire and to protect the Suez Canal, the gateway to India. He was opposed by Gladstone who abhorred the cruelty inflicted by the Ottomans upon their own people within the ever crumbling Ottoman Empire. The debate had been well promulgated throughout Britain and for William Morris it was his introduction to the world of politics and socialism. Morris's concern encouraged him to found The Eastern Question Association in 1877, and he wrote many letters and toured Britain lecturing on the subject. The plight of Constantinople was therefore at the forefront of the socialist agenda. Such political issues did not exist in Greece, so when Liberty held an exhibition of Greek embroideries he formulated a quite different marketing ploy, utilising notions of manifest destiny.

In *Modern Greek Embroideries, the work of Greek Refugees* Liberty advertised the exhibition of May 1898 as an,

> **Exhibition on behalf of the Thessalian School of Embroidery established in Athens by Lady Egerton the wife of H.M. Minister Sir Edwin Egerton, at the British Legation with the object of finding remunerative work for Greek Refugees for whom help has become necessary by events of the recent war.**[517]

Lady Egerton, it reported, felt it would be aiding 'a people whose destinies were in the hands of a King bound by the closest of ties of blood to a Princess whose name is dear to English women in every part of the

[516] Ibid p.4

[517] NAL pressmark LIB 50 *The Arms of Greece (particulars of a unique collection of modern Greek Embroideries),* (London, 1898) p.1

globe'.[518] The catalogue stated that it was appropriate to have a school in Athens as it was 'in harmony with the eternal fitness of things ... the finest traditions of the art needlework of antiquity preserved in Greece, and it was the Greeks who attributed to Minerva herself a superhuman skill with the needle.'[519] Reference to royalty and the goddess of handicrafts, not only endorsed the venture, but also gave rise to the notion of manifest destiny. The subliminal message here seems to root itself in eighteenth century Enlightenment thinking, mankind trying to reach back to its forefathers, or in this case earth mother. It was stated that the exhibition was being held rather tentatively and may not be repeated,[520] yet again the marketing ploy of an opportunity that must not be missed. The catalogue proceeds to list 74 items, ranging from chairback covers 14/9, table covers 22/6 and 40/- and mantel borders at 46/9.[521] Liberty held similar annual exhibitions, producing catalogues of persuasive, rather verbose discourse deployed as a marketing tool. Embroidery at Liberty's store did not simply revolve around household items and the Orient, as one of the most successful departments which utilised embroidery, was the costume department, where the design influences were derived mainly from medieval gothic and the Greek style.

The Costume Department

As discussed in earlier chapters, the latter part of the nineteenth century looked to an earlier, romantic period of society. This desire reached beyond the gothic revival and Greek architecture to romantic literature, but also to dress codes, especially for female attire. In 1884 Liberty opened the Costume Department with its own studio and workrooms. In order to obtain originality it was decided not to use the influence of the ateliers of Paris, but to commission designers for fashionable attire which took inspiration from historical sources, retaining the original characteristics.[522] The Pre-Raphaelites, Dante Gabriel Rossetti, John Everett Millais and William Holman Hunt were 'inspired by the art of the early Renaissance and its ideal way of life, as they perceived it, in contrast to the crass materialism and ugliness of their own age'. They created dresses with medieval influence for their female sitters, who according to Ashelford echoed the style in their daily dress.[523] The influence of the Pre-Raphaelites was interpreted by Edward Godwin (1833-1886) into a commercially attractive proposition.

[518] Ibid. p.6
[519] Ibid. p.9
[520] Ibid. p.9
[521] Ibid. p.9
[522] Adburgham, *Liberty's*, p.51
[523] Jane Ashelford, *The Art of Dress: Clothes and Society 1500-1914* (London 2000) pp.229-231

Godwin was appointed as chief dress designer for Liberty's, a self taught architect, a protagonist of the gothic style, who turned his hand to designing stage settings, theatrical costumes, wallpaper and furniture. In 1882 he became a founder member and Honourary Secretary of the Costume Society which campaigned for healthy dress wear. He advocated a return to the principles of Grecian dress, loose fitting dresses as opposed to tight restrictively suffocating corsets, a requisite of the crinoline dress. He was one of the earliest designers to engage with Japanese motifs inspired by Japanese embroidered coats, kimonos and antique Chinese robes. Godwin was a friend of Whistler and Oscar Wilde who called him 'the greatest aesthete of them all'.[524] It was Godwin who best translated the aesthetic dress, designing loose flowing garments made from 'unusual handmade fabrics: delicate muslins and filmy gauzes from India; subtly-coloured silks from China and Japan and soft woollens from Kashmir. Each design had a name, such as Greek or Medieval all hand embroidered with appropriate motifs.'[525] During the annual embroidery exhibitions the women of the department would dress in Circassian, Hindoo, and Japanese and Chinese attire, designed by the Costume Department from Liberty silks.[526]

There are sufficient pictures of Liberty style gowns to prove that embroidery was extremely popular upon the soft draping and loose fitting gowns, samples of which can be seen in plates 6.2 and 6.3. Embroidery became a signature of the Liberty dress which favoured the loose flowing simply decorated style of the medieval. The style removed the necessity for tight fitting corsets and therefore sought after by aesthetic society. Since medieval dresses had been very simple in decoration, the addition of embroidered detail would have suited the Victorian style, bringing the medieval up to date, whilst being performed at a relatively inexpensive cost, due to the availability of cheap labour. The aesthetes were a relatively small portion of London's society, mainly belonging to the art fraternity. Their love of wearing loose fitting clothing mainly for health reasons, was slow to catch on with the rest of society and they therefore stood out amongst the populace in their Bohemian dress. These women rejected the corset in favour of the simple and elegant lines of the past. Women who wore the new aesthetic, loose fitting dress risked the reputation of having loose morals, they tended to come from artistic or intellectual circles and likely to be given a 'critical and unsympathetic reaction.'[527] However their dress code was supported by the medical profession who denounced the wearing of tight corsets, the strangling in

[524] Adburgham, *Liberty's, A Biography of a Shop*, p.52
[525] Ashelford, *The Art of Dress, Clothes and Society*, p.268
[526] Adburgham, *Liberty's, A Biography of a Shop*, p.52
[527] Ashelford, *The Art of Dress, Clothes and Society*, pp.229-231

of the waist to the desired nineteen inches, not only for the safety of women but also fears of impairing their child bearing capacity.[528] By the time the rest of society had caught up with medical opinion, the suffragette movement was sufficiently established, advocating sport and leisure wear suitable for appropriate pursuits and so furthering the demise of the crinoline.[529]

Though most texts on fashion including Ashelford acknowledge that relatively few women wore the aesthetic dress, Ashelford informs us that from the 1870's women on a four day country house visit would require twelve to sixteen complete ensembles. Loose fitting five o'clock tea-gown provided relaxation after the shooting party and before more formal dress for dinner. The tea gown was first introduced in 1870 as an informal unboned garment and because it was unwaisted required no corset. By the 1880's the tea-gown became more elaborate and could be worn as an informal dinner dress. Because of the simplicity of the style and cut it became customary to embellish the dress with embroidery, beads and lace, usually as edging or borders, frequently utilising Greek motifs. By the 1880's the general trend therefore was towards loose fitting clothes due to movements such as the Rational Dress Society and Women's emancipation gaining momentum.[530] In 1905, when the Women's Social and Political Union began its agitation, Ashelford argued that the whole concept of dress changed imperceptibly. Day dresses and coats were still trimmed with embroidery, braid, tassels and large decorative buttons, as shown in a fashion plate for Harrods's department store, Knightsbridge, see plate 6.4[531] At the same time as affluence grew, so did the need for conspicuous consumption discussed in chapter one.

With the house beautifully furnished and its mistress well attired, Liberty founded a new market, one in dressing her children. Though Liberty employed famous designers such as Walter Crane to design clothes especially for children, his signature for children's clothes became that of smocking. The author and illustrator of children's books Kate Greenaway made enormous impact on the style of children's dress, which Liberty called 'Artistic Dress for Children'. Greenaway's publication *Under the Window*, 1878 was praised by Ruskin and the original illustrations exhibited at the Fine Art Society. When in 1883 the *Kate Greenaway Almanac* was published it sold 90,000 copies throughout Britain, America, France and Germany, and was succeeded by an annual

[528] Ibid. p.229
[529] Ibid. p.229
[530] Ibid.p.236
[531] Ibid. p.252

almanac.[532] Greenaway's illustrations of dress for girls consisted of a loose fitting smocked yoke, sleeves, cuffs or any combination of the three. Smocking on dresses became popular especially for children and remained so for the next 100 years. The popularity of smocking grew with the revival in of interest in rural crafts, smocks being the traditional dress for country folk, were seen as innocently romantic and therefore suitable for children. Smocking, Watt states, was most popular and sought after by royalty.[533]

Though a skilled dressmaker could perform simple smocking, more elaborate work would have deployed the skills of an embroiderer, to finish the decoration. Smocking involves the pleating of fabric, which was until relatively recently performed by hand. Smocking machines now replace that process, but the decorative embroidery over pleating must still be completed by hand. The process of smocking is complicated, requiring patience and practise and according to Barbara Morris, Mrs Oscar Wilde wrote in *Woman's World,* 1890 of her concern, that when smocking was first revived, Liberty silks had to be sent to 'humble cottages in Sussex and Dorsetshire where a few conservative rustics still adhered to the old smock frock'.[534]

Liberty continued to specialise in embroidered dress, as it was a major feature of Art and Craft dress until the First World War. Embroidery associated dress with handmade rather than machine work and therefore was by definition more artistic, it was also a relatively inexpensive way of decorating dress. As Watt observes, during the Art Nouveau period, embroidery continued to be popular as the curvilinear designs were suited to *Ladies Field* embroidery.[535] Plate 6.4 shows a girl's version of a sailor suit c. 1902 with hand embroidered collar, cuffs and buttons. Liberty advertised a similar one in, 18 September 1909 'Collar and cuffs hand embroidered on Shantung Silk, suitable for a girl twelve years of age £5 19s 6d.'[536]

During the 1920's and 1930's Liberty were still selling embroidered 'couture' dresses at 19 ½ gns and similar to ready to wear dresses decorated with printed silks at £5 19s 6d. Gowns were created in house, the embroidered designs created by an artist or to the customer's specifications. Embroidery, Watt concluded was like smocking, the hallmark of the costume department.[537] It is not clear whether Liberty's costume department and needlework department were initially one and

[532] Adburgham, *Liberty's, A Biography of a Shop* p55
[533] Watt, Judith 'Costume' in Calloway, Stephen *Liberty of London, Masters of Style and Decoration,* (London, 1992) p.150
[534] Barbara Morris, *Liberty Design* p.45
[535] Watt, 'Costume' p.72
[536] Ashelford, *The Art of Dress, Clothes and Society,* p.287
[537] Watt, Costume,149-150

the same. It would appear they were opened at the same time, 1884, but later when embroidery became the signature of Liberty dress the embroiderers were probably absorbed into the costume department.

There was most certainly an embroidery school, which is referred to in Liberty's *Catalogue of a Valuable Collection of Ancient and Modern Eastern Art* for an exhibition in November 1885. The catalogue listed many types of embroidery from China, Japan, Spain, Portugal and Italy and included twelve items made by The Liberty School of Embroidery, stating that the school had completed its first year. The report apologised that the school were only able to exhibit a dozen items due to the large number of private commissions received, but at least the few items displayed would represent the style and character of the schools work. These twelve items comprised a mantel border, two tablecloths, a tablemat, table cover, two sofa backs, one in Turkish design, firescreen, glove and handkerchief sachet, Tussore tablecover small folding screen and a partly finished piece for a cushion.[538]

Liberty's success in providing highly fashionable goods with low labour costs, control over labour production and high profit margins, prompted other department stores to follow suit. Tiffany in America, which will be discussed in chapter seven, realised the importance of branding, in the way that Liberty successfully achieved. Department stores in the UK, however, tended to be more generalised but are worthy of consideration for the importance they attached to embroidery as a commodity.

Zola, The Bon Marché and Other Department Stores

Fowler argues that many larger retailers were experimenting with the concept and practises of department stores at the end of the eighteenth century,[539] though it is generally accepted that department stores per se, did not exist until the later half of the nineteenth century. In the 1850's the genesis of the modern concept of the department store materialised in Britain, new methods in iron and glass construction enabled larger picture windows and the development of department stores based upon the Bon Marché, Paris. Geidion, Dixon and Muthesius agree that the commencement of department stores is difficult to date as they evolved from warehouses and arcades. Present day department stores with large

[538] NAL pressmark Lib.7 *Catalogue of a Valuable Collection of Ancient and Modern Eastern Art and Other Embroideries,* November 1885
[539] Christina Fowler. 'Changes in Provincial Retail Practise During Eighteenth Century, With Particular Reference to Central-Southern England' in *Business History Review* October 1998 issue 4 p.50

shop windows and ticketing began first in Paris with Eiffel's Bon Marché in 1876 deemed a model of elegance[540] followed by the rest of Europe.[541]

The writer, Emile Zola (1840 -1902) spent 4-5 hours per day for one month observing the everyday life within the Paris store, for factual material evidence to authenticate his novel *Au Bonheur des Dames*. The novel translates into English as *The Ladies Paradise*, is a celebration of commercialisation, the large department store devouring the small shop. He likened the store to the cathedral, the new religion, 'a temple, where woman was both goddess and worshipper.'[542] Ross calls the novel a 'phantasmagoric hymn to the marvels of modern commerce',[543] yet it accurately accounts for many of the commercial and marketing characteristics deployed by department stores in the 1870's, especially those deployed by Liberty. Zola's novel, according to Ross is read by a variety of historians from Marxists, postmodernists, feminists, and anyone studying the transition of the economy based on production to one based on consumption. Historians regarding Zola's work to be well researched and relaying a realistic portrayal of commercial practices in the nineteenth century and he is considered to be an authority on nineteenth century commercialisation.[544]

Department stores were the innovation of the period, designated as the new 'cathedrals' by Zola.[545] They attracted an ever growing wealthy populace, and a wider social stratum. Such stores were initially small shops, buying up neighbouring premises, expanding not only in size, but also in the range of products sold, small drapers expanding, adding furnishing departments to food stores. One of the most popular departments to be added in the initial stages by many stores was that of the embroidery department. As the stores expanded, they offered more and more delights with the sole purpose to feed the senses create passion and fervour and more importantly maximise sales. A key aspect was the layout of the store which played a significant physiological factor. Constantly changing layouts created confusion, caused diversions, leading customers to departments they may otherwise not have entered. The signified mystery and excitement of an Oriental bazaar overwhelmed the most parsimonious female shopper, and were a tactic that Zola devoted an entire chapter to in *The Ladies Paradise*. Manipulative advertising engendered notions of scarcity, 'a once in a life time opportunity', 'a never to be missed bargain' tempting females to purchase, induced by supposition that they were being frugal with the

[540] S. Giedion, *Space ,Time and Architecture,* (Harvard, 1962) p.236
[541] Roger Dixon and Stefan Muthesius, *Victorian Architecture* p.141
[542] Ross, Introduction, in Emile Zola, p. xv
[543] Ibid. p. v
[544] Ibid. p.v
[545] Zola, *The Ladies Paradise*.

family purse. Hedonistic women likewise thrived in this Utopia and commerce became religion. Lancaster points out that,

> *Zola argued the department store went beyond providing a new solidarity by taking the role of cathedral to the new culture of consumerism ... the department store tends to replace church. It marches to the religion of the cashdesk of beauty, of coquetry and fashion [women] there to pass the hours as they used to go to church: an occupation, a place of enthusiasm where they struggled between their passion for clothes and the thrift of their husbands; in the end all the strain of life with the hereafter of beauty.[546]*

Walsh disagrees that shopping was considered quite so passive and frivolous, for the nineteenth-century woman saw shopping as an activity which offered her autonomy, power and pleasure.[547] Yet, Zola's description of The Ladies Paradise defies sensibility, constructing hedonistic notions and would be as apt in describing Liberty, illustrating the use of oriental imaging to display and marketing:

> *This sumptuous pacha's tent was furnished with divans and armchairs, made with camel sacks, some ornamented with many coloured lozenges, others with primitive roses. Turkey, Arabia and the Indies were all there. They had emptied the palaces, plundered the mosques and bazaars. A barbarous gold tone prevailed in the weft of the carpets, the faded tints of which still preserved a sombre warmth, as of an extinguished furnace, a beautiful hue suggestive of old masters. Visions of the East floated beneath the luxury of this barbarous art, amid the strong odour which the old wools had retained of the country of vermin and of the rising sun.[548]*

Lancaster argues that the origins of the British department store were firmly rooted in the twin processes of industrialisation and urbanisation.[549] Harvey and Press agree that the demand for goods was fuelled by urbanisation and improved living standards and that between 1874–1896 prices fell by around 40%. Income Tax statistics indicate the

[546] Lancaster, Bill *The Department Store, a social history* London, 1995 p.19

[547] Claire Walsh, 'The Newness of the Department Store: a view from the eighteenth century,' in Geoffrey Crossick and Serge Jaumain (eds) *Cathedrals of Consumption, the European department Store, 1850-1939* (London, 1999) p.60

[548] Zola, *The Ladies Paradise,* p. 79

[549] Lancaster, *The Department Store,* p.7

number of people with an annual income of £150 or more rose from about 310,000 in 1860-61 to 530,000 in 1874-75 and 705,000 in 1881-82.[550] With relative growing wealth throughout middle class society, the mistress of the household could afford more elaborate gowns and 'cast offs' were given to the servants, which encouraged greater emulation between the classes. More worrying for the middle class, the lady of the house was persistently forced to renew her outfits to be in the lead of fashion, as well characterised by *Punch*. Lancaster continues that during the nineteenth century the old system of sweatshops and small workshops continued to produce consumer goods rather than the factory, and what could be sold was largely determined by what could be produced.[551]

In other words this was an economy based on production rather than consumerism. Liberty's awareness of this factor led him to dictate his market, which persistently led him to finding sufficient sources of production to supply his captivated audience. Fraser informs that after 1860 'goods were sold strictly for cash, prices were fixed and marked, profit margins were low and the aim was a large volume of business. Aggressive selling and advertising was another feature, and bargain sales played their part in this.'[552] Church agrees that where a selling and sales concept dominated a firm's policy, the management assumed that customers would not usually purchase sufficient products and that aggressive selling and promotion was necessary 'to sell what they produce rather than what the market wants'.[553]

Furthermore, the introduction of larger windows allowed for window shopping, enabling the general public to compare prices, for the large retailer was satisfied with minimum profit on mass sales.[554] Retailing was now based upon rapid and continued turnover of capital, which department stores were to follow the example set by the Bon Marché, and as recorded by Zola, they did not require a large working capital. The sole effort was to increase turnover, get rid of stock as quickly as possible, to replace it by new stock. Only a small profit on each consignment was necessary if one could shift considerable quantities of goods incessantly renewed. Such operations today would be called 'high turnover', or in other words as Zola's fictitious store owner Baron Hartman remarked to Mouret 'You sell cheap to sell a quantity, and you sell a quantity to sell cheap'.[555]

This proves both Tedlow and Strasser wrong; quoted in Church's paper, Tedlow regarded the period 1880-1920 as a critical period of

[550] Harvey and Press, *William Morris, Design and Enterprise*, pp.76-77
[551] Lancaster, *The Department Store, a social history*, p.7
[552] Fraser, *The Coming of the Mass Market*, p.131
[553] Church, 'New Perspectives' p.408
[554] Zola, *The Ladies Paradise*, p.68
[555] Ibid p.67

change, when profitability based upon low volume sales and high margins changed to high volume with low margins. Strasser on the other hand detected no fundamental changes to the system prior to 1920.[556] Clearly, the process of change had begun in the 1870's within department stores as demonstrated by Liberty and Zola. Crossick and Jaumain also agree that the trend for low margins and high turnover became commonplace amongst the 'new breed' of European city centre retailers, and even some provincial towns, in the 1870's.[557]

One great innovation of the Bon Marché was the introduction of ticketing; each and every item clearly marked with its set price, no negotiating, no bartering, and this set a radical change in the selling of goods. For centuries the small shopkeeper would arrange the price according to the need to sell or more importantly what the seller thought the purchaser could afford. Small shopkeepers could no longer compete with the large retailer the department store. The small retailer may have adopted ticketing, though there would undoubtedly have been a cross over period, whereby some retailers would still decide upon the price which could be met by the consumer. Small provincial retailers faced competition by mail order houses yet benefited from the fact that embroidery being a tactile product, the consumer would be enamoured by sight, touch and the immediacy of availability, encouraging sales.

Small retailers had an abundance of supply; production was not the retailer's problem. Faced with an abundance of locally produced embroideries, from women willing to supply on a sale or return basis, the retailer did not risk overstocking. Offering to achieve the best possible price for goods gave the retailer freedom to charge whatever price deemed necessary. The suppliers, in other words, the embroiderers took the risk, with both their time and materials. At best, the embroidery provided income and at worst, the work was returned. According to Walsh, mechanisation affected production of goods very slowly, having a gradual effect from the 1850's onwards. She disputes that mass consumption was linked to mass production and maintains that many department stores retailed goods not manufactured by machine, but in small batches using subcontracting systems, either from small plants and/or the putting out system. Small batch production for stores was highly successful in meeting increased demand and rapid fashion change.[558]

Miller argues that the department stores continued to use the putting out system and paid according to piecework at sweating system rates. Furthermore the stores retained maximum control over its

[556] Church, 'New Perspectives', pp.410-411
[557] Crossick and Jaumain, *Cathedrals of Consumption, p.10*
[558] Walsh, *The Newness of the Department Store,. p.57*

orders.[559] By 1890 The Bon Marché employed 600 workers in ateliers/workshops on the premises, though many more were employed as outworkers, as Miller informs, outworkers could bypass state regulations.[560] The Industrial Revolution might be regarded as a factory orientated system, yet as Miller argues for much of the century economic change was to be found as well in the backrooms and sweatshops.[561] We can interpret this in terms of the changes taking place as the sweat shops of dressmakers turned to the ready-to-wear market, saw the formation of the Rag trade, known today. It was common for assistants working in a department store to live, sleep and eat on the upper floor of the store.

Department store owners would often provide entertainment, an in-store magazine and events, all in the name of a paternalism. Employers naturally held total control over staff, from their relationships, to what time they went to bed. By operating department stores as institutions, the owner held social and moral control. Controlling and improving one's employee's morals validated the process, whilst further increasing the power and status of the employer. Such department stores were to become prevalent throughout the United Kingdom from the 1870s, many stemming from small specialist stores, expanding and diversifying into interrelated household, luxury and fashionable goods.

Debenham was one of the first empire builders, buying up firms of high repute including Maison Helbronner of New Bond Street established in 1834 as 'Ecclesiastical, Heraldic and Domestic Embroiderers'.[562] When Debenham Poole & Smith opened a store in Cheltenham in the 1830's they announced via their trading card they would be selling 'stock unrivalled in extent, and selected with the greatest of care from the British and Foreign Markets, consisting of every novelty in silks, cashmeres, shawls, mantels, cloaks, lace and embroidery'.[563] In 1896 Debenham & Freebody held an exhibition of embroidery, the exhibits consisted of old Spanish, Italian, French, Polish and Indo-Spanish embroideries. A supplementary catalogue to the exhibition listed alter frontals, and Italian churchwork, hoping obviously for a benefactor to purchase for their parish church. In total 110 items were offered for sale.[564]

In May 1901 Debenham & Freebody proudly announced that they had purchased Messr's Howell and James's famous collection of embroidery in its entirety some months before, and that only a few pieces

[559] Michael Miller, *The Bon Marché, Bourgeois Culture and the Department Store, 1869-1920* (Princeton 1981) p.57
[560] Ibid. p.58
[561] Ibid. p. 33
[562] Adburgham, *Shopping in Style* p.170
[563] Maurice Corina, *Fine Silks and Old Counters Debenhams 1778-1978* (London 1978) p.-
[564] NAL pressmark 43.00 Box 11 Debenham & Freebody *Catalogue of Exhibition of Embroideries and Brocades* London 1896

remained. Collectors in England and on the continent were invited to view the remaining collection in a special room. It was requested that important pieces bought at the start of the sale be allowed to remain until the end of the exhibition, in total 494 items were listed.[565] In 1902 another exhibition was held selling 'Old' embroideries[566] and by 1904 the firm were concentrating on English antique samplers and embroidered pictures, the quality of which only appear in the top London auction houses today. In the 1904 catalogue it was stated that the buyer had spent a long period on the continent finding embroideries, in total over 340 items were exhibited. Included in the catalogue were a Stuart piece 'supposed to be worked by the Queen's Lady in Waiting' a sampler 'which is said to have belonged to Queen Elizabeth [the first]', and an embroidered panel 'similar to Morris style'.[567] Though these were mainly antique embroideries it fed the desirability of embroidery, fuelling demand, which would expand production, in order that supply could meet those demands. For the Franco-British Exhibition in 1908 Frederick Richmond wrote a lengthy treatise on Debenham and Freebody, in which he included the words 'We undertake special embroidery, all of it executed in England, including designs for court trains and richly-trimmed gowns. At all times many of the examples of the exquisite handiwork of the Royal School are on exhibition upon our premises.' On describing the antique collection, Richmond continues that of all the antiques in which they deal, 'embroideries and brocades have for many years been the most important.'[568] The purchasing of antiques however went against the commercial practise of buying in bulk to sell cheap.

From an early stage department stores engaged with the ploy of buying in bulk quantities, at low prices, to sell cheap, with well positioned marketing, offering goods at one third of the normal price and stressing the rarity value of the product a never to be repeated offer, encouraged the fervour of 'sale time'. Miller argues that Zola's Mouret staked everything on one great sale, buying from the manufacturer or wholesaler at moment of oversupply and unloading to customers at favourable prices.[569] In the Dickens & Jones Summer Sale advertisement in *The Queen,* 10 July, 1886 (plate 6.6) it was announced that several new embroideries had been received:

[565] NAL pressmark 43 C108 Debenham and Freebody *Exhibition of Old English Samplers* London 1901
[566] NAL pressmark 43 E 109 Debenham & Freebody *Exhibition of Old Embroideries* London 1902
[567] NAL pressmark 43E1H Debenham & Freebody *Catalogue of an Exhibition of Antique Embroideries* London April 1904
[568] Corina, *Fine Silks and Old Counters,*, p.68
[569] Miller, *The Bon Marché,* p.33

> *Muslin embroidered gowns (unmade) 'over 500 Gowns in*
> *White Cream and Ecru will be marked at great reduction to*
> *affect a clearance. Handsomely embroidered, with sufficient*
> *material to make a costume; 100 Embroidered Zephyr*
> *Gingham Robes (unmade), White cambric embroidery for*
> *underwear, nursery embroidery for trimming children's*
> *underwear.*[570]

Such enormous quantity of embroidered fabric was probably machine made, and therefore less expensive than hand embroidered. Since department stores had in the main only catered for the middle class and aristocracy, cheaper machine made embroidery enabled the store to reach the lower middle class.

Crossick and Jaumain argue the department stores drew substantial white collar workers and lower middle class clientele 'as they were one source of lesson for those insecure groups on how to aspire to a bourgeois lifestyle.' Whilst mail order spread goods to the provinces Crossick and Jaumain argue that it was 'Less the democratisation of fashion than its wider bourgeoisification'.[571] Mail order provided the means for people in the provinces to purchase items previously only available to those in London, allowing for the bourgeoisification of the expanding numbers of middle class, without the large expense of travelling. Mail order was extremely popular for in 1888 Marshall & Snelgrove Country Rooms received over 1,000 letters a day and employed over 100 clerks and accountants to process the orders.[572] Compared with the Bon Marché which during the winter season of 1894, sent out 1,500,000 mail order catalogues, 740,000 were distributed to the provinces and 260,000 abroad.[573] All department stores soon followed suit such as Debenham & Freebody who ran a Country Department.[574] Liberty's Christmas catalogues flourished with illustrations of embroidered items, perusal of which depict the size of the market. Liberty provided embroidery kits and smaller household items designed by famous designers, and also those employed in the arts and crafts movement.

Ann Macbeth (1875-1948) who was employed at the Glasgow School of Art as an assistant to Jessie Newberry was commissioned by Liberty to design embroideries. Macbeth according to Barbara Morris was one of the of the most outstanding twentieth-century embroiderers. Her book entitled *Educational Needlework* was according to Morris to

[570] Adburgham, *Shopping in Style*, p.163

[571] Crossick, and Jaumain (eds) *Cathedrals of Consumption*, p. 26

[572] Ashelford, *The Art of Dress, Clothes and Society*, p.259

[573] Miller, *The Bon Marché*, pp.61-62

[574] Corina, *Fine Silks and Old Counters* pp.68

revolutionise the teaching of embroidery within schools. Some of her work for Liberty was ready worked, but many were adapted as iron on transfers for embroidery to be used on dress and furnishings. These featured in Liberty's catalogues as mail order items, until the first world war. In 1912 Liberty advertised a range of embroidered blotters, photoframes, covered with natural linen, embroidered with stylised roses in silk and metal thread. Morris is uncertain as to the designer but suggests that the influence is that of the Glasgow School of Art.[575]

The Arts and Crafts movement took on board Japonisme and the simplicity of design, especially black lattice work, the sculptural and geometric lines reflected in furniture and buildings, such as Mackintosh's Glasgow School of Art. The style influenced the Bauhaus and postmodernism was born, a theme to be returned to in the conclusion. Popularity of embroidery continued into the Edwardian era, when Ann Macbeth, Head of the Embroidery Department, Glasgow School of Art,[576] supplied Liberty's embroidery department with Art Nouveau designs, which featured in the firm's catalogues until the outbreak of the First World War. Work resumed in the interwar years, but after the Second World War, the needlework department closed, it was reported, due to staff re-organisation.[577] A natural assumption might be that post war, day dress had become utilitarian and as embroidered dresses had been one of Liberty's specialities the department may have closed, due to it being commercially non viable.

The next chapter, however will dismiss these reasons, arguing that manufacture of embroidered garments were still in demand embroidered by French couture houses and countries such as China where labour was cheap. Earlier in the chapter, it was noted that the Japanese were shocked by the poverty in England and expected it went hand in hand with industrialisation. The British knew differently; poverty and industrial production were not necessary adjuncts, whereas the class structure in Britain made poverty inevitable. The socialist movement had begun; artists and designers were amongst the first fighters for socialism. In Britain and America, embroidery as a commodity and valuable employment opportunity passed to the hands of the Arts and Crafts movement, as it was they that promoted hand made items. For the Arts and Crafts movement, hand made items and socialism went hand in hand with Ruskin's ideals, to be re-examined in the next chapter.

[575] Morris, *Liberty Design*, p.57

[576] Calloway (ed) *Liberty of* London, p64

[577] NAL pressmark 77.L *Liberty* p.11

CHAPTER 7
The Rise and Fall of Art Needlework

This chapter will examine the rise and fall of Art Embroidery as a business and philanthropic venture, concentrating on the effect the Arts and Crafts Movement had upon embroidery in Britain and America. Idealistic, socialism and the optimistic spirit of the Arts and Crafts Movement provided an escape from the industrial world, radiating quickly from Britain to America. The application of the Arts and Crafts ideology to philanthropic ventures and the commercial practices of Tiffany & Co. in America needs examination.

As Cormack argues the Arts and Crafts Movement had important social dimensions involving far more people than any other 'mass movement' in the visual arts, people from all social backgrounds became interested and it was the first time that women gained reputations as designers and craft workers.[578] This chapter will therefore concentrate on three key issues, the teachings of Ruskin and Morris, their impact on the Arts and Craft Movement in Britain and the resulting effect upon American Arts and Crafts. Finally the chapter will assess the evidence and draw a conclusion about the claim that the demise of Art embroidery correlated directly to the dogmatic adherence to the teachings of Ruskin and Morris.

The rise and fall of embroidery as a commercial product had direct links to the political ideologies of the Art and Craft Movement. The political and economic theories of Ruskin and Morris require examination for their theories were embodied in the Arts and Craft Movement, which provided work for women, especially in the embroidery field. The meteoric rise in both Britain and America of commercial Art Embroidery practices suffered a sudden demise in both Britain and America after the First World War, yet embroidered dresses remained popular amongst the middle classes. Embroidery work was sent abroad, to China and France, continuing to be made by cheap labour. The Arts and Crafts Movement tried to move towards a paternalistic working ethos, an ideology which led to a dichotomy, for how could they reconcile philanthropy with commercial practise? Yet it will be argued that this conflict was not the sole reason for the demise in the embroidery industry, neither can changing markets be found totally culpable. One major contributing issue lay with the Arts and Crafts Movement which failed to keep abreast of the times. They remained dogmatic to Ruskin and Morris' ideals, they failed to recognise that Western Europe was advancing commercially and technologically embracing new materials and production methods.

[578] Peter Cormack, 'A Truly British Movement', in *Apollo*, April 2005, pp.49-53

Ruskin and Morris formed the Arts and Craft movement, therefore their teachings will be examined and the socialist beliefs they held, for they each believed that improved working conditions would lead to higher standard products. In turn, greater pride in one's work would ultimately lead to a higher quality of life. Both believed in the intrinsic value of work, only through good honest toil could mankind find reward. They sought to change working methods, and social attitudes, to return to artistic working practices, and the standards set by medieval craftsmen. In Boris's view the craftsman ideal sought a new holism, to unite art with labour, mental with manual, city with country, individual with community, and work with play. Neither Ruskin nor Morris visited America, but they had a profound effect there, in the years between the Centennial Exhibition of 1876 and the First World War. The majority of those who adhered to their teachings, were looking for an alternative lifestyle, one based on the cultivation of art. This sensibility Boris claims was expressed by individual craft workshops, their products 'came to symbolise democratic art, becoming the style for and of the middle class, serving as the counterpart to progressive [social] reform.'[579] Both Ruskin and Morris were exceptional philosophers and orators gathering disciples, which led to many groups and societies adhering to their teachings. The practicalities of those ideologies in execution and the effect on their contemporaries need to be examined.

Ruskin and Morris' Theoretical Beliefs

Lucy Crane gave a series of lectures, *Art and the Formation of Taste* which was published in 1882. She spoke of the two great teachers of art, Ruskin and Morris, agreeing with their views of the past and present, the eternal principles of right and wrong, of good and bad. Lucy considered that the two men differed in the way they viewed the future of art, Ruskin full of despair, Morris of hope, and she advised that people should cling to the hopeful side of Morris.[580] In another lecture she qualified her reasoning for quoting Ruskin and Morris so frequently, by stating that all that was known about art was known through them. 'The one being by original genius and long practical experience, the other by splendid gifts of imagination and expression, joined to a lifelong study, qualified to tell us what the Arts really are, and how we ought to think and talk about them'.[581] Lucy's brother Walter Crane had a slightly different perspective. He considered that Ruskin had 'been driving home

[579] Eileen Boris, *Art and Labour, Ruskin, Morris and the Craftsman Ideal in America* (Philadelphia, 1986) pp.xiv-14
[580] Crane, *Art and the Formation of Taste*, p.43
[581] Ibid. p.93

the same truths [as Morris] in his politico-economic writings', but Ruskin was a voice in the wilderness, receiving 'the scorn and scoff of the professional economists'. Professing that 'everyone went on buying in the cheapest market and selling in the dearest with perfect unconcern, as if *The Song of the Shirt* had never been written' (see Appendix A).[582] Crane felt Morris accepted the economic teachings of Ruskin but went much further, and gave his allegiance to 'the banner of socialism.'[583] From an historical perspective, Boris argues that Morris 'dramatised, elaborated upon, and ultimately transformed Ruskin's views' he maintained Ruskin's moral aesthetics but 'secularised them by judging society on its social relationships rather than its godliness.'[584]

Though Ruskin had socialist beliefs he always held the belief of government and hierarchy within. Government and co-operation he said were in all things the 'Laws of Life; Anarchy and Competition the Laws of Death.'[585] Ruskin believed in a hierarchical society, he believed in powers of government, but that man should be governed in such a way as to create conditions in which man would find joy and pleasure in his work. Humanity he felt, should find fulfilment and pride in all it produced and that the sin lay with unbridled capitalism, and poor working conditions, which ultimately led to uncompassionate, poor workmanship. He advocated a return to the working conditions of the medieval period, 'when men rejoiced' in the pride of their work, working together to build the great gothic cathedrals. Ruskin felt that the medieval period progressed from the Greek period which enslaved man to raise large mantels onto the temple columns.[586]

The system of ornamentation, utilised in the medieval period removed this type of slavery, as it recognised the individual value of every soul. Medieval art Ruskin preached, recognised man's imperfections and bestowed dignity upon a man who admitted his imperfections: 'Do what you can, and confess what you are unable to do: neither let your effort be shortened for fear of failure, nor your confession silenced for fear of shame.' Ruskin rebelled against the conditions in which man had to toil, especially slaving for ten hours a day, in such work the employer, he claimed, would make a tool of the creature and man was not intended to work with the precision of tools, thereby dehumanising him.[587] Ruskin implored his audience to look around their homes, which were furnished by slaves no better than the African or

[582] Walter Crane, 'The Work of Walter Crane, with notes by the artist' in *The Easter Art Annual for 1898 (extra number of the Art Journal)* (London,1898) p.13
[583] Walter Crane, *William Morris to Whistler*, p.5
[584] Boris, *Art and Labour* p.7
[585] John Ruskin, *Unto This Last* (London, 1968, reprint of 1860 edition) p.160
[586] John Ruskin, 'The Nature of Gothic' in JG Links (ed) *Stones of Venice* (London, 1960) pp.157-190
[587] Ibid. pp157-190

Greek slaves and to compare this with the gargoyles on medieval cathedrals which were struck by the imaginative hand. The great civilised invention of the division of labour, Ruskin argued, was a false premise. It was not labour that was divided, but men, 'divided into small segments of men, broken into small fragments and crumbs of life; so that all the little piece of intelligence that' was left in a man was 'not enough to make a pin, or a nail.'[588]

In *Unto this Last*, a lengthy treatise, Ruskin attempted to explain his economic theories. Ruskin believed that merchants or manufacturers in their office as governor of men, were 'invested with a distinctly paternal authority and responsibility.' A youth entering into a commercial practise would, in most cases, be removed from his home environment and therefore would, for all intent and purposes, be without a father. Ruskin believed it was therefore the duty of the master to treat the subordinate as he would treat his own son. Just as a captain would be the last to leave a sinking ship, or share his crust with the sailors in case of famine, so must the manufacturer in times of commercial crisis or distress put duty before self. He should be bound to suffer with his men, and even take more of the burden himself.[589]

Ruskin thought that too often masters felt they could determine the market value of labour, particularly of domestic labour. By fixing the limits of hardship to that of his neighbours, a servant could be expected to do as much work as required of him, with low wages, and being poorly fed and lodged. These conditions could be pushed to the extreme, and the master would not be causing a violation of justice, if the servant were free to leave, to find a better position. This of course, would be impossible if the master had set the limit of hardship with the neighbouring masters. Ruskin argued that this was not the way to get the best service from employees, for the servant was not a machine. The best service was obtained where there was affection between the master and servant, and the amount of work then performed would be of the highest possible standard. He likened this to the armed forces, whereby if an officer applied rules of discipline, to make the regiment effective with the least trouble to himself, he would not develop the full strength of his subordinates. If, however, the officer showed interest in each individual subordinate, and valued their life, he would develop their full effective strength and earn their trust, thus a battle 'charge may be successful' Ruskin argued 'though the men dislike their officers; a battle has rarely been won, unless they loved their general.'[590]

[588] Ibid. p.157-190
[589] Ruskin *Unto this Last* pp.130-131
[590] Ibid. pp.118-121

Ruskin believed in a fixed wage for labourers, just as there were for servants and soldiers. The latter, he argued were paid a fixed wage for a fixed time, unlike the workman who was paid a variable wage according to the demand for his labour, and the risk of being thrown out of work by the vagaries of trade. Ruskin realised there were problems with this idea and it needed careful consideration, as it was necessary to regulate wages so as not to vary the demand for labour, neither enlarging nor diminishing their numbers, so that each workman had a permanent interest in his place of work. Variable wages, Ruskin observed, were a destructive system, for the bad workman might offer his work at half the price, thereby forcing a good workman out of employment or forcing him to work for an inadequate sum. A fixed wage Ruskin continued, meant that the good workman was employed, the poor workman unemployed. It was in 'the interest of both that work should be rightly done and a just price obtained for it; but, in the division of profits, the gain of the one may or may not be the loss of the other.' It would not be in the master's interest to underpay the worker to the extent that he was left sickly and depressed. Neither would it be in the workers' interest, if the master paid such high wages, that his profits be too small to expand the business, or conduct it in a safe and liberal way. 'A stoker ought not to desire high pay if the company is too poor to keep the engine-wheels in repair'.[591]

Ruskin stated that workmen needed a higher wage if the work was intermittent. If a man needed 1s a day to live, then 7s a week must be earned either through 'three days violent work or six days deliberate work'. The master would then be able to check disorderly habits, in both himself and his workforce. Ruskin advocated that the master should keep his business operations on a scale which would 'enable him to pursue them securely, not yielding to temptations of precarious gain' whilst at the same time, 'leading his workmen into regular habits of labour and life.' Ruskin advised that it was better to have a workforce that worked for six days of moderate work and 'wise rest' as opposed to three days violent labour and three days of drunkenness.[592] Unusually though, Morris did not follow this advice, for as was shown in the chapter on Morris, he deployed the services of over one hundred outworkers, mainly in the embroidery department, outworkers whose work was intermittent.

Morris toured the country speaking of his hope of rest, hope of product, hope of pleasure in work itself. First delivered in 1884 and published as a Socialist League pamphlet in 1885, his lecture entitled *Useful Work Versus Useless Toil*, was well publicised throughout Britain.[593] Hope of rest he spoke of first, for as he said, whatever pleasure

[591] Ibid. pp. 117, 122-124
[592] Ibid. pp. 124-125
[593] Morton (ed), *Political Writings of William Morris* p.86

in work, there was always some pain, and therefore one needed hope of rest from that work. The hope of pleasure in work was vital as all living things took pleasure in exercising their energies; even beasts he said rejoiced in being lithe, swift and strong. A man at work, making something, which he felt would exist was,

> *exercising the energies of his mind and soul as well as of his body. ... Thus worthy work carries with it the hope of pleasure in rest, the hope of the pleasure in using what it makes, and the hope of pleasure in our daily creative skill. All other work but this is worthless; it is slaves work, mere toiling to live, that we live to toil.*[594]

Morris agreed therefore with Ruskin's theories that man should find pleasure in his work, stating that 'Nothing should be made by man's labour which is not worth making; or which must be made by labour degrading to the makers.'[595] According to Morton, *Useful Work Versus Useless Toil* was one of Morris's most popular and often repeated lectures, which was most notable for his clear explanation and his position regarding the role of machinery, which was 'more positive than he is often credited with'.[596] As Boris argued, Morris chose whatever processes provided the best art, therefore machinery might be used, provided it did not interfere with the artistic quality of work. He agreed with Ruskin and thought machinery removed the soul from labour, though in Boris's opinion Morris applauded machinery, which removed the drudgery from work.[597] A similar point is made by Powers, who points out that Morris did not deplore the machine as much as claimed, that machines were useful if used to produce worthwhile goods, reduce working hours and increase job satisfaction by leaving more time for creative input.[598]

Art and Socialism, a lecture before the Leicester Secular Society in 1884, and published later the same year as a pamphlet in Leek, indicates that Morris did not deplore the machine quite as much as commonly supposed, rather it was the way in which the machine was deployed that he condemned. Machinery, he thought, was utilised in such a manner as to make life harder for the working man rather than easier, driving all men into 'mere frantic haste and hurry.' Instead of lightening the workload, the converse was true labour had been intensified, adding more

[594] William Morris, ' Useful Work Versus Useless Toil', in A.L.Morton (ed.) *Political Writings of William Morris* (London, 1979) pp87-88

[595] William Morris, 'Art and Socialism' p.123

[596] Morton *Political Writings*. p.86

[597] Boris, *Art and Labour,* pp.9-11

[598] Powers, '1884 and the Arts and Crafts Movement' pp.61-65

weariness to the burden the poor already carried. This system had 'trampled down' art exalting commerce as a sacred religion. Morris claimed 'It was right and necessary that all men should have work to do' which would be worth doing, and 'be of itself pleasant to do; and which should be done under such conditions as would make it neither over-wearisome nor over-anxious.'[599]

Morris and his critics all missed the fact that machinery actually increased handwork in many trades, especially embroidery, as already shown in chapter three. Morris could have seized the day to improve the lot of the embroiderer, thereby using increased handwork to his advantage; instead he forecast that each new machine would bring misery to men, reducing them from skilled workers to unskilled. Factories, he felt, could be centres of intellectual activity if the work were varied and only a portion of time spent on tending the machines. He realised this would make the finished item more expensive, but there had to be some sacrifices. Morris thought that man had not made use of machines, that they were called labour saving machines, but were not utilised in such a way, instead they increased the 'precariousness of life' and intensified the labour of those who operated the machines, 'all in the name of commercial war and profits'.[600]

Morris, perhaps spoke too vehemently on the intensified labour caused by machines, certainly, his words were taken for granted by the Arts and Crafts Movement and his abhorrence of machinery has become an 'historical fact'. However, the opposite is true as he employed industrialised firms to manufacture his goods. Wallpaper was printed by Jefferson & Co. (see plate 7.1), carpets by Heckmondwike Manufacturing Co. and Wilton Royal Carpet Factory. Woven fabrics were produced by Alexander Morton and Co; J.O. Nicholson, H.C. McCrea and Dixons, and linoleum made by Nairn & Co. (see Appendix B).[601] If Morris deplored machines to the extent acclaimed, he would have insisted upon hand painted wallpaper, rugs and textiles, which could be hand woven, as at his factory in Merton, and linoleum would most certainly not have been under consideration. Morris has been much misunderstood, What he deplored was the way in which machines had been put to use. An example to prove this key issue is found in his method of weaving. Morris could have used the draw loom technique, but chose to use the Jacquard loom, which was faster and more accurate. The Jacquard loom however requires pre-programming by punched cards setting the pattern, leaving no room for aesthetic and spontaneous alterations by the weaver. Morris chose to use the hand powered Jacquard loom at his factory in

[599] Morris, 'Art and Socialism' *pp.110-111*
[600] Morris, ' Useful Work Versus Useless Toil' pp.96 - 106
[601] Harvey and Press, *William Morris, Design and Enterprise*, p.143

Merton, but commissioned work from outside contractors who used a power driven Jacquard loom. According to Thompson, Morris could not afford a power driven loom, stating that his capital could not encompass such machinery.[602]

Morris was influenced by the ideas of John Stuart Mill, in whose opinion reiterated by Morris, the modern mechanical inventions had done nothing to lighten the toil of men, and were not made for that end, but to only to increase profitability. With forethought, Morris argued that machinery could have been put to use, removing the drudgery of labour, leaving time for the 'skill of hand and energy of mind.' He asked 'what have they done for us now? Those machines, of which the civilised world is so proud, has it any right to be proud of the use they have been put to by commercial war and waste.'[603] Therein lies a profound problem with embroidery, for often the more tedious work in filling the background were given to less skilled workforce. Indeed, embroidery frequently deployed a division in labour, hence questioning Lucy Crane's theories on working methods. On the one hand she deplored division of labour, attributing the culpability to machinery but on the other hand deploys the method in hand embroidery. Lucy Crane, like her brother Walter, were both disciples of Morris, with a preference for the handmade as opposed to machine made embroidery. The 'Division of labour' she observed, referring to Adam Smith's theory, was 'good for pins, but bad for works of art'.

Ornamentation, which she believed began with 'the mere draughtsman' and ended with 'the mere salesman', deteriorated at every stage, in its change of hands from the original design. Lucy explained this more clearly when she expanded on this theme, in a later lecture, where she admitted that the division of labour was good if it removed the drudgery of manufacture, but was poor for works of art. Elaborating by saying this was primarily the defect of Berlin woolwork, where the pattern was drawn and coloured by one person, materials chosen by another, stitched by a third and very often the background work, stitched by a fourth person. Art needlework, she argued was different, for though the pattern may have been designed by another it was selected, arranged by the worker, who fixed its dimensions, chose the materials, and executed the work, hence the worker had some control over the work process.[604] However that was not always complied with by either Morris or the embroidery societies as often the background work was completed by a lesser skilled embroiderer.

[602] Paul Thompson, *The Work of William Morris*, (Oxford, 1991) p.

[603] Morris, 'Art and Socialism' p.124

[604] Ibid pp. 142-143

Both Morris and Ruskin toured Britain lecturing on their ideals. Under their influence The Arts and Craft movement was formed with associations established throughout Britain and America which had similar aims to influence industry in Ruskinsian traditions, so bringing joy to work, providing fair working conditions and for a fair wage. The majority of art and craft associations recognised that the split between fine art and crafts happened during the Renaissance period,[605] a period which the Arts and Crafts societies wished to emulate, as discussed earlier in the thesis. Most importantly the Arts and Crafts Societies were to have a major impact on embroidery.

The Craftsman Ideal in Britain

In 1893, Morris claimed that the Arts and Crafts Exhibition Society was established to awaken public taste, wishing to call special attention to the 'most important side of art, the decoration of utilities by furnishing them with genuine finish in place of trade finish.'[606] Walter Crane aired his feelings in a more vociferous way when he stated that the very producer, designer and craftsman had lost sight of artistic talent, 'his personality submerged in that of a business form, reached the reduction ad absurdum of an impersonal artist or craftsman trying to produce things of beauty for an impersonal and unknown public'.[607]

Many Arts and Crafts associations were set up throughout Britain and Ireland in the latter part of the nineteenth century; some of the better known ones are listed in Appendix C. Their raison d'être was to promote handmade produce, a rebellion against the industrial revolution and through socialist idealism to provide a better way of life for workers within the industry. Production within each association might be limited to certain products, but most included an embroidery section due to its commercial viability, which will be examined. All the associations have interesting histories, however, the Keswick, Langdale and Windermere industries are reviewed as they had very close ties to Ruskin and his ideals. The Langdale Linen Industry set up by Alfred Fleming had the support and patronage of John Ruskin to produce hand woven linen for embroidery, based on sixteenth century cutwork or reticella embroidery.[608]

[605] Ewles, 'Embroidery' p.76

[606] William Morris 'Preface' to *Arts and Crafts Essays by members of the Arts and Crafts Exhibition Society* (London, 1903) (1893) p.xiii

[607] Walter Crane, ' Of the Revival of Design and Handicraft: with notes on the work of the Arts and Crafts Exhibition Society' in *Arts and Craft Essays by Members of the Arts and Crafts Exhibition Society* (London, 1903) (1893) p.10

[608] Ewles, 'Embroidery', p.77

A local historian, Frederick Benjamin, recorded that the Langdale Linen Industry was formed sometime after 1880 following solicitor Alfred Fleming's move to Elterwater, Westmorland, where he was to make friends with Ruskin who lived nearby at Brantwood, Coniston. Fleming set about reviving the cottage industry of spinning and weaving, which in the early nineteenth century had been a staple industry in the area prior to power looms, providing income, and occupation for the area. He believed in a return to the medieval production of handicrafts as influenced by Ruskin. His housekeeper, Miss Twelves, learnt the art of spinning, which she then taught to local residents and to whom Fleming paid two shillings for a pound of spun flax. According to Barbara Morris, The Langdale Industry produced its first piece of hand-spun, hand-woven cloth in 1884.[609]

Once Miss Twelves had established the Langdale Linen Industry, she went on to teach at the Keswick School of Industrial Design, which by 1889 had formed the Keswick Industrial Society, with a weaving loom set up and, according to Miss Twelves, sufficient orders to keep the spinners busy all winter. Miss Twelves' notes indicate that the Keswick industry was embroidering cloth by 1890, in designs created by W. Christie, of The Keswick School of Industrial Arts. Encouraged by Ruskin the designs were based upon sixteenth-century Greek embroidery, worked both in Greece and Italy. The cloth was cut and threads drawn, the intervening gaps then filled with needleweaving, which resembled lace work. The whole process was called, 'Ruskin Work' in an endeavour to promote the ideals of Ruskin, and in February 1894 he signed an authority for Miss Twelves to use his motto 'Today' for the industry's trademark, the only established industry to be given such authority.[610]

From the Keswick Industry accounts it can be deduced that the embroidery department was successful, in as much that the department eventually had its own set of accounts. Benjamin attempts to itemise some of the Keswick Industry accounts, in which he explains the difficulties, as they do not reach present day standards of accounting practice. Records for 1890 show receipts of £434.0.10 ½ d. and a stock in hand of unbleached linen and embroidery valued at £113.14.3d so it would appear that the business was productive and commercially viable. Accounts for 1892-1893 show that a separate division had been created for The Art Embroidery Branch, which had an opening balance of £115. 3. 9d. During the period November to March, the accounts show the sum of £142. 7. 8d. in receipts.[611] Therefore receipts for embroidery were

[609] Morris *Victorian Embroidery* p.47
[610] Frederick A. Benjamin, *The Ruskin Linen Industry of Keswick,* (Cumbria, 1974) p.29
[611] Ibid. pp. 12-13

roughly a quarter of the total receipts of two years earlier, bearing in mind that the industry's main manufacture was woven cloth, the embroidery enterprise appears to have been extremely lucrative.

Annie Garnett began The Windermere Industries or The Spinnery in 1899. Initially set up for weaving, 'Greek' or 'Ruskin' lace the embroideries were reported by *Art Workers Quarterly* in 1905 to have 'exquisite colour and beauty of design'. Garnett was obviously more business like than philanthropic as she was loathe to use the poor ladies, a class in need of help, as she found them 'hemmed in by tradition'. Most of the embroidery was therefore given to outworkers, chiefly village girls and tradesmen's daughters, who stitched in their spare time. Liberty department store bought some of Garnett's designs, the pattern was traced onto paper, which was sold in store ready to be perforated and copied onto fabric by the customer. So successful were Garnett's patterns that Liberty wrote to her in 1900, in need of more frequent designs.[612]

The commercial viability of embroidery, a way for women to gain independence and the idyll of community craft organisations was bought to the attention of America by The Centennial Exhibition, which was held in 1876 in Philadelphia to celebrate 100 years of independence and to exhibit the nation's progress in trade, manufacture and decorative arts. It also promoted cultural exchange between the United States and Europe.[613]

The Craftsman ideal in America

At the Philadelphia Centennial Exhibition to celebrate one hundred years of independence, Americans were particularly influenced by the work of Walter Crane, the Royal School of Art Needlework, William Morris and Edward Burne-Jones.[614] The exhibition stimulated such interest that a School of Art Needlework was formed at Pennsylvania Museum in 1877.[615] Tuition was initially provided by teachers from the Royal School of Art Needlework sent out from England to instruct in the art of 'Kensington Embroidery'.[616] America set up many organisations, Decorative Arts Society, Woman's Exchange, Needlework Society, Household Art Society, Deerfield Blue and White Industries, Needlework and Textile Guild and School of Art Needlework in Boston Museum of

[612] Jennie Brunton, 'Annie Garnett' pp. 228-231

[613] Amelia Peck and Carol Irish, *Candace Wheeler, the Art and Enterprise of American Design, 1875-1900* (Yale, 2001) p.21

[614] Tessa Paul, *The Art of Louis Comfort Tiffany* (Hertfordshire, 1987) p.29

[615] Blum, 'Ecclesiastical Embroidery' pp.16-21

[616] Ewles, 'Embroidery' p.76

Fine Arts. Some of the organisations developed their own style, of a colonial craft revival, embroidery of eighteenth-century, New England.[617]

Most of the women instructed were of the middle and upper classes and though they were aware of altruistic ventures in Britain, there was not the same sentiment in the United States. Callen argues that this was a society with pioneering spirit, where their grandmothers had wielded shot guns or axes as well as the needle.[618] Nevertheless, there were both philanthropic and commercially viable institutions operating in America. The foremost pioneer of such ventures both commercial and philanthropic was Candace Wheeler, who saw examples of The Royal School of Art Needlework at the Centennial Exhibition and she was inspired by the notion of a female run business which benefited women, and a way in which women could gain emancipation and liberation. There is only one published full account of Candace Wheeler and her work, by Peck and Irish, and the following summarises their findings, for it is important in this study to discover the impact that Britain made upon the embroidery business in America. In her memoirs, Wheeler records the smaller household items, rather than the more elaborate portieres and hangings and stated that the work seemed 'a very simple sort of effort' which she saw as 'easily within the compass of almost every woman.'[619] In other words, whilst she embroidered large wallhangings, she envisaged the production of smaller items a way for women to help themselves by producing cheaper, more commercial items.

Wheeler knew that the success of benevolent societies depended upon attracting women from the upper echelons of society to support the venture. She asked Mrs David Lane, one of the chief organisers of The Metropolitan Fair, who in turn attracted, according to Wheeler 'all the great names in New York,' each paying a hundred dollar subscription fee, which provided the initial funding. Mrs Lane was appointed president and Wheeler as correspondence secretary of the Society of Decorative Arts (SDA). Wheeler's duties were to set up auxiliary societies throughout the States. By the end of her first year she had formed societies in Chicago, Saint Louis, Hartford, Detroit, Troy (New York), and Charleston. The first meeting took place in February 1877 with five people in attendance, three meetings and one month later more than twenty people attended, most of whom became officers.[620]

The objective of the SDA was 'to encourage profitable industries among women' who possessed 'artistic talent, and to furnish a standard of

[617] Callen, *Angel in the Studio*, p.133
[618] Ibid. p.130-131
[619] Peck and Irish *Candace Wheeler*, pp.22-23
[620] Ibid. pp.27-28

excellence and a market for their work'.[621] Initially work was sold anonymously and the society accepted work from men, on the basis that it might keep prices higher, though it appears this venture was short lived.[622] By the end of the first year the SDA had received 6,303 items, but only 2,765 were accepted for sale. The sale of art works brought in $18,416.73 of which ten percent went to the SDA. Instruction in needlework was given to 203 people, classes were also offered in china painting, carving and tile work. A modest fee was paid by the student, or sometimes free if they donated the fruits of their labour, or they might be sent to work as teachers at auxiliary societies in other cities.[623]

The SDA sold various crafts and art work, but the main focus was on embroidery, the standard had to be high and they refused to sell Berlin Woolwork, wax flowers and knitted items. After one year and too many works rejected on grounds of poor design, the society appointed a Design Committee consisting of artist/designer Louis Comfort Tiffany and his fellow artists Samuel Colman, and Lockwood de Forest. Besides deciding on works to be accepted, the committee would also design work to be stitched, paralleling the role of Morris and Crane at The Royal School of Art Needlework.[624] During the first year only 75 orders were executed but by 1878 and the formation of the Committee on Orders for Needleworks, orders had grown to 1,074, though this was mainly prepared work, ready to be finished. By the third year orders had grown to 4,769 from designs belonging to the SDA, or commissioned by architects and New York designers.[625]

Items accepted for sale were kept in the sale room for three months and then returned to the maker at her expense. If sold the SDA took ten percent commission.[626] The salesroom did not fare well at first and so it was decided to hold an exhibition, which would exhibit works loaned by famous socialites to attract attention. The *New York Times* described the 1878 exhibition as resembling a dusky Eastern Prince's palace or the famous corridor of Sir Walter Scott's Abbotsford. According to the report, there was an abundance of tapestries, lace and embroidery though paintings ceramics, antique cabinet work, jewellery and illuminated manuscripts were also on display. The exhibition consisted of two thousand items and ran for six weeks, raising eight thousand dollars from admission fees alone.[627]

[621] Ibid. p.28
[622] Ibid. p.29
[623] Ibid. p.33
[624] Ibid. p.29
[625] Ibid. p.30
[626] Ibid. p.30
[627] Ibid. pp.32-34

The New York Woman's Exchange was opened by Wheeler and others in 1878; it mirrored the SDA but sold utility wares and fancy decorative work from household linens, clothes, needlework and food. The Women's Exchange was a more independently successful venture than the SDA. It organised itself, produced catalogues of its products and services, and ran as a business, whereas the SDA was always dependent upon the ten percent commission, and consistently required subscriptions, donations and fund raising inorder to survive. On the tenth anniversary of The Woman's Exchange it was reported an aggregate amount of $360,000 had established thirty-eight exchanges in other cities and towns.[628]

These ventures obviously led the designer Tiffany to conclude that embroidery had commercial viability, along with the other decorative arts, deciding to set up a business in retailing. In 1879, he asked Wheeler to help him in a new decorating business.[629] Wheeler records in her memoirs, how after a meeting of the SDA, Tiffany approached her to say that he and the designers de Forest and Colman were going into business. He was to work out ideas he had for glass, de Forest was going to India to look up carved wood and Coleman would look after colour and textiles. Wheeler records Tiffany as saying,

It is the real thing, you know; a business, not a philanthropy or an amateur educational scheme. We are going after the money there is in art, but the art is there, all the same. If your husband will let you, you had better join us and take up embroidery and decorative needlework. There are great possibilities in it.[630]

This short statement raises two interesting issues. He clearly saw Wheeler as an independent person, capable of running the embroidery side of the business, whilst acknowledging her 'duty' to ask permission from her husband. Of far more interest though was his recognition that this venture had to be purely commercial, neither a philanthropic venture nor an amateur educational scheme. However, it would appear that the embroidery side of the business did not entirely operate on the commercial basis advocated by Tiffany. Peck and Irish discussed the great confusion over the company's name, but it is sufficicient here to say that Tiffany & Co. were originally three or four different companies, one of which in 1879 was called Tiffany and Wheeler Embroideries. Tiffany and Wheeler Embroidery operated as a school, the scholars being paid for

[628] Ibid p.35
[629] Ibid p.37
[630] Ibid. p.38

their work and instruction. Many of the girls were taken from Cooper's Union art classes, where they were taught drawing and composition. When eventually they became of too great a pecuniary value, or in other words able to command high prices, they were deemed to have graduated and free to take their place as independent decorators.[631]

In 1881, the embroidery department moved to larger premises, the deeds were in Wheeler's name, hence Peck and Irish argue that Wheeler was operating a semi-independent operation. A few months later Wheeler employed forty to fifty women each earning around fifteen dollars per week. In 1883 the partners went their separate ways and Wheeler continued to operate under the name of Associated Artists, employing at times up to sixty staff. The firm concentrated on printed textiles and many were designed such that they were ideal for ornamenting with embroidery. An advertisement in *Harper's Bazaar,* August 1884, stated that the firm was designing on cheaper fabrics such as Kentucky jean, denim and a raw silk, chintzes and cottons, with the 'same care' as devoted to expensive brocades, in order that the aesthetic housekeeper or modest mother of a household may adorn her room. The firm was also famous for it needlewoven tapestries, where loose weave silk was used and stitches woven in and out of the threads, so that they looked like part of the weave.[632]

Art Needlework or native peasant embroideries proved popular both in the United Kingdom and in America. The Arts and Crafts movement enjoyed traditional working methods, whilst department stores such as Liberty and Tiffany ensured its commercial viability, by the very fact, embroidery was sold within their stores. Though the name was not used at the time 'branding' played a part, it was not the item necessarily, more the image the customer was purchasing. To purchase from Morris, Liberty or Tiffany was a conspicuous display of wealth and taste. Throughout this book, the emulation of the upper classes has been revisited on several occasions, and the success of high quality goods such as those produced by Morris, Liberty and Tiffany were much sought after. The Arts and Crafts movement, collectively had a type of brand image, so it must be asked why the centre of production of a popular commodity such as embroidery, cheaply produced and continually sought after, moved from Britain to countries such as France and China.

The Demise of Art Needlework

The ideals of the Arts and Craft movement remained strong into the twentieth century. At a lecture to the Sheffield Art-Crafts Guild *Art*

[631] Ibid. p.46
[632] Ibid. pp.50-53

in the Workshop, 1903, T. Swaffield Brown reminded the members of Ruskin's theories, which the guild had adopted. From the commencement, the guild had dropped 'and' from Arts and Crafts to be known as Art-Craft to foster 'artcraftmanship'. 'The only difference between high or fine art, and applied art' he said 'is that one may be said to apply to the making of beautiful things for the few, and the other to the making of things beautiful for the many.' He warned members that they should not work for financial gain and that satisfaction, pleasure, and the repute that his work brought should provide compensation, otherwise he was not an artist, nor ever likely to be one.[633]

Arts and Crafts it will be argued were on the wane, too concerned with socialist political movements, they mixed their ideals of manufacture with that of politics. They were too concerned about fighting for better working conditions, and they continued to concentrate on traditional working methods, which they considered as the superlative model, dogmatically applying Ruskin's theories, they continued to revolt against mechanisation and mass production. Politics by now had progressed, socialism was more concerned with the plight of the masses, and as the socialist A. R. Orage theorised in 1907, the demise of the Arts and Crafts movement, coincided with the rise of the Labour party. He reasoned that members of the Arts and Crafts were absorbed by the socialist movement, but the socialist movement put their trust in the Labour party, who were more interested in the less skilled worker, than the craftsman. After the death of Morris, craftsmen became more absorbed with their own economic situations, rather than political reform, hence the crafts movement he observed turned into a 'series of little guilds, hole in the corner institutions.'[634]

The turn of the century began to see the closure of many societies and industries, though each for varying reasons. Ashbee's guild in Chipping Campden, Gloucestershire set up in 1902 lasted only a few years, and the co-operative was dissolved in 1908. The guild never really came to fruition; it employed outworkers with an attempt to involve the existing community. Ashbee it seems tried to form a community venture. Boris rather more charitably claims that Ashbee's main fault was that he remained the dominant figure and his middle class background stymied true brotherhood, 'producing a family of brother artisans under a paternal father-artist'. As a business venture it was too far from London, failed to meet the changes in fashion and finally killed by the economic depression of 1907-8.[635] When the war came, the Spinnery's production ceased and became the headquarters for the Windermere War Supply Depot,

[633] T.Swaffield Brown, *Art in the Workshop,* (Sheffield, 1903) pp.1-12

[634] Boris *Art and Labour,* p.17

[635] Ibid. p.17

producing medical supplies such as bandages and splints. It culminated in Garnett being appointed Honorary Censor and Secretary of the War Supply Depot. There seems to have been some effort to revive the business, though this was unsuccessful and after the war efforts were finally defeated by Garnett's ill health.[636]

William Morris's work whilst extremely popular amongst certain elite circles nevertheless was not appreciated by all. Some considered his designs retrospective, looking back to the medieval past, and therefore could not be considered forward looking, innovative designs. As early as 1862, *Building News* scathingly criticised Morris's furnishings for being only fit for a family that awoke after four centuries of sleep, that the furniture was 'no more adapted to the wants of living men, than medieval armour would be to modern warfare.' Two doors of the painted cabinet, the author admits he might keep, but the rest with its 'rude execution and bar ornament of centuries ago' was fit only for the fire.[637] Lanto Synge argued that Morris 'was the principal pioneer of the modern movement but failed narrowly to achieve a style descendent from the wide scope of historical and cultural forms which had influenced him.' He added that Morris neglected the 'philosophy of contemporary technical achievements, and was unable to accept the benefits they had to offer.'[638]

Boris argues that it was commercial competition which played a key factor in the demise of the Arts and Crafts movement. From the early 1880's manufacturers had started to take the lead from Morris, at first copying his designs and later employing their own designers. Boris claims that Walter Crane recognised the impact on consumer goods, he recognised that there was a commercial market and that designs of the Arts and Crafts were being adulterated, mass produced and introduced into the commercial market by those not afraid to adapt them to machine production:

> *A handful of independent workers (inspired largely by a new social ideal) have at least set up a new standard; have created a new class of artist-craftsman and a more or less sympathetic public. No-one supposed they could suddenly transform the factory system and machine production for profit into artistic production for use in the great world; but it is remarkable how quick commercial industry has*

[636] Brunton, *Annie Garnett*, p. 234-236
[637] *The Builder*, (London, 1862) Vol.IX p.99
[638] Synge, *Antique Needlework* p.155

*been to imitate some of the aforesaid artist-craftsmen –
how largely, in fact, it lives upon their ideas.*[639]

Crane's fears were for commerce corrupting the designs of the Arts and Crafts. He was too concerned with self protectionism, and individualism, rather than perceiving how the general populace could be provided with arts and crafts designs, 'Let a band of artists and craftsmen band together. Straightway commercialisation perceiving a demand brings out what it calls art-furniture, art-colours, sucks the brains of designers, steals their designs and devotes them to objects for which they were never attended.'[640] Crane thought that commercialism may seem triumphant 'but the seeds of destruction' lay 'within its bosom' the penalty of which would be paid by nations, systems and individuals, that 'dissolution must inevitably set in'. He believed the beginning of the end was in sight and the only hope for art and humanity lay with socialism.[641] It was these same social attitudes which made Ruskin, and Morris so popular; the rise of the Arts and Crafts movement coincided with a need for relief from the pressures of life, an idyll that grew alongside myths, fairy stories and Christmas. Their attitudes were akin to Canute turning back the tide, yet that need not have proved so, they could have turned technology to their advantage as with Candace Wheeler and Wardle who were producing woven fabric in readiness for ornamentation by embroidery.

With hindsight, it is men such as Christopher Dresser, little written about until recently, that proved a pioneer of design; but his voice was lost in the wilderness of the nineteenth century. In chapter six it was shown how Liberty copied works by Dresser whose designs, modern by today's standards, were more akin to the designs of the Bauhaus, with sleek, minimalist lines, free of all ornamentation. Dresser utilised machinery and appointed manufacturers to make his wares and though some manufacturers did indeed plagiarise his designs, but he protected himself by patenting his designs. From the 1840's Owen Jones had provided designs for mass production, designing stationary, calendars, biscuit wrappers for Huntley and Palmer, decorative and title pages for publishers, wallpapers, textiles and carpets.[642] His influence was also forward thinking and his book entitled *The Grammar of Ornament* discussed in chapter two remains popular source material for designers and artists.

[639] Boris, *Art and Labour*, p.19 citing Walter Crane, 'Art and Industry' in *Moot Points: Friendly Disputes Upon Art and Industry between Walter Crane and Lewis F. Day* (London, 1903) p.41
[640] Walter Crane, *The Claims of Decorative Art* p.136
[641] Ibid. p.138
[642] Kathryn Ferry, 'Writers and Thinkers, Owen Jones' in *Crafts* Vol. no. 198 Jan/Feb. (London, 2006) pp.20-21

It should be remembered also, that the time had come for the passing of most of the great protagonists mentioned within this book, Morris, Wardle, Crane, Liberty, Wheeler and others. Their passing ended an era though their daughters and those they had taught continued to carry on the fight to raise the standard of embroidery. When Morris's daughter took over the running of the company as illustrated in chapter four, she did not move the company forward, choosing instead to remain with the brand image, the Morrisian look. Thirty years after the commencement of Morris's company, May was still appealing to the embroiderer to look to the Middle Ages for inspiration. In *Decorative Needlework,* 1893, she wrote,

> *modern embroidery does not compare favourably with that of any period, but it is the very antithesis to the early art, and it is indeed time that something was done to raise it to a higher level.*[643]

May Morris ultimately moved to teach at the Central School for Arts and Crafts between 1897 and 1907 and lectured at several art schools.[644]

By the turn of the century, with the growth of the women's suffrage movement some of Britain's professional embroiderers gained positions within art colleges. The business environment made it difficult for the artist-craftsman to gain a living, hence they were forced into a position to sell their labour to a manufacturer, become an employer or enter the teaching profession. With the realisation that social upheaval was not going to happen, the Arts and Crafts fraternity believed that education might change the economic and political situation.[645] In 1905 Ellen and Fanny Wright who had both worked for Morris & Co. moved to teach at Camberwell, School of Art,[646] and Mary Newill went to teach at Birmingham School of Art.[647] The greatest protagonist of embroidery teaching was Jessie Newbery at The Glasgow School of Art, built by Charles Rennie Mackintosh in 1897. Jessie moved embroidery design forward, introducing the Art Nouveau style and using more affordable fabrics and in Stewart's words 'helped to bring about a quiet revolution in needlework education'.[648] There was certainly a 'quiet revolution' as the future was to see embroidery entered into the curriculum of universities leading to the formation of City and Guilds embroidery.

[643] NAL Pressmark 43E47, May Morris, *Decorative Needlework,* (London, 1983) p.10

[644] Linda Parry, *Textiles of the Arts and Crafts Movement* (London, 1998) p.136

[645] Boris, *Art and Labour,* p30

[646] Parry, *Textiles of Arts and Craft Movement,* p.153

[647] Ibid. p.140

[648] Imogen Stewart, 'Embroidery and Dress' in Lanto Synge (ed) *The Royal School of Needlework Book of Needlework and Embroidery,* (London, 1986) p.162

Embroidery as an art form was too expensive, only available to the wealthy and as Parry comments, the products of the Arts and Crafts, Liberty and Morris could only be afforded by the middle class. For the majority of people all the objects shown in the 1851 exhibition were still available in their 'infinite variety.'[649] High quality embroidery though, remained a fashionable commodity for evening dress in the early twentieth century, even day dress was according to Ashelford 'a delicious concoction of delicate silk chiffons and crêpes in soft pastel shades overlaid with yards of fine lace, embellished with embroidery and trimmings'. The centre of production, she states, had shifted back to Paris. By 1900, the French couture houses were the Mecca for fashionable women all over the world, where Ashelford states ten of the leading houses were run by women.[650] The First World War brought no demise to the upper middle class dress, in fact the opposite was true, and the twenties, hedonistic flapper girls wore embroidered, beaded and sequined evening wear and headdress. Haute Couture evening dress was often covered with layers of net, heavily bead embroidered, and although Luxeuil in France developed a method of machine embroidering sequins, beads still had to be embroidered by hand; a method which still deployed sweated labour.

The firm of Worth also made lavish embroidered evening gowns as well as softer embroidered garments for day wear. By 1926, the opening of Tutankhamen's tomb inspired garments reflecting Egyptian art, embroidered in soft colours, 'a glittering mass, punctuated with gold, silver and black.'[651] The 1930's saw a return to romantic clothes by designers such as Norman Hartnell, who would often use Botticelli's paintings for inspiration in designing his embroidered and beaded gowns. Ball gowns made by a couturier house might have a mixture of hand, machine and bead embroidery, which could take up to three hundred hours of work. The 1950's brought American gingham to Europe and with it, a revival of smocking and broderie anglaise. Even the space age, 1960s did not see the demise of embroidered garments.[652]

Throughout the first half of the twentieth century, embroidered garments were generally only available to the upper middle class. It was not until the advent of the hippy movement and 'flower power' that embroidery influenced by India made a major revival, seemingly within reach of the general populace, though it could be argued, that the majority of hippies came from middle class families. The twenty-first century

[649] Linda Parry 'Arts and Crafts' in Michael Snodin and John Styles *Design and the Decorative Arts, Britain 1500-1900* (London, 2001) p.366
[650] Ashelford, *Art of Dress, Clothes and Society*, pp.246-249
[651] Stuart, 'Embroidery and Dress' pp.162-163
[652] Ibid.pp.166-167

finally saw yet another revival of Indian embroidered garments, on a much larger scale. Half way through the first decade stores from cheap boutiques to haute couture are full of embroidered garments, handbags, belts, shoes and cushions, some machine embroidered, but mainly hand embroidered, or a combination of both. As Britain's economy changed from a manufacturing nation to a service nation embroidered items began being imported from countries with cheap labour. Hence, embroidery provides a livelihood for women in developing countries, and the redistribution of wealth.

The trichotomy mentioned in the introduction remains in existence, embroidery continues to be a hobby, a viable business venture and an art form, yet the later two characteristics are generally recognised only by the initiated and embroidery remains firmly categorised as a hobby. On the domestic front the popularity of embroidery never diminished, hobbyists both male and female continue to stitch Berlin woolwork, simple Jacobean trailing flowers upon antimacassars, pictures of crinoline ladies amongst hollyhocks, cross stitch pictures of rocking horses and country cottages more often than not on closely woven fabric, where the background need not be filled. Yet there remained a hard core of professional embroiderers academically qualified, producing innovative work with new techniques. Such embroiderers exist today, many educated in fine art, who choose to use cloth, fibres and threads as their working materials.

The one legacy left by the Arts and Crafts movement was to see embroidery lifted to academic status, to see it finally recognised as an art form. Though still denigrated by many as a craft, embroiderer Hannah Frew Paterson MBE trained at the Glasgow School of Art commented on the fact that in all areas of art, there have been leaders and followers and amateur painters excessively outweigh the number of famous artists. In embroidery she stated, the innovators are copied by the many, thereby denigrating the work of the originator. 'Outstanding embroidery' she said demanded 'not only the originality of concept, but the skill and sensitivity of relating stitch, thread, texture and craftsmanship to that concept in order to lift it above the vast majority of mediocre work.'[653] That concept is better described by her colleague Michael Spender, Director of the Embroiderers Guild, when he proclaimed that,

> *There has to be a struggle, self searching and strong belief in what you are saying and how you are saying it, before it begins to show in the end result. If the thought and content is not strong enough, no amount of excellently*

[653] Hannah Frew Patterson, 'How do we break down the barriers of indifference put up by art critics, serious art collectors and gallery owners?' in *Art of the Stitch* exhibition catalogue for the Embroiderers Guild International Open Exhibition, 1995 (London, 1995) p.10

worked, skilful embroidery will make it a worthy art object.
Equally so, a brilliantly conceived piece will be badly let
down by unskilled craftsmanship.[654]

These are the words we hear from forward thinking artists, they
could and should have been spoken by Ruskin, Morris and their
contemporaries. However, they were not the great pioneers as often made
out to be. The Arts and Craft movement were not forward thinking, they
were too introspective, and looked back to the medieval period, calling for
better design schools, and yet did not teach design themselves, preferring
to train copyists. Powers argues that a range of radical developments in
politics and beliefs shaped the Arts and Crafts movement and which was
ultimately linked to the time of its origins.[655] They followed Ruskin's
ideals too closely, they were not adaptable to modern taste and
persistently supplied goods that only the wealthy could afford. Nikolaus
Pevsner considered William Morris as being one of the first great pioneers
of modern design, whom he said laid the 'foundations of modern style
which Gropius ultimately determined.'[656]

Pevsner was obsequious to Morris, though in hindsight there is
some sympathy with his train of thought as he wrote these words in 1936,
the work of Walter Gropius, appertaining at that stage to Germany and
America. Gropius formed small workshops similar to the Arts and Crafts
movement, the Werkstaadt and the Bauhaus, but they embraced new
materials, new technology such as tubular stainless steel for furniture.
Their work was innovative, imaginative and most importantly minimalist,
after the second world war their designs fed a host of designers making
goods for the masses. Giedion acknowledged the influence of Gropius on
modern design, but recognised that the original thinkers were from the
Henry Cole, Owen Jones and Richard Redgrave circle, all involved with
the Great Exhibition of 1851. Giedion traces Owen Jones designs and
their direct influence upon Art Nouveau, the group's failure, was to
proffer a new artistic vision, one in which Ruskin and Morris succeeded.
Yet Giedion, criticised the Arts and Crafts Movement complaining 'To
refute mechanisation is not to cope with it'.[657]

Peter Floud, whilst employed by the V&A museum studied
Morris's designs declaring that the revolution in design had started some
ten years before MMF by Pugin and Owen Jones who both said design
must be flat. Morris's designs were never truly representational or three

[654]Michael Spender, 'Why Stitch?' in *Art of the Stitch* exhibition catalogue for the Embroiderers Guild
International Open Exhibition, 1995 (London, 1995) p. 8

[655] Powers '1884 and the Arts and Crafts Movement' pp.61-65

[656] Nikolaus Pevsnor, *Pioneers of Modern Design,* (Middlesex, 1960) (1936) p.39

[657] S. Giedion, *Mechanisation Takes Command'* (Oxford, 1948) pp.346-349

dimensional, but were never flat in the sense of Jones's which were completely flat. Jones's designs appear to be no thicker than strips of paper cut out, whereas Morris's floral patterns looked 'grown'. Morris never reinforced the revolution for flatness in design and Floud considered that he 'actually reacted against it and, to some extent, turned the wheel backwards.'[658] From a design perspective, the Arts and Crafts movement complied too rigidly to the teaching of business practise and economics of Ruskin and Morris. They clung to the past and failed to embrace technology in the way that modernist groups such as the Bauhaus managed.

It might be thought therefore with a reprint of *Pioneers of Modern Design* in 1960, Pevsnor might have altered his words, but the 1960s saw a revival in William Morris' work. The British populace forever looking back to the past building Tudor style supermarkets, Elizabethan style Barratt homes and more recently shopping malls in classical style with palisades, columns and domes. The arts and crafts survive and thrive mainly in quaint holiday resorts to feed the tourists with holiday souvenirs. Pevsnor's attesting to Morris being a pioneer however is perhaps unintentionally retracted by his comments that Morris' style became broader and statelier, losing its youthful and adventurous charm, especially in carpet design, which borrowed from oriental carpets.[659] He in other words was a copyist of oriental design and the medieval gothic. From an economic perspective, Britain's manufacturing economy was changing, embroidery production along with others was sent abroad as the British economy changed to that of a service nation. Nevertheless, Ruskin, Morris and the Arts and Crafts movement created business and philanthropic ventures in embroidery which were relevant for the time.

[658] Peter Floud, 'Morris as an Artist: A new View' in *The Listener,* October (London, 1954) pp.562-564
[659] Ibid. p.49

Plate 1.1

FA Caulfield and BC Saward, *The Dictionary of Needlework*, *(Exeter, 1989)*
facsimile of 1885 edition)

Top: Richelieu Guipure p. 425
Bottom: Renaissance p.421 (see p.29)

Plate 3.1
James Collinson, *For Sale*, *1857* oil on canvas
Courtesy of Castle Museum, Nottingham (see p.57)

FELICITOUS QUOTATIONS.

Hostess (of Upper Tooting, showing new house to Friend). "WE'RE VERY PROUD OF THIS ROOM, MRS. HOMMY. OUR OWN LITTLE UPHOLSTERER DID IT UP JUST AS YOU SEE IT, AND ALL OUR FRIENDS THINK IT WAS *LIBERTY!*" *Visitor (sotto voce).* "'OH, LIBERTY, LIBERTY, HOW MANY CRIMES ARE COMMITTED IN THY NAME!'"

Plate 6.1
Punch Cartoon - Barbara Morris, *Liberty Design, 1874–1914* (London, 1989) (see p.12)

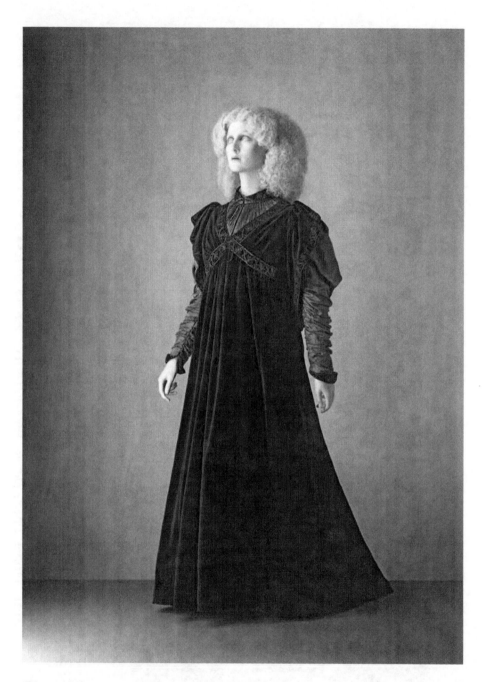

Plate 6.2
Liberty Dress, ca. 1905, embroidered silk velvet
© Victoria and Albert Museum, London (see p.132)

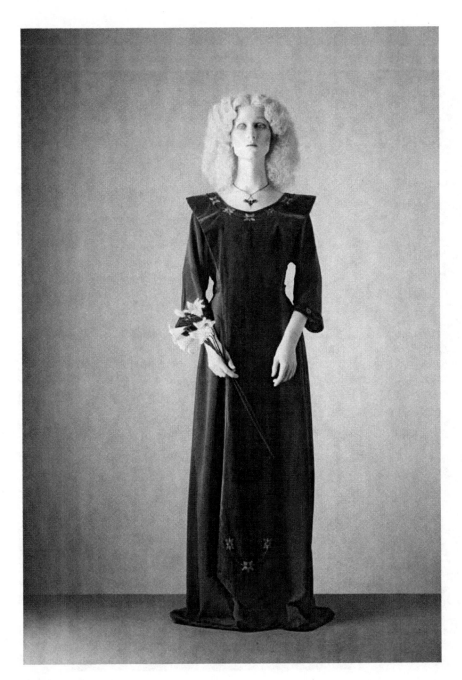

Plate 6.3
Liberty dress, ca.1905, crepe dress with embroidered velvet tabard
© Victoria and Albert Museum, London (see p.132)

Plate 6.4
Harrods, Jane Ashelford, *The Art of Dress, Clothes and Society 1500-1914* (London, 2000) (See p.133)

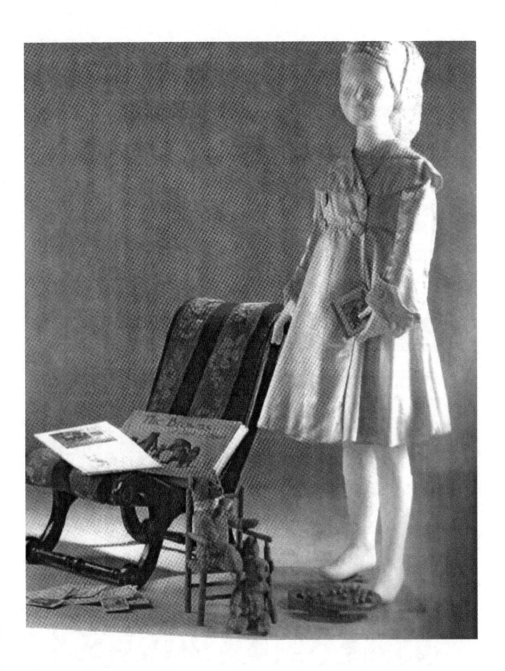

Plate 6.5
Girls Sailor Suit – Jane Ashelford, *The Art of Dress, Clothes & Society 1500-1914*
(London, 2000)
(See p.134)

Plate 7.1
Michael Snodin & John Styles, *Design and Decorative Arts, Britain 1500-1900* (London,2001) p.33
(See p.150)

APPENDIX A
from page 77

There remains now but the embroideries and the painted glass to complete the review of our exhibit. We will turn to the embroideries in the next room.

EMBROIDERY must have been in its origin a much later art than tapestry, unless we suppose the dressed skins which preceded cloth were ornamented by stitches. If embroidery was originally an attempt to ornament plain pieces of woollen or silken cloth, the loom is presupposed for the making of the cloth; and the original loom, we have described, being as fit for pattern weaving as for plain, the pattern or border would scarcely take longer than the unpatterned part. Decoration by means of the needle, after the weaving, therefore, implies such improved mechanism of the loom as would take the weaving of plain cloth a much quicker thing than pattern weaving. It must therefore, have followed the invention of the shuttle.

The use of the shuttle at once quickened the process of weaving but made all pattern weaving, except the merest plaids, impossible for many years to come, - until, in fact, the apparatus we now calla Jacquard was, not invented, but prototyped. The first embroideries were no doubt very simple affairs of borderings and powderings, and the weaver in course of time found means to imitate some of these; and since then has continually increased the size and richness of his patterning, but under conditions that limit him in many ways. He has succeeded in restricting the field of the embroiderer, but not in replacing him, and he never will do that. There will always be a limit to pattern- making by the loom, even by the tapestry-loom, the ablest of all; and outside that limit, embroidery is supreme.

This unapproachable ground is therefore the proper field for the embroiderer; and his occupation of this ground - or of the lost country where the weaver, of whatever kind, is his superior in price and style - a is good test of the embroiderer's understanding of his art. We sometimes see a needle-worker trying to enrich a beautiful damask with cobble-stitch, or wasting much time in doing what the loom would do much better. Embroidery, to be worth doing, should in our opinion, achieve something that cannot be so well done in any other way. Its advantage lies in the perfect freedom of the worker, in the means it gives him to do what is quite unattainable by other means. When therefore, we see embroidery getting daily coarser in a foolish competition with machine work, and hear the boast that the machine can "produce the effects of the best class hand-work, it is not useless to show of what the art is capable.

The large, framed piece is a work of pure embroidery. The surface is completely covered with stitching, so that the effect is wholly produced by the needle. The workmanship, we will venture to say, is quite unrivalled.

Notice the perfect gradations of shade and colour; how truly the lines radiate with the growth and play of leafage, and how perfectly the lustre of the silk is preserved! The perfect beauty of the colouring is also due, in great part, to the sympathy and skill of the worker. How would it have been possible for any master, otherwise, to have directed the choice of so many shades, and to have obtained that blending of them which is part of refinement of the work? Notice, also, how skilfully the ground has been used to modify the tint where gradations too subtle for the dyer were needle. This is truly a work 'sui generis'.

Oil painting would have less depth and lustre; the Jaquard loom could not have given the immense variety, not the tapestry loom the purity of gradation. It is emphatically embroidery, and we may say, without affectation, embroidery at its best. But what is it for? Well, it is permitted to some things to be simply beautiful, and no other service is asked of them. This is more beautiful than many useless things we buy and are proud to possess. If it should not be found worthy to join one of the collections of rare and beautiful things in America, it may perhaps find a place in the South Kensington Museum, as a model of excellence in this art. It was exhibited for a short time in our show-room in London before this Exhibition opened. Its value in the United States is $2000. The size is 7 feet 9 inches by 5 feet 9 inches.

We are not exhibiting any other work quite so beautiful as this, but there are a few in the case only inferior to it The most important is a coverlet worked after the same manner, but with filoselle upon cotton. It is about 6 feet 9 inches long by 4 feet 6 inches wide. There is a border of about 12 inches; inside this the ground is covered with pale gold, on which the design, freely flowing from the centre, is inlaid with yellow green, blue, pain, purple, and dark-green. The border has a pink ground, with pale-blue, deep-blue, light-green, dark-green, purple, and yellow, - the inner and outer lines of the border being blue. The subdued sheen of the filoselle makes this beautiful piece of work not to magnificent for its purpose. It is lines with silk and fringed.

As a sample of another kind of work is a table -cover of blue cloth, embroidered with silk twist. The work is necessarily of a firm close kind; and the design is adapted to it, being somewhat more conventional in its form and treatment. The stitch, we may say, is not chain stitch, as so many visitors seem to think.

A quite different kind is represented by the embroidered cushion, which is intended to exhibit the full richness of floss. To get that, the silk

is laid on the surface in long tresses, and bound to it by stitches which make a diaper pattern. This kind of embroidery is of course only fit for shapes that can be treated flatly. The flowers , which give variety and scale to the pattern, are worked with ordinary embroider-stitch

In the same case are many smaller things, - chair-backs, five-o'clock tea-cloths, &c., - worked mostly on linen, with washable silks; and there are some pieces of the simpler kind prepared for finishing.

The silks and wool we sell for embroidery are of our own dyeing, and are all washable.*

[* It may be a proper caution to say that for such washing only pure toilet soaps should be used, and the object must not be soaped, but immersed in a warm lather made with soap.]

To this explanation we are almost ashamed to add that none of the work is done by machinery. This announcement has already caused much surprise by visitors, who have asked if the work was really done by hand. It is equally surprising to us that there should be any belief the embroidery we are exhibiting could be done by means less delicate in operation, and less sensitive to the least change of the worker's intention. Our preliminary remarks will have shown that we consider the province of embroidery outside of all kinds of mechanical work. Machine-embroidery, lace-making, and weaving have all uses quite distinct from those of hand embroidery.

APPENDIX B
from page 146
Thomas Hood (1799-1845)

The Song of the Shirt

With fingers weary and worn,
With eyelids heavy and red,
A Woman sat, in unwomanly rags,
Plying her needle and thread---
Stitch! Stitch! stitch!
In poverty, hunger, and dirt,
And still with the voice of dolorous pitch
She sang the Song of the Shirt!

Work! Work! Work!
While the cock is crowing aloof!
And work---work---work,
Till the stars shine through the roof!

It's O! to be a slave
Along with the barbarous Turk,
Where woman has never a soul to save
If this is Christian work!

Work---work---work
Till the brain begins to swim,
Work---work---work
Till the eyes are heavy and dim!
Seam, and gusset, and band,
Band, and gusset, and seam.
Till over the buttons I fall asleep,
And sew them on in a dream!

O, Men with Sisters dear!
O, Men! With Mothers and Wives!
It is not linen you're wearing out,
But human creatures' lives!
Stitch---stitch---stitch,
In poverty, hunger, and dirt,
Sewing at once, with a double thread,
A Shroud as well as a Shirt.

"But why do I talk of Death!
That Phantom of grisly bone,
I hardly fear his terrible shape,
It seems so like my own---
It seems so like my own,
Because of the fasts I keep;
O God! That bread should be so dear,
And flesh and blood so cheap!

"Work---work---work!
My labour never flags;
And what are its wages? A bed of straw,
A crust of bread---and rags,
That shatter'd roof, ---and this naked floor---
A table---a broken chair---
And a wall so blank, my shadow I thank
For sometimes falling there!

Work---work---work!
From weary chime to chime,
Work---work---work!
As prisoners work for crime!
Band, and gusset, and seam,
Seam, and gusset, and band,
Till the heart is sick, and the brain benumb'd.
As well as the weary hand.

Work---work---work,
In the dull December light,
And work---work---work,
When the weather is warm and bright---
While underneath the eaves
The brooding swallows cling,
As if to show me their sunny backs
And twit me with the spring.

"O, but to breathe the breath
 Of the cowslip and primrose sweet!---
With the sky above my head,
And the grass beneath my feet;
For only one short hour
To feel as I used to feel,
Before I knew the woes of want
And the walk that costs a meal!

"O, but for one short hour!
A respite however brief!
No blessed leisure for Love or Hope,
But only time for Grief!
A little weeping would ease my heart,
But in their briny bed
My tears must stop, for every drop
Hinders needle and thread!

"Seam, and gusset, and band,
Band, and gusset, and bank,
Bank, and gusset, and seam,
Work, work, work,
Like the Engine that works by Steam!
A mere machine of iron and wood
That toils for Mammon's sake---
Without a brain to ponder and craze
Or a heart to feel---and break!"

--With fingers weary and worn,
With eyelids heavy and red,
A Woman sat, in unwomanly rags,
Plying the needle and thread—
Stitch! stitch! stitch! stitch!
In poverty, hunger, and dirt,
And still with a voice of dolorous pitch---
Would that its tone could reach the Pitch!---
She sang this "Song of the Shirt!"

Product range of Morris & Co. after completion of the Move to Merton Abbey, 1882

Product or Service production	Entered production	Main source(s) of design	Main place(s) of
Stained glass	1861	Burne-Jones	Merton
Hand –Painted tiles	1861	Bought in	William De Morgan's Merton Works
Furniture	1861	MMF & Co, bought in	Great Ormond Yard and Brazenose Street Manchester
Embroidery	1861	Morris	Outworkers
Wallpapers	1864	Morris	Jeffrey & Co, Islington
Carpets:			
Hammersmith	1879	Morris	Merton
Kidderminster	1875	Morris	Heckmondwike Manuaturing Co. Yorkshire
Wilton	c. 1877	Morris	Wilton Royal Carpet Factory Ltd, Wiltshire
Brussels	c. 1877	Morris	Wilton Royal Carpet Factory Ltd. Wiltshire
Real Axminster	?	Morris	Wilton Royal Carpet Factory Ltd. Wiltshire
Patent Axminster	1876*	Morris	Wilton Royal Carpet Factory Ltd. Wiltshire
Printed fabrics	1868**	Morris	Merton
Woven fabrics	1876	Morris	Alexander Morton & Co. Darvel (silk and wool) J.O. Nicholson, Macclesfield (silk, silk and wool) H.C. McCrea, Halifax (silk and

Wool)

Dixons, Bradford (lightweight
Woollens)

Tapestry		1881	Morris, Burne-Jones	Merton
Linoleum	1875	Morris		Nairn & Co. Kirkcaldy***
Upholstery service	?	n.a.		Great Ormond Yard
Interior design and decorating service	1862	Morris		n.a.
Carpet and fabric- cleaning service	early 1880s	n.a.		

Notes: * Date of first registration of design. It is not known when this design went into production, although a second design is known to have been produced in 1880.

 ** A few printed fabrics were produced for the firm by Thomas Clarkson of Preston. Quantity production began after 1876 as a result of Morris's association with Thomas Wardle.

 *** Tentatively identified by Parry.

Sources; H.C. Marillier, *History of the Merton Abbey Tapestry Works* (1927); L. Parry, *William Morris Textiles* (1983) P. Thompson, *The Work of William Morris* (1967) ; R. Watkinson, *William Morris as Designer* (1970)[660]

APPENDIX D
from page 152
Committees and Work Societies

- The Royal School of Needlework, Exhibition Rd. South Kensington London
- The Decorative Needlework Society 45 Baker St. London
- The Ladies Work Society 31Sloane St London
- The Society for promoting female Welfare 47 Weymouth St. London
- The Ass. For the sale of work of Ladies of Limited Means 47 Gt. Portland St London.
- The Working Ladies Guild, 113Gloscester Rd London
- The Ladies Industrial Society 11 Porchester St London
- Gentlewomen's Work Society 56 Regent St. London

Harvey and Press, *William Morris, Design and Enterprise,* p.143

- The London Institute for the advancement of Plain Needlework 40 Upper Berkley St. London.
- Ladies School of Technical Needlework and dressmaking 42 Somerset St. London.
- The Church Heraldic and Artistic Department 15 Dorset St London.
- Mrs Elliott's Work Society 28 Cornhill London
- Miss Reidell's Work Department 44 Sussex Place London
- The Ladies Work Department 39 George St. London
- Ladies Work Society 131 Edgware Rd London
- The Co-operative Needlewoman's Society 18 Theobald Rd London
- The Ladies crystal Palace Stall 2 The Glen Forest Hill London
- The Royal Charitable Repository The Parade Leamington Spa
- Gentlewomen's Home Work Association Surbiton London
- Gentlewomen's Aid Society 55 Waterloo St Brighton
- Department for the Sale of Work by Ladies of Limited Means 2 Portland St Bristol.
- The Ladies Work Society 83 Bold St. Liverpool
- The Ladies Work Bazaar 5 Newington Liverpool
- The Ladies Work Society 217 Lord St. Southport.
- Yorkshire Department for the Sale of Ladies Work 9 Oxford Place Leeds.
- Art Department 8 Alfred Street Plymouth
- Mrs Geyselman's Department for Ladies Work 2 Lover Uncroft Torquay.
- The Ass for the Sale of Work of Ladies of Limited Means 3 Castle St Reading
- Irish Ladies Work Society 25 Mellifort Ave Co. Dublin

Barbara Morris *Victorian Embroidery* (London,1962)

Primary Sources
Archives

National Art Library (NAL) Victoria and Albert Museum
Pressmark:A47 Box 1 Thomas Wardle, *Colonial and Indian Exhibition, 1886, Empire of India. Special Catalogue of Exhibits by the Government of India and Private Exhibitors. Royal Commission and Government of India si Court.* (London,1886)

Pressmark: 43.A.2 (J) *Vice presidents Report to the Council, 1875*

Pressmark: 86.CC.3 *Special Collection, Day Book concerning work done by May Morris and her assistants for Morris & Co. 1892 Nov. – 1896 Nov.*

Pressmark:86.CC.31 *Day book concerning work done by May Morris and her assistants, 1896 Nov. mainly for Morris & Co. 1892 Nov.*

Pressmark Lib 8 *Eastern Art and Other Embroideries*

Pressmark 77.1 *Liberty's, 1875-1975 : exhibition guide* (London 1975)

Pressmark Lib. 1 *Eastern Art Manufactures and Decorative Objects* (London 1881)

Pressmark Lib. 50 *The Arms of Greece (particulars of a unique collection of modern Greek Embroideries),* (London, 1898)

Pressmark Lib.7 *Catalogue of a Valuable Collection of Ancient and Modern Eastern Art and Other Embroideries,* November 1885

Pressmark 43.00 Box 11 Debenham & Freebody *Catalogue of Exhibition of Embroideries and Brocades* London 1896

Pressmark 43 C108 Debenham and Freebody *Exhibition of Old English Samplers* London 1901

Pressmark 43 E 109 Debenham & Freebody *Exhibition of Old Embroideries* London 1902

Pressmark 43E1H Debenham & Freebody *Catalogue of an Exhibition of Antique Embroideries* London April 1904

Pressmark 43E47, May Morris, *Decorative Needlework,* (London, 1983)

Hammersmith and Fulham Archives Department
Accession No. DD/235/1 MMF & Co. Minute Book, 1861 -1874

Staffordshire Records Office, (SRO)
D618 *transcript of 61 letters from William Morris to Wardle of Leek, 13 April 1877*

Nicholson Institute, Leek (NI)

Box A, Wardle, T. *Monograph of the Wilds Silks and Dye Stuffs of India, Illustrative of Specimens exhibited in the British India Section of the Paris Universal Exhibition of 1878*, London 1878

Box C: *Pamphlets and Correspondence Relating to Lady Wardle and the Leek Embroidery Society, several letters, from various royal households.*

Box C cutting from *The Queen* 1885, (no page number)

Box C, cutting from *The Lady* 7 February 1888 (no page number)

Box C cutting from *Glasgow Evening News,* March, 1892 (no page number)

Trade Directories

Bennett (ed.), *Bennett's Business Directory for Derbyshire* (Birmingham, 189[-])
Bulmer (ed.), *Bulmer's History and Directory for Derbyshire, 1895,* (Derby,1895)
Kelly (ed.), *White's Sheffield District Directory, 1898-1899,* (London,1899)
Kelly (ed.), *Kelly's Directory of Staffordshire*(London, 1900)
Sutton, Alfred, *Sutton's Directory of North Wales, 1889-1890*
White (ed.), *Directory of Sheffield and District, 1872* (London, 1872)
White, *White's Directory of Staffordshire* (London, 1851)

Books

Baudelaire, Charles, 'The Artist, Man of the World, Man of the Crowd, and Child' in Jonathan Mayne (ed.), *The Painter of Modern Life and Other Essays,* (London, 1964) (reprint of 1863)

Brontë, Charlotte, *Shirley,* (Middlesex,1974)(reprint of 1849)

Craik, Dinah Mulock, 'On Sisterhoods, A Women's Thoughts about Women' in Elaine Showalter (ed.) *Maude and on Sisterhoods* (London, 1993)

Crane, Lucy, *Art and the Formation of Taste,* (London, 1882)

Crane, Walter, *An Artists Reminiscences,* (London, 1907)

Crane, Walter, *The Claims of Decorative Art,* (London, 1892)

Crane, Walter, 'Of the revival of Design and Handicraft: with notes on the work of the Arts and Crafts Exhibition Society in William Morris (ed) *Arts and Crafts Essays by Members of the Arts and Crafts Exhibition Society* (London,1903)

Crane, Walter, *Morris to Whistler, papers on art and craft,* (London, 1911)

Disraeli, Benjamin, *Sybil: or the two nations,* (Oxford, 1926) (reprint of 1845)

Dickens, Charles, *Hard Times,* (London, 1969)

Dresser, Christopher, *Japan and its Architecture, Art and Art Manufactures,* (London, 1882).

Du Maurier, George, 'Punch, October 20 1894' in Calloway, Stephen (ed) *Liberty of London, Masters of Style and Decoration* (London 1992)

Eastlake, Charles, *A History of Gothic Revival,* (Leicester, 1970) (reprint of 1872 edition)

Eastlake, Charles, *Hints on Household Taste* (London, 1868)

Image, Selwyn, 'On Designing for the Art of Embroidery' in William Morris (ed.) *Arts and Crafts Essays by members of the Arts and Crafts Exhibition Society,*(London, 1903) (1893*)*

Jones, Owen, *The Grammar of Ornament,* (Hertfordshire, 1986) (reprint of 1856 edition)

Kingsley, Charles, *Alton Locke, Tailor, and Poet, an Autobiography,* (London, facsimile of 1862)

Mackail, J.W., *The Life of William Morris,* (London, 1922)

Marx, Karl, 'The Theory of Compensation as regards the Workpeople Displaced by Machinery in *Capital* (reprint, Oxford, 1999)

Marx, Karl, 'The Future results of British Rule in India (1853) cited in frontispiece, V.G. Kiernan *Imperialism and its Contradictions* (London, 1995)

Mayhew, Henry, in E.P. Thompson and Eileen Yeo (eds) *The Unknown Mayhew: selections from the 'Morning Chronicle' 1849-1850,* (London, 1971)

Mayhew, Henry, in Anne Humphreys (ed.), *Voices of the Poor, selections from The Morning Chronicle, 1849-1850,* (London, 1971)

Morris, William, 'Art and Socialism' in C.D.H. Cole (ed.) *William Morris, Selected Writings, (London, 1948)*

Morris, William, 'Textiles' in William Morris (ed.) *Arts and Crafts Essays by members of the Arts and Crafts Exhibition Society,* (London, 1903) (1893)

Morris William, 'Preface' to *Arts and Crafts Essays by members of the Arts and Crafts Exhibition Society* (London, 1903) (1893)

Morris, William. (ed.), 'Introduction' in *Arts and Crafts Essays by members of the Arts and Crafts Exhibition Society,* (London, 1903) (1893)

Morris, William, 'Art and Plutocracy, 1883' in Morton, A.L. (ed.) *Political Writings of William Morris* (London, 1979)

Morris, William, 'The Lesser Arts' in Morton, A. L. (ed.) *Political Writings of William Morris* (London, 1979)

Morris, William, ' Useful Work Versus Useless Toil', in A.L.Morton (ed.) *Political Writings of William Morris* (London, 1979)

Morris, May, 'Of Embroidery' in William Morris (ed.) *Arts and Crafts Essays by members of the Arts and Crafts Exhibition Society,*(London, 1903) (1893)

Pugin, AWN, *Contrasts* (New York, 1969) (reprint of 1836 edition)

Pugin, AWN, *The Present State of Ecclesiastical Architecture* (London, 1969) (reprint of 1843 edition)

Ruskin, John, 'Nature of Gothic' in J.G. Links (ed.) *The Stones of Venice* (London, 1960)

Ruskin, John, *Unto This Last* (London, 1968, reprint of 1860 edition)

Smith, Adam, *Wealth of Nations,* (Oxford, 1998)

Swaffield T. Brown, *Art in the Workshop,* (Sheffield, 1903)

Turner, Mary, E. 'Of Modern Embroidery' in William Morris (ed.) *Arts and Crafts Essays by members of the Arts and Crafts Exhibition Society,*(London, 1903) (1893)

Veblen, Thorstein, *The Theory of the Leisure Class,* (New York, 1994) (reprint of 1899 edition)

Wyatt, Digby, 'On Renaissance' in Owen Jones, *The Grammar of Ornament* (Hertfordshire, 1986) (reprint of 1856)

Yonge, Charlotte Mary, *Womankind,* (London, 1877)

Zola, Émile, *The Ladies Paradise,* (California, 1992) (reprinted from first edition, 1883)

Journals

'Art Trades' in *The Arts* October (London,1886)

Art Journal, 1870

The Artist 1881

'Art Trade, Decorative Needlework' in *The Artist, journal of home culture* (London, 1886)

'Art Work for Women' in *Art Journal,* (London, 1872)

Crane, Walter The Work of Walter Crane, with notes by the artist in *The Easter Art Annual for 1898 (extra number of the Art Journal)* (London,1898)

'Furniture and Decoration at the Royal School of Needlework.' in *The Artist, journal of home culture,*(London, 1884)

Stewart, J., 'Art Decoration, a suitable employment for Women in *Art Journal,*(London, 1860)

Ladies Field, October 22, 1898

Liberty, Arthur, 'Spitalfields Brocades' in *The Studio*, Vol. 1 1893

'Notes of an Exhibition of the School of Art Embroidery' in *Art Journal* (London, 1876)

Paliser, Mrs Bury, 'The School of Art Needlework, in *Art Journal* (London,1877)

Parkes, Kineton, 'The Leek Embroidery Society' in *The Studio* Vol.1, 1893

Parkes, Kineton, The Arts and Crafts Exhibition, 1893 in *The Studio* Vol. 2 1894

General Sources

Adburgham, Alison, *Liberty - A Biography of a Shop.*(London, 1975)

Addleshaw, G.W.O. and Etchels, F., *Architectural Setting of Anglican Worship* (London, no date)

Anscombe, Isobel and Gere Charlotte, *Arts and Crafts in Britain and America,* (London, 1978)

Ashelford, Jane, *The Art of Dress, Clothes and Society 1500-1914* (London, 2000)

Barranger, Tim, 'Imperial Visions' in John M. Mackenzie (ed.) *The Victorian Vision, Inventing New Britain,* (London, 2001)

Berg, M., *The Age of Manufacturers,* (London,1985)

Bell, Carol, *The Manchester School of Embroidery* (Manchester, 1988)

Bellamy, Joan; Golby, John; Parsons, Gerald, Roberts, Gerrylynn and Walder, Dennis, 'Population Culture and the Labouring Classes' in *An Arts Foundation Course, Culture: Production, Consumption and Status* (London,1990)

Benjamin, Frederick, A. *The Ruskin Linen Industry of Keswick,* (Cumbria, 1974)

BIBLIOGRAPHY

Boris, Eileen, *Art and Labour, Ruskin, Morris and the Craftsman Ideal in America* (Philadelphia, 1986)

Bryson, John, 'Introduction' in John Ruskin, *Unto this Last, the political economy of art* (London, 1968)

Buckley, Cheryl, ' Made in Patriarchy :Toward a Feminist Analysis of Women and Design' in Margolin, V. (ed) *Design Discourse* (Chicago, 1989)

Bythell, Duncan, *The Sweated Trades, Outwork in nineteenth century Britain* (London, 1978)

Cain, P.J. and Hopkins, A.G., *British Imperialism – innovation and expansion, 1688-1914 (London, 1993)*

Callen, Anthea, *Angel in the Studio,* (London, 1979)

Calloway, Stephan (ed), *Liberty of London, Masters of Style and Decoration* (London 1992)

Chaloner, W.H. (ed), *Passages in the Life of a Radical* (London, 1967),

Chapman, Stanley, *The Early Factory Masters,* (Newton Abbot, 1967)

Chapman, Stanley, *Hosiery and Knitwear, Four Centuries of Small Scale Industry in Britain, c. 1589-2000* (Oxford, 2002)

Craig, David (ed.), *Hard Times* (London, 1969)

Crook, Mordaunt, J. 'Introduction' in Charles Eastlake, *A History of the Gothic Revival,* (Leicester, 1970)

Corina, Maurice *Fine Silks and Old Counters Debenhams 1778-1978* (London 1978)

Crossick, G. and Jaumain, S. (eds.), Cathedrals *of Consumption,* (London, 1999)

Dixon, Roger and Muthesius, Stefan, *Victorian Architecture* (London,1995)

De Beauvoir, Simone, *The Second Sex,* (London, 1997)

Ewles, Rosemary. 'Embroidery: one thousand years' in Lanto Synge (ed.), *The Royal School of Art Needlework, Book of Needlework and Embroidery* (London, 1986)

Fraser, Hamish, W., *The Coming of the Mass Market,* (London, 1981)

Giedion, S. *Space ,Time and Architecture,* (Harvard, 1962)

Girouard, Mark, *Return to Camelot* (New Haven and London, 1981)

Halén, Wider, 'Dresser and Japan' in *Christopher Dresser- a design revolution* (London, 2004)

Hall, Stuart,' The Spectacle of the Other' in Stuart Hall (ed) *Representation: cultural representations and signifying practices* (London, 1997)

Harvey, Charles and Press, Jon, *Art, Enterprise and Ethics, The Life of William Morris,* (London, 1996)

Harvey, Charles and Press, Jon. *Design and Enterprise in Victorian Britain,* (Manchester, 1991)

Helm, Marie, Conte, *Japan and the North East of England, from 1862 to the present day* (London, 1989)

Hilton, Timothy., *The Pre-Raphaelites. (London, 1983)*

Hitchcock, HR., 'Introduction' in A.W.N. Pugin, *Contrasts,* (New York, 1969)

Hoskins, Lesley, 'Wallpaper' in L. Parry *William Morris, (London, 1996)*

John, Angela, V. (ed.), *Unequal Opportunities, women's employment, 1800-1918* (Oxford, 1986)

Johnson, Marion, *Derbyshire Village Schools, in nineteenth century* (Newton Abbot, 1970)

Kelvin, Norman, *The Collected Letters of William Morris,* Vol. I (Princeton, 1984)

Kiernan, *V.G., Imperialism and its Contradictions,* (London, 1995)

Lawson, John and Silver, Harold, *A Social History of Education in England* (London, 1973)

Lemire, Beverley, *Dress, Culture and Commerce, the English Clothing Trade before the Factory* (London and New York, 1997)

Levy, Mervyn, Liberty Style, The Classic Years 1898-1910 (London 1986)

Levy, Santina, *An Elizabethan Inheritance, The Hardwick Hall Textiles,* (London,1998)

Lichten, Frances, *Decorative Art of Victoria's Era,* (London, 1950)

Loeb, Lori Anne, *Consuming Angels, Advertising and Victorian Women,* (Oxford , 1994)

Mackenzie, John, M., *Orientalism, History, Theory and the Arts,* (Manchester, 1995)

Marsh, Jan, *Jane and May Morris, a biographical story, 1839-1938 (London, 1986)*

BIBLIOGRAPHY

McKendrick, Neil, Brewer, John and Plumb, J.H., *The Birth of a Consumer Society,* (London, 1982)

Miller, M., *The Bon Marché, bourgeois culture and the department store, 1869-1920* (London, 1981)

Minihan, Janet. *The Nationalisation of Culture,*(London, 1977)

Mitter, Partha, *Much Maligned Monsters, history of European reactions to Indian art* (Oxford, 1977)

Morris, Barbara, *Victorian Embroidery,* (London, 1962)

Morton, A.L. (ed.), *Political Writings of William Morris,* (London, 1979)

Page, William (ed) *Victorian History of the County of Stafford Vol.1,* (Oxford,1968)

Parker, Rozsika, *The Subversive Stitch, embroidery and the making of the Feminine,* (London, 1996) (1984)

Parker, Rozsika and Pollock, Griselda, *Old Mistresses, women art and ideology,* (London, 1981)

Parry, Linda, 'Arts and Crafts' in Michael Snodin and John Styles Design and the Decorative Arts, Britain 1500-1900

Parry, Linda, *Textiles of the Arts and Crafts Movement* (London, 1990)

Parry, Linda, *William Morris,* (London, 1996)

Parry, Linda, *William Morris Textiles,* (London,1983)

Paul, Tessa, *The Art of Louis Comfort Tiffany* (Hertfordshire, 1987)

Payne, P.L., *British Entrepreneurship in the 19th Century,* (London, 1974)

Peck, Amelia and Irish, Carol, *Candace Wheeler, the Art and Enterprise of American Design,1875-1900* (Yale, 2001)

Pennington, Shelley and Westover, Belinda. *A Hidden Workforce, A Hidden Workforce, 1850-1985* (Basingstoke, 1989)

Pinchbeck, Ivy, *Women Workers and the Industrial Revolution, 1750-1850* (London, 1981)

Poulson, Christine, *William Morris,* (London, 1996)

Purvis, June, *Hard Lessons* (Cambridge, 1989)

Roberts, David, *Paternalism in Early Victorian Britain* (London, 1979)

Roe, F.W. *Social Philosophy of Carlyle and Ruskin,* (New York, and London, 1921)

Ross, Kristin, 'Introduction' in Émile Zola *The Ladies Paradise,* (California, 1992)

Said, Edward 'On Flaubert' in A.L. Macfie (ed) *Orientalism, a reader* (Edinburgh, 2000)

Said, Edward, O*rientalism, Western Conceptions of the Orient* (London 2003)

Schmiechen, James. *Sweated Industries and Sweated Labour, the London clothing trades 1860-1914)* (London, 1967)

Snodin, Michael 'Style' in Michael Snodin and John Styles (eds) *Design and the Decorative Arts, Britain 1500-1900* (London, 2001)

Stewart ,Imogen, 'Embroidery and Dress' in Lanto Synge (ed) *The Royal School of Needlework Book of Needlework and Embroidery,* (London, 1986)

Stuart, D.G., *The History of the Leek Embroidery Society,* (Keele 1969)

Swain, Margaret, *The Needlework of Mary Queen of Scots,* (Bedford, 1986)

Synge, Lanto, *Antique Needlework,* (London, 1982)

Synge, Lanto, *The Royal School of Needlework, Book of Needlework and Embroidery* (London, 1986)

Thompson, EP, *William Morris, Romantic to Revolutionary* (London, 1977)

Thompson, EP and Yeo, *The Unknown Mayhew, selections from the Morning Chronicle 1849-1850* (London,1971)

V&A publication (no author) *Liberties, 1875-1975* Exhibition Guide, (London, 1975)

Vicinus, Martha, *Independent Women, work and community for single women, 1850-1920, (London, 1985)*

Watt, Judith Costume in Calloway, Stephen *Liberty of London, Masters of Style and Decoration,* (London, 1992

Wilson , John, F. *British Business History* (Manchester, 1995),

Wilson, J.F. and Popp, Andrew (eds) *Industrial Clusters and Regional Business Networks in England, 1750-1970,* (Aldershot, 2003)

Woods, Christine, 'Sir Thomas Wardle' in Jeremy David (ed.) *Dictionary of Business Biography,* Vol.5 (London, 1986)

BIBLIOGRAPHY

Journals

Blum, D. 'Ecclesiastical Embroidery c. 1896 attributed to Walter Crane', in *Bulletin – Philadelphia Museum of Art,* Vol.86 Spring (Philadelphia, 1990)

Braverman, H.,, 'Labour and Monopoly' in *Monthly Review Press,* (January, 1999)

Brunton, Jennie 'Annie Garnett: The Arts and Crafts Movement and the Business of Textile Manufactures' in *Textile History,* (32) 2

Burchill, F. 'The Leek Textile Unions' in *A History of Trade Unionism in the North Staffordshire Textile Industry* (Staffordshire, 1971)

Church, Roy. 'New Perspectives on the History of Products, Firms, Marketing and Consumers in Britain and the United States, since the Mid-Nineteenth Century', in *History Review, LII, 3 (1999)*

Comitini, P. 'More than Half a Poet: vocational philanthropy and Dorothy Wordsworth's 'Grasmere Journals' in *European Romantic Review'* Vol.14 issue 3 (London, 2003)

Cormack, Peter, 'A Truly British Movement', in *Apollo,* April 2005,

Darley, Gillian, 'Salvation Army' in *Crafts, no.140 May/June (1996)*

Davidson, J. 'William Morris, Eminent Victorian Businessman' in *Interior Design,* (New York) Vol. 67, October, 1996,

Dupree Margurite, 'Firm, Family and Community' in *Industry and Business*

Ferry, Kathryn, 'Writers and Thinkers, Owen Jones', in *Crafts* Vol. no. 198 Jan/Feb. (London, 2006)

Fowler, Christina, 'Changes in Provincial Retail Practise During Eighteenth Century, With Particular Reference to Central-Southern England' in *Business History Review* October 98 Vol.XX issue 4 (1998)

Greenhalgh, Paul. 'The Trouble with Utopia' in *Crafts* no. 140 May/June (1996)

Hill, Rosemary, 'Pugin and Ruskin' in *The British Art Journal,* Vol.II no. 3 Spring/Summer 2001

Horton, M. 'William Morris Victorian England's Medieval Artisan' in *Piecework,* Vol.7 Issue 1

Jacques, Anne, G. *Leek Embroidery,*(Staffordshire, 1990)

Jacques, Anne, G. *The Wardle Story* (Leek, 1996),

Lloyd-Jones, Roger and Myrddin Lewis, 'Personal Capitalism, and British Industrial Decline, the Personally Managed Firm and Business Strategy in Sheffield, 1880-1920' in *Business History Review,* Vol.68, Autumn 1994

Marsh, Jan, 'The female Side of the Firm' in *Crafts,* no.140 May/June 1996

McClean, Polly, 'The Love of Giving' in *Resurgence* issue 215 (London, 2002)

Nenadic, Stana, 'The Small Family Firm in Victorian Britain' in *Business History* Vol. 35 no.4,

Owens, Alistair, Inheritance and the Life-Cycle of Family Firms in the Early Industrial Revolution' in *Business History* Vol.44 No. 1

Parry, Linda, 'Women's Work' in *Crafts* Vol. no.128 May/June, 1994 pp.42-47

Powers, Alan, '1884 and the Arts and Crafts Movement' in *Apollo,* April (London, 2005)

Thompson, Paul Warwick, 'The Forward' in Michael Whiteway (ed) *Christopher dresser - a design revolution* (London, 2004)

Wainwright, Clive. 'Principles True and False: Pugin and the Foundation of the Museum of Modern Manufactures', in *Burlington*, Vol. COX no. 105, June 1994

Websites

http://www.charon.sfsu.edu/Tennyson/TENNCHRON>HTML

http://www..liberty.co.uk/store_info/history.asp

http://www.sticerd.lse.ac.uk/dps/is/IS349.pdf

Lightning Source UK Ltd.
Milton Keynes UK
UKOW041802110213

206130UK00004B/151/P